stone canoe

A Journal of Arts and Ideas from Upstate New York

Spring 2007 | Number 1

SYRACUSE
UNIVERSITY
University College

Continuing education since 1918

Stone Canoe, a journal of arts and ideas from Upstate New York, is published annually, each spring, by University College of Syracuse University, 700 University Avenue, Syracuse, New York 13244-2530. Address all correspondence to the above address, or to *stonecanoe@uc.syr.edu.* Phone: 315-443-1802/3225. Fax: 315-443-4174.

Stone Canoe showcases the work of a diverse mix of emerging and well-established artists and writers with connections to Upstate New York. In so doing, the journal supports Syracuse University's ongoing efforts to nurture creative community partnerships and seeks to promote a greater awareness of the cultural and intellectual richness that characterizes life in the region.

Stone Canoe considers for inclusion previously unpublished short stories, short plays, poems, essays, and works of visual art. Unsolicited submissions are welcome from March until August of each year. Send materials to *Stone Canoe* at the address above. Include a self-addressed, stamped envelope. Art work should be on a CD, in pdf or jpg format, at a minimum of 300 dpi. Work may also be sent electronically to *stonecanoe@uc.syr.edu.* Manuscripts should be sent as Microsoft® Word documents. Each submission must include a short biographical statement and all contact information. See inside back cover for further information on *Stone Canoe* prizes for emerging writers and artists.

Stone Canoe is available at Syracuse University Bookstores and other selected college and commercial bookstores. Individual copies are $18. To order by mail, send a personal check or money order to *Stone Canoe* at the address above. Visit *stonecanoejournal.org* for more information on contributors and their work, as well as related news about the Upstate New York arts community.

Stone Canoe is printed by Quartier Printing, 5795 Bridge Street, East Syracuse, New York 13057.

Stone Canoe is typeset in Bembo, a trademark font of the Monotype Corporation, based on a typeface designed by Francesco Griffo in 1495.

Stone Canoe is distributed by Syracuse University Press, 621 Skytop Road, Syracuse, New York 13244-5160 *www.SyracuseUniversityPress.syr.edu*

ISSN: 1934-9963 ISBN: 978-0-9791944-0-5

Stone Canoe SPRING 2007 | NUMBER 1

STAFF

EDITOR
Robert Colley

POETRY EDITOR
Michael Burkard

FICTION EDITOR
Dan Torday

NONFICTION EDITOR
Johanna Keller

VISUAL ARTS EDITOR
David MacDonald

CONTRIBUTING EDITOR
George Saunders

GRAPHIC DESIGNER
E.L. Cummings Serafini

PRODUCTION MANAGER
Karen Nadolski

COPY EDITOR
Lois Gridley

EDITORIAL COORDINATOR
Tiffany Bentley

WEB DESIGNER
Denise Heckman

WEB MANAGER
Allison Vincent

WEB TECHNICAL CONSULTANT
Michael Frasciello

PROOFREADERS
Martha Zvonik
Mary Kate O'Brien

ADVISORY BOARD

Omanii Abdullah-Grace
Paul Aviles
Michael Burkard
Carol Charles
Leo Crandall
Stephen Dunn
Arthur Flowers
Wendy Gonyea
Kenneth Hine
Jeffrey Hoone
Elizabeth Kamell
Johanna Keller
Christopher Kennedy

Robin Wall Kimmerer
David MacDonald
Timothy Mahar
Pamela McLaughlin
Philip Memmer
Francis Parks
Minnie Bruce Pratt
Maria Russell
Carol Terry
Silvio Torres-Saillant
Stephanie Vaughn
John von Bergen
Marion Wilson

ACKNOWLEDGEMENTS

S tone Canoe is dedicated to the memory of Syracuse University Professors Donald Dike and David Owen, who devoted themselves to teaching the importance of literature to diverse audiences, including adult students in the College of Arts and Sciences' Independent Study Degree Program and the Higher Education Opportunity Program at Auburn Penitentiary. All who heard them were transformed.

Special thanks to the following people whose support and guidance have helped make possible this inaugural issue.

Philip Arnold, *Associate Professor, Syracuse University Department of Religion*

Steven Barclay, *Barclay Associates*

Carol Brzozowski, *Dean, Syracuse University College of Visual and Performing Arts*

Alex Charters, *Professor Emeritus, Syracuse University School of Education*

Pascal Cravedi-Cheng, *Community Access Coordinator, Howard Center for Human Services, Burlington, Vermont*

Pedro Cuperman, *Editor,* Point of Contact

Ron Derutte, *Instructor/Technician, Syracuse University School of Art*

Bill Delavan, *Delavan Art Gallery*

John Dowling, *John Dowling Photography*

Debbie Downing, *Manager, Precision Reporters, PC*

Rob Enslin, *Communications Manager, Syracuse University College of Arts and Sciences*

Mary Selden Evans, *Executive Editor, Syracuse University Press*

Michael Fawcett, *Chief Corporate Development Officer, Health Dialogue*

Allen and Nirelle Galson, *Arts patrons extraordinaire*

Freida Jacques, *Clan Mother, Onondaga Nation and Home/School Liaison, Onondaga Nation School*

Don Lee, *Editor,* Ploughshares

John Fruehwirth, *Managing Editor, Syracuse University Press*

Michael Gray, *Workshop Programs Director, GRACE, Hardwick, Vermont*

Roberta Jones, *Associate Dean, University College of Syracuse University*

Mary Lerner, *Friends of the Central Library, Onondaga County*

Kristiina Montero, *Assistant Professor, Syracuse University School of Education*

Mary Peterson Moore, *Design and Production Manager, Syracuse University Press*

Deirdre Neilen, *Editor,* The Healing Muse

Ahn T. Nguyen, *Program Staff, InterReligious Council of Central New York/Center for New Americans*

Cathryn Newton, *Dean, Syracuse University College of Arts and Sciences*

William Patrick, *Director, New York State Young Writers Conference*

Lil O'Rourke, *Vice President and Senior Development Officer, Syracuse University*

Mark Robbins, *Dean, Syracuse University School of Architecture*

Robert Seidman, *Professor, Southern New Hampshire University*

Amy Speach Shires, *Associate Editor,* Syracuse Magazine

Mary Jo Slazak, *Manager, Subsidiary Rights, Book Division, National Geographic Society*

Clint Tankersley, *Senior Associate Dean, The Martin J. Whitman School of Management, Syracuse University*

Thom Ward, *Editor, BOA Editions, Rochester, New York*

Carrie Mae Weems, *Artist and world citizen*

Particular thanks to Bea González, interim dean, University College of Syracuse University, who immediately understood the value of the *Stone Canoe* project and embraced it as part of University College's mission. She has also generously funded the *Stone Canoe* prize for poetry.

The Constance Saltonstall Foundation for the Arts, Ithaca, New York, is a valued partner of *Stone Canoe,* and we are pleased to note that the following Saltonstall Fellows are featured in this issue: Paul Aviles, Mary Giehl, Christopher Kennedy, Joseph Scheer, Laurie Stone, Marion Wilson, and Leah Zazulyer.

Thanks also to Steve Parks, associate professor in the Syracuse University Writing Program, and the New City Community Press for permission to use poems by Evalena Johnson and Jakk Glen III.

"The Discreet Advantages of a Reichstag Fire," by W. D. Snodgrass, is from *Not For Specialists: New and Selected Poems,* 2006, BOA Editions, Ltd., and is used with permission of the publisher.

EDITOR'S NOTES

Welcome to the inaugural issue of *Stone Canoe*. Why such a name for an arts journal? It is a long story, as the saying goes—a sacred Native American story, in fact, that dates back some 2000 years and is embedded in the DNA of our region. It is the story of the Peacemaker, who was chosen by the Great Spirit to travel from the shores of Lake Ontario to New York's Finger Lakes region, to spread the message of peace and harmony among the warring tribes who lived there. The Peacemaker made his trip in a canoe carved out of white granite, causing his relatives great concern: how could it float? But it did, and by the miracle of his conveyance, people understood the power of his message, shared in the form of magic songs. The Peacemaker braved many hardships, but ultimately succeeded in converting the tribal chiefs to his vision, and founded the Haudenosaunee Confederacy, which had its first council fire on the shores of Onondaga Lake—perhaps where Syracuse's Carousel Mall now sits. The Confederacy is regarded by many scholars as the first participatory democracy in the Western hemisphere, and its constitution, known as the Great Law of Peace, served as a blueprint for the founding fathers of the fledgling U.S. government, notably Washington and Franklin. The full story of the Peacemaker and his stone canoe can be found on various web sites, such as *firstpeople.us.* The lead essay in this issue, Robin Wall Kimmerer's *The Sacred and the Superfund,* is both a scientific treatise and a meditation on the Peacemaker's legacy, in the context of Onondaga Lake's more recent ignominious history.

The Peacemaker's story conjures up larger themes as well. It is an ode to the possiblities of peaceful coexistence. As Robert Muller, former Assistant Secretary General of the U.N., put it, the Peacemaker's journey is "perhaps the oldest effort for disarmament in world history." It is also a voyage of self-discovery and a testament to the transformative power of art. In all these respects, *Stone Canoe* seems a fitting name for Upstate New York's new community arts journal.

Stone Canoe is a community project in the broadest sense. It is committed to showcasing the work of artists and writers from, or somehow connected to, the Upstate New York region. But, as you will discover by even a brief

glance at its contents, the perspective of the journal is far from parochial. The contributors to *Stone Canoe* No. 1—71 in all—represent remarkable diversity in every respect—age, level of experience, cultural background, choice of subject matter, and point of view. Geographically, our "local" contributors range from Albany to Buffalo, and from Binghamton to Canton. There are writers and artists representing 11 of the region's colleges and universities. There are people who grew up in Syracuse, like Diana Abu-Jaber, or those who were educated here, like Stephen Dunn and Robert Phillips, who have gone on to forge distinguished careers elsewhere. There are major writers like Jhumpa Lahiri and Rhina Espaillat whose brief visits have energized our community. There are artists like Wendy Gonyea and Tom Huff whose ancestors have lived in the region since the beginnings of oral history. There are recent immigrants like John Bul Dau and Mario Javier whose celebration of their heritage further enriches the lives of their newfound neighbors. There are students from local and regional high schools. There are artists and writers whose life circumstances have forced them to pursue their artistic goals "on the side," and others who have had to fight through disabilities to make their voices heard. Pulitzer Prize winners are positioned next to writers publishing their first work. Our editorial strategy has been to mix all these together in an attempt to dramatize the collective power of their artistic contribution and to discover what new meanings their work takes on in juxtaposition.

Each voice or hand adds to the texture of our collective experience. Some of the work is directly related to local history, such as Elaine Handley's tale of the Underground Railroad and the Erie Canal, David Hajdu's account of the burning of comic books in Upstate towns, and Marion Wilson's encounter with the malevolent spirit of John Jamelske. There are homages to the environment, such as Lewraine Graham's graceful landscapes and Joseph Scheer's remarkable moth photographs. Others range further afield, taking on subjects like racism and jazz, addiction in the family, village life in India, and the horrors of war in Viet Nam, Iraq, or Africa. There are multiple perspectives on what it means to be Native American, Jewish American, Arab American, or African American; what it means to be a son, daughter, mother, or father; what it feels like to be young, old, rejected, loved, lonely, angry, full of joy, or full of fear. Occasionally the subject matter or language may be troubling to some readers. One must remember, however, that the best artists often expose us to unfamiliar or unpleasant truths, and challenge us to confront them with new clarity.

We are grateful to the many community partners and friends in schools, colleges, and arts organizations who have connected us to deserving artists in our midst. We are also grateful for the generosity of those well-established artists whose presence in *Stone Canoe* lends affirmation to the efforts of their lesser-known fellow contributors.

Finally, it is important to acknowledge the generosity and dedication of the four principal editors: Michael Burkard, Daniel Torday, Johanna Keller, and David MacDonald. Without their expertise, professional contacts, and inspired collaborative work across genres, *Stone Canoe* No.1 could never have been launched. Heartfelt thanks also to George Saunders, contributing editor, for his advice, support, and nurturing of new talent. Our intent is to periodically rotate editorial responsibilities, to ensure freshness of approach and to include the perspectives of people from other institutions in the region, as well as from the community at large.

One version of the Peacemaker's story mentions the amazement of his friends as they watched him set out on his voyage: "They had never seen a stone float before." One imagines he may have been somewhat amazed himself, and relieved. This approximates the feelings of those of us who have labored over *Stone Canoe,* now that the first issue is launched. With the continued good will of the community, the financial support of our intrepid sponsors, and some occasional help from "a mysterious and unseen current," we hope to keep it afloat for a long time to come.

Robert Colley
Editor, *Stone Canoe*
Syracuse, New York
February 2007

Table of Contents

Stone Canoe Spring 2007 | Number 1

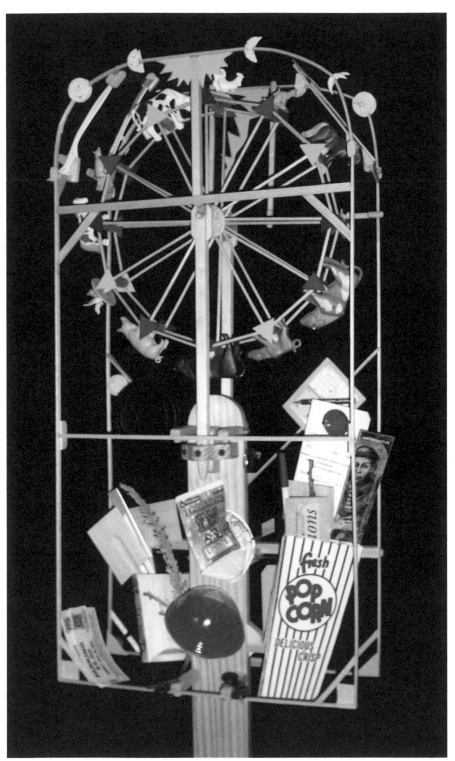

HUGH JONES, *Everything at the Fair Comes on a Stick,*
mixed media/wood, 2006

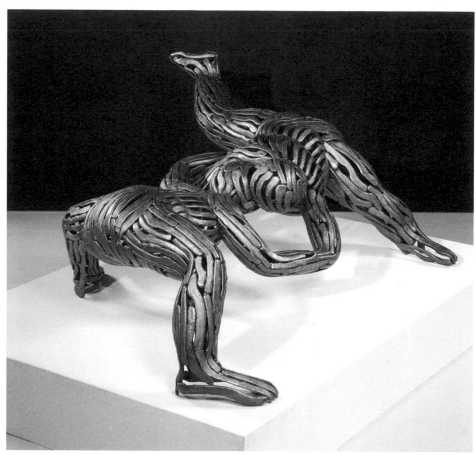

JOHN VON BERGEN, *Uwatenage,* bronze, 2004

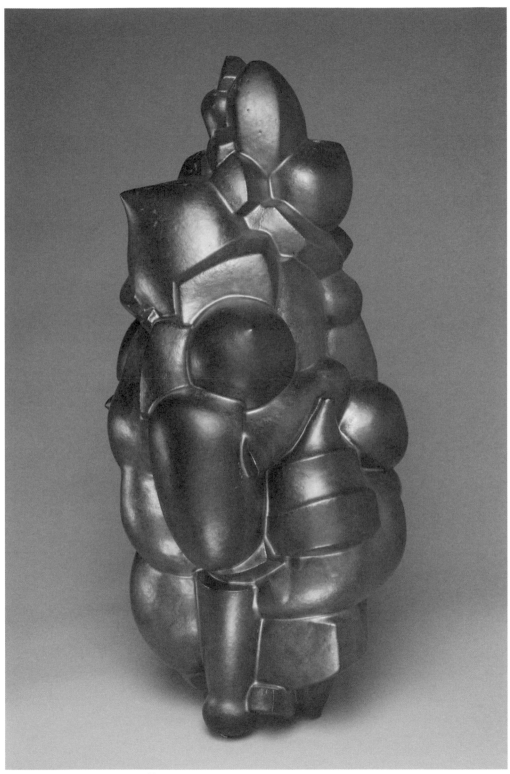

ERROL WILLETT, *Banff #1,* ceramic, 2003

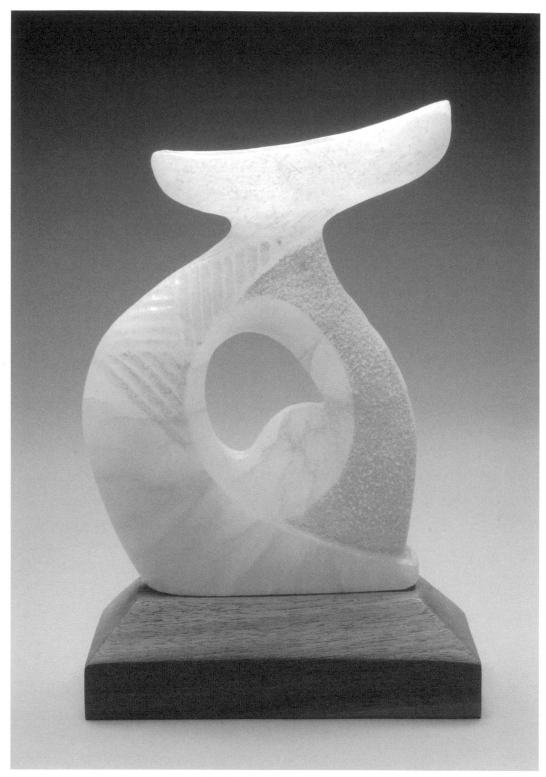

Tom Huff, *Stone Canoe,* white alabaster, 2006

Robin Wall Kimmerer

THE SACRED AND THE SUPERFUND

A drop forms at the end of a mossy branch, hangs in a momentary sparkle, and then lets go. Other drips and drops join in the procession, one of a hundred rivulets from the hills above Otisco Lake. Gathering speed they splash over rocky ledges with growing urgency to be on their way, down Nine Mile Creek, and to Onondaga Lake. I cup my hands to the spring and drink. Knowing what I know, I want to tell it to stop, to hold it back from its fate. But, there is no stopping water.

This watershed lies within the ancestral homelands of the Onondaga people, the central fire of the Iroquois or Haudenosaunee Confederacy. Traditional Onondaga understand a world in which all beings were given a gift, a gift which simultaneously engenders a responsibility to the world. Water is a life sustainer. It has manifold duties: making plants grow, creating homes for fish and mayflies, and providing, for me, a cool drink. Fulfilling the role to which it is assigned is sacred work, a covenant with the rest of creation. Is it not a great wrong for any being to interfere with the sacred purpose of another, including water?

The sweetness of this water comes from the hills themselves, great shoulders of fine-grained limestone of inordinate purity. These old seafloors are almost pure calcium carbonate, with scarcely a trace of other elements to discolor its pearly gray. But, not all springs in these hills are sweet. Beneath the limestone shelves are salt-filled caverns, crystal palaces lined with cubes of halite. The Onondaga used the salt springs to season their corn soup and venison and to preserve the baskets of fish the waters offered up. Life was good and the people offered their thanks in the ways passed down for generations. Water rushes off to do its work, faithful to its responsibility, but people are not always as mindful as water. We can forget. And so the Haudenosaunee were given the Thanksgiving Address, a beautiful river of words by which the people send their greetings and thanks to all the elements of the natural world. Whenever the people gather, no matter how many or few, they begin with thanks for every element of the ecosystem. To the waters they say:

> *We give thanks to all the waters of the world for quenching our thirst and providing us with strength. Water is life. We know its power in many forms—waterfalls and rain, mists and streams, rivers and oceans. With one mind we send greetings and thanks to the Spirit of Water.* [1]

These "words that come before all else" reflect the sacred purpose of the people. For just as water was given certain responsibilities for sustaining the world, so too were the people. Chief among their duties was to give thanks for the gifts of the earth and to care for them. People are charged with sustaining those who sustain them, in the web of reciprocity.

The stories are told of the long ago times when the Haudenosaunee people did forget to live in gratitude. They became greedy and jealous and began fighting among themselves. Conflict brought only more conflict, until war between the nations became continuous. Soon, grief was known in every longhouse, and yet the violence went on. All were suffering.

It is told that, at that sorry time, far to the west, a son was born to a Huron woman who had not yet known a man. This handsome youth grew to manhood knowing that he had a special purpose. He explained to his family that he must leave home to carry a message to people in the east, a message from the Creator. He built for himself a great canoe carved of white granite. He journeyed across many waters until he pulled his stone canoe ashore, in the midst of the warring Iroquois. Here he spoke his message of peace and became known to all by the name of the Peacemaker. Few would hear him, but those who listened were transformed. His life in danger, weighted down with sorrow, the Peacemaker and his allies spoke peace in times of terrible trouble. For years, they traveled among villages. One by one, the chiefs of the warring nations came to accept the message of peace. All but one. Tadodaho, an evil wizard of the Onondaga, refused the way of peace for his people. He was a man so filled with evil that his hair was writhing with snakes and his body was crippled by hate. Tadodaho sent death and sorrow to the carriers of the message. But, the message was more powerful than he and eventually, Onondaga too accepted the words of peace. His twisted body was restored and, together, the messengers of peace combed the snakes from his hair. Tadodaho, was transformed.

The Peacemaker gathered together the leaders of all five Haudenosaunee nations. With his words and actions, he joined them with one mind. Here on the shores of Onondaga Lake, the Great Tree of Peace was planted, an enormous white pine. Five long green needles, joined in one bundle, represented the unity of the Five Nations. With one hand, it is told that the Peacemaker lifted the great tree from the soil. The assembled chiefs stepped forward to cast into the hole their weapons of war. On this very shore, the Nations agreed to "bury the hatchet" and live by the Great Law of Peace, which sets out right relations among peoples and with the natural world. Four white roots spread out to the four directions, inviting all peace-loving nations to shelter under

its branches. So was born the great Haudenosaunee Confederacy, the oldest living democracy on the planet. For its pivotal role, the Onondaga Nation became the central fire of the Confederacy. From that time forward, the name Tadodaho is carried by the spiritual leader of the Confederacy, the name of a loving leader and a holder of the Great Law of Peace.

The Peacemaker placed the far-seeing eagle atop the Great Tree, to warn the people of approaching danger. For the many centuries that followed, the eagle did its work and the Haudenosaunee people lived in peace and prosperity. But then another danger came to their homelands. A different kind of violence. The great bird must have called and called, but its voice was lost in the maelstrom winds of change. Today, the ground where the Peacemaker walked is a Superfund site.

In fact, nine Superfund sites line the shore of Onondaga Lake, around which the present-day city of Syracuse, New York, has grown. Thanks to more than a century of industrial development, the lake historically known as one of North America's most sacred sites is now known as the most polluted lake in the country. The Onondaga homelands came once again under attack.

Drawn by abundant resources and the coming of the Erie Canal, the captains of industry brought their innovations to Onondaga territory. Early journals record that smokestacks made the air "a choking miasma." The manufacturers were thankful for the presence of the sparkling waters of Onondaga Lake, so close at hand as to be an ideal dumping ground. Millions of tons of industrial waste were slurried onto the lake bottom. The growing city followed suit, adding sewage to the suffering of the waters. It is as if the newcomers to Onondaga Lake had declared war, not on each other, but with the land.

Today, the land where the Peacemaker walked, the land that held the Tree of Peace, isn't land at all, but beds of industrial waste sixty feet deep. It sticks to my shoes like the thick white school paste we used in kindergarten to glue cutout birds onto construction-paper trees. There aren't too many birds here and the Tree of Peace is buried. The original people could no longer find even the familiar curve of the shore. The old contours were filled in, creating a new shoreline of more than a mile of waste beds.

It's been said that the waste beds made new land, but that's a lie. The wastebeds are the old homeland, chemically rearranged. This greasy sludge used to be our limestone hills. It used to be our water. It used to be our soil. This new terrain is our old land—pulverized, extracted, and poured out the end of a pipe. These hills of waste are the topographic inverse of the open pit mines where these rocks were quarried. They are the largest open pit mines

in New York State, and still unreclaimed. The earth was gouged out in one place, to bury the ground in another. If time could run backward, like a film in reverse, we would see this mess reassemble itself into lush green hills and moss-covered ledges of limestone. The streams would run back up the hills to the springs and the salt would stay glittering in underground rooms.

The waste that covers the sacred ground is known as Solvay waste, after the Solvay Process Company that left it behind. The Solvay Process was a chemical breakthrough that allowed the production of soda ash, an essential component of other industrial processes such as the manufacture of glass, detergents, pulp, and paper. Native limestone was melted in coke-fired furnaces and then reacted with salt to produce soda ash. Its manufacture fueled the growth of the whole region and chemical processing expanded to include organic chemicals, dyes, and chlorine gas. Train lines ran steadily past the factories, shipping out tons of product. Pipes ran in the other direction, pouring out tons of waste.

What used to be the lush sedge meadows and streamside forests where Nine Mile Creek met the lake is now more than one square mile of waste bed. There are five new hills where no hills had been before. This new "land" arrived at the end of a slurry pipe.

I can too easily imagine what it must have been like, those first ejections from the pipe, falling in chalky-white splats like the droppings of an enormous mechanical bird. Splurting and pulsing at first, with air in the mile-long intestine that stretched back to the gut of the factory. It soon settled into a steady flow burying the reeds and rushes. Did the frogs and mink get away in time to avoid being entombed? What about the turtles? Too slow, they wouldn't be able to escape being embedded at the bottom of the pile, in a perversion of the Onondaga story of the world's creation, when the earth was carried on Turtle's back.

First, they filled in the lakeshore itself, sending tons of sludge into the waters in a plume that turned blue water to white paste. The Peacemaker's shore was buried under sludge. Then they moved the end of the pipe to the surrounding wetlands. The flow continued for decades, long enough to bury the land sixty feet deep for one square mile, right up to the edges of the stream. The water of Nine Mile Creek must have wanted to head back up hill, to defy gravity and find again the mossy pools beneath the Otisco springs. Instead it kept to its work and found its way, seeping through the waste beds and out to the lake. Rain knows its responsibility to the land. But the rain can't choose where it falls and rain that falls on the waste beds is in trouble. The waste particles are so fine that they trap the water in the white clay. But gravity is

a patient force and rain eventually finds its way through sixty feet of sludge and out the bottom of the pile to join a drainage ditch instead of a stream. As it passes through the depths, it cannot help doing what it's been called to do: dissolving minerals, carrying ions intended to nurture plants and fish. By the time it reaches the bottom of the heap, the water has picked up enough ions to be as salty as soup and as corrosive as lye. I've walked along that original water, at the headwaters where it sluices over mossy rocks, where minnows school in the shallows. I can't recognize it here where it leaves the waste beds. This is a raw ditch through white banks that ooze streaks of iron like bloodstains. It doesn't look like water anymore, but some flat, viscous liquid. No sparkle, no sound. It has lost even its beautiful name of water. It is now called leachate. Leachate seeps from the waste beds with a pH of 11. Normal drinking water has a pH value of 7. pH 11 is like drain cleaner. It will burn your skin. Today, engineers collect the leachate and mix it with hydrochloric acid in order to neutralize the pH. It is then released to Nine Mile Creek and out into Onondaga Lake.

The water has been tricked. It has been corrupted and instead of being a bearer of life it must now deliver poison. And yet, it cannot stop itself from flowing. It must do what it must do, with the gifts bestowed upon it by the Creator. It is only people who have a choice, and they have chosen to foul the sacred intentions of water.

Today, you can boat on the lake the Peacemaker paddled. From across the water, the western shore stands out in sharp relief. Bright white bluffs gleam in the summer sun like the White Cliffs of Dover. But, when we approach them by water, you'll see that the cliffs are not rock at all, but sheer walls of Solvay waste. While the boat bobs on the waves, you can see erosion gullies in the wall. The weather conspires to mix the waste into the lake. Summer sun dries out the pasty surface until it blows, and subzero winter temperatures fracture it off in plates which fall to the water. A beach beckons around the point. But there are no swimmers, no docks. This bright white expanse is not a beach at all, but a flat expanse of waste that slumped into the water when a retaining wall collapsed many years ago. The water is very shallow and quite clear today. Leaning over the edge of the boat, you can see the white pavement of settled waste extending far out from shore. The smooth shelf is punctuated by cobble-size rocks, ghostly beneath the water, unlike any rock you know. These are oncolites, accretions of calcium carbonate that pepper the lake bottom. Oncolites or tumorous rocks. The word aptly shares its origin with oncology, the study of cancer.

If you put into shore, and step out onto the barren flat, the white sludge will suck at your feet. Pilings stick up through it like a skeleton backbone, remnants of the old retaining wall. Here and there, among bleached-out tufts of grass are rusted old pipes that carried the sludge. *Rhizomes of Phragmites,* common reeds, run over the surface of the spoils, as if their roots wanted to avoid touching the "soil" below. Where the sludge piles meet the flats, there are small, trickling seeps that are eerily reminiscent of the springs above Otisco Lake. But, the liquid that emerges seems slightly thicker than water and there are plates of ice along the little rivulets that drain toward the lake. Ice? In August? What are these clear plates, these crystal sheets beneath which the water bubbles like a melting stream at the end of winter? It is salt. Crystallized windows of salt. The waste beds continue to leach tons of salt into the lake every year. Before Allied Chemical ceased operation, the salinity of Onondaga Lake was 10 times the salinity of the headwaters above Otisco.

The salt, the oncolites, and the waste impede the growth of rooted aquatic plants. Lakes rely on their submerged plants to generate oxygen by photosynthesis; so, without plants, the depths of Onondaga Lake are oxygen-poor. And without the swaying beds of vegetation, fish, frogs, insects, herons, the whole food chain is left without habitat. While rooted water plants have a hard time, floating algae flourish in Onondaga Lake. High quantities of nitrogen and phosphorous from municipal sewage fertilize the lake and fuel their growth. The algae cover the surface of the water, but then die and sink to the bottom. Their decay depletes what little oxygen is in the water and the lake begins to smell like dead fish, which can wash up on shore on any hot summer's day.

The fish that do survive, you may not eat. A ban was placed on fishing in 1970 due to high concentrations of mercury. The lake was re-opened to fishing in 1986, but whatever you catch, you must throw back. Fish from Onondaga Lake are unsafe for human consumption. It is estimated that 165,000 pounds of mercury were discharged into Onondaga Lake between 1946 and 1970. The Allied Chemical Company, successor to Solvay Process, used the mercury cell process to produce industrial chlorine from the native salt brines. The mercury waste which we know today as extremely toxic was handled quite freely on its way to disposal in the lake. Local people recall that a kid could make good pocket money on "reclaimed" mercury. One old timer told me that you could go out to the waste beds with a kitchen spoon and just pick up the small glistening spheres of mercury that lay on the ground. A kid could fill an old canning jar with mercury and sell it back to the company for the price of a movie ticket. Inputs of mercury were sharply

curtailed in the 1970s but the mercury didn't go away. It remains trapped in the sediments where, when methylated, it can circulate through the aquatic food chain. It is estimated that seven million cubic yards of lake sediments are today contaminated with mercury.

If I were you, I'd probably want to stop reading by now. I'd like not to write it. Witnessing the slow death of a lake is a painful process. The wounds to these waters are as numerous as the snakes in the Tadodaho's hair, and they must be named before they can be combed out.

Allied Chemical and the city of Syracuse were not solely to blame for the contamination. Hanlin Plastics, General Electric, Crucible Steel, and others all used the lake in the same way. Some of the corporate culprits are still unnamed, but their inputs are apparent. A sampling core, drilled into the lake bottom, cuts through sludge, trapped layers of discharged gas, oil, and sticky black ooze. Analysis of the lake sediments reveals significant concentrations of cadmium, barium, chromium, cobalt, lead, benzene, chlorobenzene, assorted xylenes, pesticides, and PCBs. But not many insects.

And not many fish. But it wasn't always that way. Onondaga Lake in the 1880s was famed for its whitefish, served freshly caught on steaming platters, alongside potatoes boiled in salty brine. Fine restaurants did a booming business along the lakeshore, where tourists came for the scenery, the amusement parks, and picnic grounds where families spread their blankets on a Sunday afternoon. A trolley delivered passengers to the grand hotels that lined its shore. One famed resort, "White Beach," featured a long wooden slide, lit with strings of glittering gaslights. Holiday makers would sit in wheeled carts and whoosh down the ramp to splash into the lake below, promising an "exhilarating dousing for ladies, gentlemen, and children of all ages." Swimming was banned in 1940. Beautiful Onondaga Lake. People spoke of it with pride. Now they barely speak of it at all, like a family member whose death was so shameful that the name never comes up.

You'd think that such toxic waters would be nearly transparent with the absence of life. But instead, some areas of the lake are often nearly opaque with a dark cloud of silt. The turbidity comes from a muddy plume which enters the lake from another tributary, Onondaga Creek. It flows in from the south, from the high ridge above the Tully Valley, from hillsides of forests, farms, and sweet-smelling apple orchards. The headwater brooks are crystal clear. Muddy water is usually attributed to runoff from farmland, but in this case the mud comes from below. High in the watershed are the Tully mudboils, which erupt into the creek like a mud volcano, sending tons of soft sediment downstream.

There is some debate as to whether the mudboils are of natural geologic origin. The Onondaga elders remember the times, not so long ago, when Onondaga Creek ran so clear through their Nation that they could spear fish by lantern light. They know that there was no mud in the creek until salt mining began upstream. When the salt wells near the factories ran out, Allied Chemical used solution mining to access the underground salt deposits up near the headwaters. They pumped water into the subterranean salt deposits, dissolved them away and then pumped the brine miles down the valley to the Solvay plant. The brine line was run through the remaining territory of the Onondaga Nation, where breaks in the line ruined the well water for the community. Eventually, the dissolved salt domes collapsed underground, creating holes through which groundwater pushed with high pressure. The resulting gushers created the mudboils that flow downstream and fill the lake with sediment. The creek that was once a fishery for Atlantic salmon, a swimming hole for kids, and a focal point of community life now runs as brown as chocolate milk. Allied Chemical and its successors deny any role in formation of the mudboils. They claim it was an act of God. What kind of God would that be?

The ancestral Onondaga territory stretches from the Pennsylvania border north to Canada. It was a mosaic of rich woodlands, expansive cornfields, lakes, and rivers that sustained the native people for centuries. Indigenous rights to these lands were guaranteed by treaties between the two sovereign nations, Onondaga Nation and the United States Government. But water is more faithful to its responsibilities than was the United States.

George Washington directed federal troops to exterminate the Onondaga; the Nation that had numbered in the tens of thousands was reduced to a few hundred people. Every single treaty was broken. Illegal takings of land by the State of New York diminished their aboriginal territories to a reservation of only 4,300 acres. The size of the Onondaga Nation territory today is not much bigger than the size of the Solvay waste beds. Living on a remnant of their homelands, assaults on Onondaga culture continued. Parents tried to hide them from Indian agents, but their children were taken from them and sent to boarding schools. The express intent was cultural extermination through the assimilating engines of education. The language that framed the Great Law of Peace was forbidden. Missionaries were dispatched to the matrilineal communities in which men and women were equals, to show them the error of their ways. Longhouse ceremonies of thanksgiving, ceremonies meant to keep the world in balance, were banned by law.

The people have endured the pain of being bystanders to the degradation of their lands. But they have never surrendered their caregiving responsibilities, continuing the ceremonies of honoring the land and their connection to it. The Onondaga people still live by the precepts of the Great Law, which sets forth right relationships not only among people, but also between people and the land. However, without title to their ancestral lands, their hands were tied.

Evicted from their homelands, with wounds to land, language, and family, they saw strangers bury the Peacemaker's footsteps. The plants, animals, and waters they were bound to protect dwindled away. But the covenant with the land was never broken. Like the springs above Otisco Lake, the people just kept doing what they were called to do, no matter what fate would meet them downstream. Human beings are given the responsibility of caring for the non-human, for stewardship of the land. In return for the gifts of Mother Earth, their duty is to care for those gifts. It is this reciprocity that allows the world to continue. Although physically exiled from their land-care duties, the Onondaga continued in their spiritual responsibilities. Whenever people gathered, "the words that come before all else" were spoken. Every day, they sent thanks to the natural world, through the words of the Thanksgiving Address. The people went on giving thanks to the land, although so much of the land had little reason to be thankful for the people.

Generations of grief, generations of loss, but also of strength. They did not surrender. They had spirit on their side. They had their traditional teachings. And they also had the law. The Onondaga Nation never relinquished its title to its lands nor compromised its status as a sovereign nation. Onondaga is a rarity in the United States, a native nation that has never surrendered its traditional government, never given up its identity. Federal laws were ignored by their own authors.

Out of grief and its strength has come a rising power, a resurgence that became public on March 11, 2005. The Nation has filed a complaint in federal court with the goal of reclaiming title to their lost homelands, so that they might once again exercise their caregiving responsibilities.

While elders remembered and babies became elders, the people held to the dream of regaining their traditional lands, but they had no legal voice to do so. The halls of justice were closed to them for decades. As the judicial climate gradually changed to permit tribes to bring federal suit, other Haudenosaunee tribes filed claims to recover their lands. The substance of these claims has been upheld by the Supreme Court, which has ruled that Haudenosaunee

lands were illegally taken, and the people greatly wronged. Indian lands were unlawfully "purchased" in contravention of the United States Constitution. New York State has been ordered to forge a settlement. However, remedies and reparations for the illegal seizures have proven difficult to find.

Some nations have negotiated land claims for cash payoffs, land gains, and casino deals in an effort to find relief from poverty and ensure their cultural survival on the remnants of their territories. Their ancestral lands have effectively been converted to cash and casinos. Others have sought to reclaim their original lands by outright purchase from willing sellers, land swaps with New York State, or by the threat of retaking private lands by suing individual land owners.

But the Onondaga Nation has taken a different approach. Its claim is made under United States law, but its moral power lies in the directives of the Great Law: to act on behalf of peace, the natural world, and the future generations.

The Onondaga have sought a solution which honors their land and their spiritual responsibility. They do not call their suit a land "claim," because they know that land is not property, but a gift, the sustainer of life. Tadodaho Sid Hill has said that the Onondaga Nation will never seek to evict people from their homes. The Onondaga people know the pain of displacement too well to inflict it on their neighbors. Instead, the suit is termed a Land Rights Action. The motion begins with a statement unprecedented in Indian Law:

> "The Onondaga people wish to bring about a healing between themselves and all others who live in this region that has been the homeland of the Onondaga Nation since the dawn of time. The Nation and its people have a unique spiritual, cultural, and historic relationship with the land, which is embodied in Gayanashagowa, the Great Law of Peace. This relationship goes far beyond federal and state legal concerns of ownership, possession, or other legal rights. The people are one with the land and consider themselves stewards of it. It is the duty of the Nation's leaders to work for a healing of this land, to protect it, and to pass it on to future generations. The Onondaga Nation brings this action on behalf of its people in the hope that it may hasten the process of reconciliation and bring lasting justice, peace, and respect among all who inhabit this area."

The Onondaga land rights action seeks legal recognition of title to their home, not to remove their neighbors and not for development of casinos, which they view as destructive to community life. Their intention is to use their title to give them a legal voice. Only with title can the Onondaga gain the legal standing to begin restoration of land which has suffered at the hands of its

occupiers. Only with title can they ensure that mines are reclaimed and that Onondaga Lake is cleaned up. The land action, which elders have longed for since their grandparents dreamed it, strengthens the ability of the Onondaga to regain their traditional role as stewards of their homelands. Tadodaho Sid Hill says, "We had to stand by and watch what happens to Mother Earth, but nobody listens to what we think. The land claim will give us a voice."

The list of named defendants is headed by the State of New York, who illegally took the lands. However, the suit also lists those corporations which have been responsible for its degradation. A quarry, a mine, an air polluting power plant, and the more sweetly named successor to Allied Chemical, Honeywell Incorporated, are called to responsibility for damage they've caused to the earth on which they stand.

The legal action not only concerns rights *to* the land, but also the rights *of* the land, the right to be whole and healthy. The Onondaga Nation is calling for restoration of their homelands. Clan Mother Audrey Shenandoah makes the goal clear. It is not casinos and not money and not revenge. "In this land claim," she says, "we seek justice. Justice for the waters. Justice for the four leggeds and the wingeds, whose habitats have been taken. We seek justice, not just for ourselves, but justice for the whole of creation." The spirit of the Peacemaker still walks along this lake.

Despite all efforts at eradication, the Onondaga are still here, still carrying out their responsibilities as human people. The resilience of the people is synchronously mirrored in the resilience of the lake. I think that this is no coincidence. I think they gather courage from each other. Reciprocity is taught by the land. On the land it is written, "What you do to the earth, you do to yourself." This includes healing.

The lake shows its own desire for healing. In just the past few years, the lake has given us signs of hope. As factories have closed and citizens of the watershed build better sewage treatment plants, the waters of the lake have responded to that care. The natural resilience of the lake is making its presence known in tiny increments of dissolved oxygen and returning fish. Hydrogeologists have redirected the energies of the mudboils so that their load is lightened. Engineers, scientists, and activists have all applied the gift of human ingenuity on behalf of the water. The water, too, has done its part. With lessened inputs, the lakes and streams seem to be cleaning themselves as the water moves through. In some places, plants are starting to inhabit the bottom. Just this spring, trout were found once again in the lake, and when water quality took an upward turn it was front-page news. The waters have

not forgotten their responsibility. The waters are reminding the people that they will use their healing gifts, if we will use ours.

The cleansing potential of the water itself is powerful, which gives even greater weight to the work that lies ahead. After all, the trout that come to the lake are likely to become contaminated by the mercury and other toxins. Passing it up the food chain can spell disaster, as the eagle can attest. Oxygen levels are still way too low for a healthy lake; it is too salty, and toxins ooze from the bottom. There is great debate on the best approach to clean up the contaminated sediments so that natural healing can go forward: dredging, capping, leaving it alone.

Allied Chemical, now going by its less tarnished name of Honeywell, Inc., is finally being held accountable for the lake cleanup. State, local, and federal environmental agencies are all offering solutions with a range of price tags. The scientific issues surrounding competing lake restoration proposals are complex and each scenario offers a suite of environmental and economic trade-offs. After decades of foot dragging, Honeywell has predictably offered its own cleanup plan that involves the minimum cost to corporate profits and the minimum benefit to the lake.

They've negotiated a plan to dredge and clean the most contaminated sediments and bury them in a sealed landfill in the waste beds. That may be a good beginning, but the bulk of the contaminants lie diffused in the sediments spread over the entire lake bottom. From here they enter the food chain. The Honeywell plan is to leave those sediments in place, but cover them with a four-inch layer of sand that would partially isolate them from the ecosystem. Even if isolation were technically feasible, they propose to cap less than half of the lake bottom, leaving the rest to circulate as usual. Onondaga Chief Irving Powless characterizes the solution as a Band-Aid® on the lake bottom. Band-Aids are fine for small hurts, but he says that, "You don't prescribe a Band-Aid for cancer." This solution might benefit the Honeywell shareholders, but does not ensure a cleanup of the lake. The Onondaga Nation has called for a thorough cleanup of their sacred lake, but the powers-that-be have not given the Nation a place at the negotiating table. Regaining title to their homeland will give them a voice.

History may turn itself to prophecy, as the Onondaga Nation combs the snakes from the hair of Honeywell. While the others quarrel over cleanup costs, the Onondaga are taking a stance that reverses the usual equation where

economics takes priority over well being. The Onondaga Nation Land Rights Action stipulates a full cleanup as part of the restitution; no halfway measures will be accepted.

In the midst of technical debates and environmental models, it is important that we not lose sight of the sacred nature of the task. Isn't it possible that this most polluted lake can be made sacred again? Made whole by the sacrifices and care of the people, all of the people who live here, guided by the ones who never abandoned the Great Law for the law of supply and demand. The spirit of the Peacemaker still walks along this lake.

What we contemplate here is more than ecological restoration; it is the restoration of right relationship between land and people. Scientists have made a dent in understanding how to put ecosystems back together, but the experiments focus on salinity and hydrology, on matter, to the exclusion of spirit. Often it is not the land which is broken, but our relationship to it. The Onondaga people are offering us a gift of vision. They lead us to dream of a time when the land might give thanks for the people, to envision a time when the Tree of Peace will stand again, growing from the wastebeds.

1. *Thanksgiving Address: Greetings to the Natural World*. Native Self-Sufficiency Center, Six Nations Indian Museum, Tracking Project, Tree of Peace Society. ISBN 0-9643214-0-8

Sarah C. Harwell

Deer in the Headlights

There was something wrong with the deer.
All wired with little white lights.
They invaded the used car dealership
And stood stiff in convertibles.

The deer didn't understand what was wrong.
They were adaptable.
They stood frozen on grass, no matter
the chemical content.

In the used car lot, no grass, just asphalt
warm under their hooves.
They pawed the upholstery.
Oh dear, the used car salesman moaned.

He thought about moving
to another city. He thought about how
he wanted a house in the country.
Then he switched on the deer.

Look how beautiful
it makes the cars, he said.
Everything lit up by wired deer.
I do like nature.

But then he turned everything off.
Go home, he said to them. You're deer. Deer.

Michael Jennings

A SONG

I am the song of fortune the dog of fate
tambourines and the hills down close
torches of nightfall
procession of shadows and ecstatic dancers
I am the song of the heart the open song the wind's song
and the hard song of hands behind bars
the tortured sex of pistols and knives
I am the black slurred song of things gone wrong
a nursery song with its crib slat lies
I am the song of lust song of forgiving
and rose blood on the snow white breast
when the highwayman came riding
I am the dream song in the pickled brain
a song of bones and a song of chains
I am the song of weight of moving freight
I am the pibroch airs of a lonely hour
the wind's flower the stones' psalm
the sleep-stealing stains of old lullabies
I am whatever wakes and dies
the curlews cry

Thom Ward

AFTER THE EXPULSION

A man had almost finished tiling the Chinese dragon when he ran out of dreams.

That's not good, said the scorpion, who always sat on the patio's lone cactus. What will you do now?

I'm not sure, said the man, busy stirring a bowl of grout. Maybe someone else will invent new dreams.

But you're all alone, said the scorpion.

Of course, said the man. And most alone when the dreams run away.

He continued to stir the bowl of grout. The sun continued to sit in the sky, a very hot sun. Maybe it too had run out of dreams, the man thought.

You think too much, said the scorpion. Thinking is the enemy of dreams, cannot tile the dragon.

You're probably right, said the man, who stood up, stepped out of the shade, squinting.

Look! said the man, pointing at the sky. The Chinese dragon is flying to the sun.

No, said the scorpion. That is a man built from thoughts, trying to dream one more dream.

Christopher Kennedy

SPEECH IDENTIFICATION PROCEDURE

The word *father* flew by like a wounded hawk, but I saw clearly the past,
the present, and the future ploughed up, taste of a dying star.

A word can stand for an absence the way light stands for dead stars.
A father can fly by like a bird and disappear in a copse of trees.

I can stand still for a very long time while moving about in the world.
My days are like this, a scarecrow in a field, trying to imagine *birds*.

LIFE CYCLE

How many centuries flew by like startled birds,
I'll never know, but the earth teemed
with modern cities by the time I was awake.
This wasn't a dream. It was a life
in which a dream is a small part and means
almost nothing. Now I was the earth's shadow,
a penumbra, still, in the swirling dust
of the exploded universe, waiting to be reborn.
It seems I had a choice, the kind no one
tells you about until you're a tree,
rooted in the soil, trying to scream your roots
and branches free. That's the wind at night
when you're a child, wide awake in bed,
counting the strange thoughts you thought were stars.

King Cobra Does the Mambo

Mad provocateurs, your monocles are bull's eyes
in prosthetic heaven. The sky reeks of neutrinos
and crows. Days are serpentine. Gold is priceless;
the moon a worthless stone. Manufacturers
suggest the luminous coloratura of ad agencies
as crippled blood coagulates in shrines, the Lourdes
of which is unknown. Mastodons of long extinction
rise from the tar pits to say, *I love you,*
but you never phone. For this, our species waited centuries.
That's as far as I go today; the chores of destiny
can wait. Maybe it's me. Maybe the tongues
of my shoes have taken over. When I walk,
people listen. When I dream, I intuit the laughter
of trees. That, or a runaway train headed your way.

Kelle Groom

THE BEGINNING OF THE WORLD

Men are wrapped in blankets on the sidewalks
mummies rolled in donated quilts, others
pee secretly between cars in the parking
lot, one waves to me, "Hi, Mami," every day
a wave & smile while I try not to run
over the birds or men, gray that makes even
the bright sky dull, on my way through all
the locked doors to my closet office with
a tiny oblong window like you'd put
in a padded room. My skin ashy as
if hundreds of cigarettes have been tapped
down on us, a boy ahead on the sidewalk,
still young enough for daycare, under three,
holds out three fingers, his candle face shining
at me, our handholding, his delicate
features tapered like Brancusi's sleeping
face taking shape, on its side, an invisible
pillow to rest on. Later he runs to me,
grabs my legs, head leaning on my hip, surprised
at himself & glad. In daycare, a photographer
has visited, is on his way out when
the boy says, "Take her picture," so I kneel down,
reach out to him, my hand around his shoulder,
fine as a wrist, & he wants the photo
immediately, asks & asks, blocks my
way he wants it so badly, to take it
with him. That night his mother beat and kicked
him, so he is put in foster care, gone when I arrive.

Omanii Abdullah-Grace

It Ain't Only Hard Out Here for a Pimp

White folks were shocked
Appalled
Dumbfounded
And dare I say perplexed
That their aggregate of conservative movie pundits
Picked their first hip-hop song
For song of the year
What bothered them
(And let's be honest
It bothered a lot of Black folks too)
Was the song's title
"It's hard out here for a pimp"
It ain't only hard out here for a pimp
But it's hard for a sister
Working as a temp
With good secretarial skills
Who interviewed well over the phone
Had a nice sounding European surname
But once on site
The sight of this short-hair-cut African-looking Black woman
Was too much for them
And was told—"we'll call you"
Like I say
It ain't only hard out here for a pimp
But for a brotha
Who's just trying to pay the rent
Who has served his time
And now is back in society
And having a hard time finding affordable housing
Or being able to get into school or the workforce
And you may be thinking I'm talking about a brother
Who's been locked up
Well, in a sense he was locked up
Or maybe I should say locked "in" to

Uncle Sam's lies and promises
A thin line (sometimes) between bars and stripes
Like I said it ain't only hard out here for a pimp
But a single mother
Trying to get out of the trench
Trying to raise her children amidst TV images
Glorifying Black males with "grillz" in their mouths
And soft porn music videos
Where our Black women sometimes with high aspirations
Have to lower them—temporarily
For instant monetary gratification
And mothers struggle from day to day
And they know all too well
It ain't only hard out here for a pimp
But it's hard for people trying to get a grip
And not just Black people
But alternative lifestyle people
Overweight, undernourished, unappreciated people
Gray haired, dred-locked, no-hair-locked people
Southern accent, country-sounding, bourgeois-acting people
So think about it
And maybe you'll see yourself in a category
A category life has catalogued you into
And you'll realize
Much to your dismay
Damn, man
It ain't only hard out here for a pimp

Philip Memmer

Mouse

You know that smell—it overwhelms
Every last room, insisting on itself

until, like an infant's fury,
it is simply gone. I check the trap

in the kitchen cupboard
and there's the mouse, gray fur

not yet stiff. Peeling back the bar,
shaking him into a bag—and still

he could be a toy, despite the crease of red
in his thumb-sized chest, the dread

even the smallest of deaths
brings to a house. A fire

in the hearth, a woman nursing
her almost sleeping son. My boy,

who one day might weep
for such a loss, or might, laughing

scrape the blood-matted hair
from the heel of his boot—

but who today, when I read him stories,
took his purposeful finger

and pressed it hard to the sketch
of *Goodnight Moon*'s young mouse,

the first thing he's learned
in the realm of words. Enough,

almost, to forget the reproach
of air gone sharp, the line of fur

hardened to the plank. More footsteps,
even now, behind the wall—entire lives

lived in that dark. In terror.
But not his life. Not his.

Stephen Dunn

LIMRANCE

I don't know how to spell it,
and the three dictionaries
in this borrowed, mountain house
 don't list it.

But a friend in San Diego
once said he was in it, *in limrance,*
and it was deeper than infatuation,
 more like love

but when love's so large
it can't stay with just one person,
it's for everyone, something you feel
 must be given away

like breath because of the plenitude
of air. As he spoke, I remember
my wife was falling in love with him.
 She who loved me.

Yesterday, I saw this sign:
"Please don't take any flowers
into the rose garden," and would
 have thought it strange

had I not been thinking of limrance.
No doubt it was limrance-preventive,
somebody's sense that things so aromatic,
 so beautiful,

couldn't resist each other
and the garden would be ruined.
I'm in this mountain house, alone,
 feeling an absence

I can't find in any of these dictionaries,
which may mean my friend made it up –
a word, a good embracing noun he needed
 so as not to feel insane.

Now it strikes me that great poems
are limrant, are gifts you feel like
passing on, which if kept only for yourself
 would pinch up your face,

cause your body to turn in at the shoulders
and squeeze your heart. Art is limrant,
and there must be people wrongly in jail
 for limrance misnamed.

E.C. Osondu

TEETH

The husband was home when the pains came. It was a drizzling fall evening. The doctor had told them to start coming to the hospital when the contractions became regular. They called a cab and she cried all the way to the hospital. He thought she was in a lot of pain but she told him later that she had cried because back home when a woman was to have a baby the men sat outside drinking *ogogoro,* the local gin, while the woman was surrounded by local midwives and aunts and cousins and grandmothers who had had many children themselves and knew how to flip the baby in the womb if it chose to come feet first instead of head first.

It was the wife's idea that they should have a baby while in America. He was not very enthusiastic about the idea; he was here to study, he told her. And, besides, babies cried a lot and one of the things that was said about white people when he was growing up in Nigeria was that they did not like noise, the other two being that 1) they did not tell lies, and 2) they were completely fearless. Since they came to America he had added reason to agree with the fact that white people did not like noise. The tiny apartment where they lived was always deathly quiet. They had a long argument, keeping their voices down. He could not tell the wife that his classes were not going so well. He could hardly follow the speech of the professors. Their language was very idiomatic; they and the students had common terms of reference that he lacked. Sometimes in class, the professor and everyone else would be laughing. He would have his head buried in his notebook not even knowing a joke had been made.

"Every child born on American soil is an American citizen," she told him. The husband did not know that citizenship was automatic. He thought it was something the child got after living for a certain number of years on American soil and meeting certain eligibility requirements. "And any child born here can become the president of this country." Can you imagine that, their child a president of the most powerful country in the world? He could imagine it, himself, seeing his grandmother and all his relations from Nigeria with colorful loincloths around their waists lounging on the beautiful green lawn of the White House. She told him about the Kenyan whose father had been an international student just like him when he had had him. She told him he was now a Senator and that his Kenyan relatives told the *New York*

Times that they had danced through the night when they heard the news that he had been elected a Senator.

"But that is not even the best part, the best part is that when our son is eighteen he can file for a green card for us his parents to join him here in America, and you know what that means, it means we can get to spend our old age in this beautiful country."

He did not know that either. He sometimes wondered about all the things she knew about the country. The country puzzled him by the day. None of his assumptions held. He was constantly in a state of bewilderment and would open his mouth to gulp in air each time he was shocked or surprised. Since he was puzzled all the time, his mouth was perpetually open.

What he did not tell the wife was that love-making was not on top of his list anymore. He had tried to reason through it, why it no longer meant anything to him, but he couldn't be sure. He sometimes reasoned it was the half-naked girls that he saw on campus every day. It had shocked him at first but after some time he had gotten used to them. He sometimes told himself it was the cold. The winter in upstate New York that year had been the worst in ten years. He would come in from campus after walking one and a half miles in the snow with his eyes red, his face frozen, even the snot in his nostrils frozen stiff.

He would stay in the sitting room pretending to be reading while the wife got ready for bed. She would look at him and go to bed while he sat in the sitting room reading the same line a hundred times and would sleep on the couch when he got tired.

Sometimes the wife told him she had learnt some new things about love-making from the shows she watched on television. This bit of news perked him up and made him leave the couch and go to the bedroom. She was right; she had indeed learned new things.

He did not believe her when she said she was pregnant. He still imagined that it had to be done in a certain position for at least a dozen times. He took her to the university health center. The nurse who smiled all the time ran a test for her and within five minutes confirmed that she was indeed pregnant. She also told them that in a few months time they could have a sonogram to determine the sex of the baby, like most couples did in America. But his wife, who otherwise embraced everything American, objected to that.

"We don't do that in Africa," she told the nurse.

She then went into a long analogy about how babies were like parcels that had been handed to us and sonograms were like peeking at the parcel on the

way home to find out what its contents were instead of waiting to get home to find out what it contained in the privacy of your house.

"It is your decision and I respect it," the nurse practitioner had told them. This was one of those American expressions that baffled him—he encountered them everyday and they transformed conversations into legal expressions that frightened him.

The wife saw it differently; she was happy. She thought the nurse practitioner was a nice person and had a lot of respect for Africans. She added it to the list of things that made America such a strange country. She added it to the list of things she told her mother on the phone each time she made those long distance calls she made to her mum back home. Those conversations that always began, …"Hmm these people are very strange you know; can you imagine that criminals must be read their rights and told to remain silent while being arrested, you know, unlike our own policemen that would let you say incriminating things about yourself that would put you in even more trouble. Hmm do you know that if your husband lays his hands on you here, you could have him arrested? Our uncle Zanza who beats his wife on the 30th of every month when he collects and drinks away his wages should come here. Hmm do you know there are couples here who chose not to have babies so that they can enjoy each other more?"

She would hear her mother's angry hiss from the other end of the telephone line.

"And they call that life?" her mother would ask.

The nurse had also told them to announce it to their friends that they were having a baby, which was yet another strange American practice. In their part of the world you did not need to tell people. You waited till they could see it with their eyes that you were pregnant. Little wonder there were many proverbs about pregnancy, one of which was that it was like smoke, and could not be hidden. Another proverb had it that pregnancy was Nature's way of telling the world not to trust women with secrets.

The pregnancy gave her something to do. She now had doctor's appointments and lab appointments and was able to leave the house, unlike before, when she spent all her time indoors. The doctor gave her a note to the county office and she was given coupons for milk and tuna and carrots.

"See, we are already reaping the rewards of an American baby," she told her husband as she brandished the coupons.

They debated what she should do in case the pains started while he was away on campus. He gave her twenty dollars and told her to keep it some-

where and to call a cab if the pains began while he was not there. She told him that American men held their wives' hands while they had their babies. He smiled and told her to watch less television.

Now he sat on a chair by the labor room and thought about death. He was more worried about the fact that she could die while having the baby than anything else. The school made international students take out an insurance policy for themselves and their spouses that would cover the cost of taking their bodies home in case they died.

He heard his wife's cry and then the cry of the baby and a brief silence and then only the cry of the baby. He walked to the door and waited. The doctor came out and beckoned to him; he was frowning slightly.

"What is wrong, is she dead?" he asked

"Mother and baby are fine. Please come in, we want you to take a look at something."

He walked in, his feet feeling as if his shoes were made of heavy steel. He saw his wife was alive; she looked at him and smiled.

"He is very dark just like you," she said smiling wanly. What had she expected, that the baby would be white, because they lived among many white people?

"It is very unusual, just take a look at this," the doctor said lifting the new baby's upper lip.

He peered into the little mouth; the baby had a full set of teeth. He grabbed the doctor's hands; the nurses and attendants were looking up to him like he held the answer and all he needed do was open his mouth and give them a logical explanation. The father was frightened.

Back in Nigeria, the Elders would have consulted the oracle so they could know what this meant. He did not imagine this kind of thing would happen here. He would have been less shocked if the baby had been a curly blond or was born an albino. He turned to the doctor.

"How did this happen?" he asked.

The doctor gently removed his hands from the father's and assumed a professional manner.

"Otherwise he is a perfect baby and very long for a child, too. You just might have a basketball player in the family."

He looked at the doctor and looked at the surgical knives stained with blood surrounding them and began to weep. His wife too, as if she had been waiting for this cue, began to cry.

"There are options, I mean. We have run a battery of tests and all that, and we still plan to do more but I just thought I should ask you since you people are not from the United States and all, is this common where you come from? We were wondering whether it was cultural. No doubt it is a medical mystery. I have heard that in some parts of the world people are born with only two toes; at the university hospital up the hill, an African woman had this lovely baby with six fingers and six toes. I do not mean to embarrass you; I feel you may be able to offer some kind of explanation."

He trailed off.

He had hardly heard what the doctor said. His mouth felt dry and he gulped in air, feeling suffocated. The nursing aides began to clean up. One of the nurses was talking to his wife about breast-feeding. It appeared everything had once again returned to normal.

The hospital staff were furtive in their dealings with the husband and wife, they could hear people whispering in the large hallway about the strange African baby. The husband was afraid he told the wife that he had heard on television that the government took away strange babies to secret government laboratories in the desert where they put them in glass boxes like tropical butterflies and studied them. While they were talking a woman with a camera came in. She was smiling.

"Hello mum and dad. Can I take a picture of the baby?"

"Are you from the newspaper?" the woman asked, clutching the baby tightly to her chest.

"No, actually I work for the hospital. We need the baby's photograph for our records and our web site."

"Do we have to pay?" the man asked, regaining his voice.

"No, it is absolutely free," the female photographer said, and repeated the word.

"What is the baby's name?" she asked.

"He has no name yet," the husband said. "In our part of Africa you don't give a new baby a name until the seventh day."

"How neat," the female photographer said and began to position her camera. She touched the baby's cheeks to get a smile. The baby smiled showing his teeth, the photographer's face reddened and she very nearly dropped the camera.

"Oh my goodness, I never saw oh my goodness," she said again and began to snap away feverishly, the popping flashbulb brightening the room and temporarily blinding the husband and wife.

"You've got a long one there too," she said as she detached the flashbulb from her camera and started putting it away.

The husband shared the food the hospital provided for the wife. The wife urged him to eat. "You know I am not home and there is no one to make your food."

The husband urged her to eat, telling her that she needed to eat well in order to be able to breast-feed the baby. The baby began to cry; the woman picked him up and began to breast-feed him.

"Thank God it is producing milk; the nurse told me that for some women it took a couple of days before they began to produce milk."

"Is he biting you?" the man asked.

"No he is just sucking away, I don't feel anything. He must be very hungry."

"Come and take a look," she said, raising his blanket and pointing at his stomach. Half a dozen fine lines ran from one side of the tiny stomach to the other.

"Remember the doctor said he was going to be a basketball player, see the lines must have come from his curling himself up so tightly in that little space."

"What are we going to do with that?" the husband said, pointing at the drooping bit of navel from the umbilical cord.

"Don't worry it will fall off in a couple of weeks."

"I mean where are we going to bury it when it falls off. Or do you mean you don't know that in our culture you are buried wherever that bit of navel is buried?"

"Oh yes that, when it falls off I will keep it at the bottom of my box where I keep my clothes and preserve it with camphor. We can take it back with us whenever we are going back home."

The husband did not respond to this. His head fell back on the hospital chair and his mind went back to his childhood.

He was sitting by his grandmother's feet and she was telling him a story; it was something that happened in the land of Idunoba. The inhabitants of Idunoba were dying of thirst. They woke up one morning and discovered that a black python had taken over the well which was the community's only source of water. All the brave hunters who went to the well to kill the python ended up being strangled by it. Then a woman who had been pregnant for seven years began to feel birth pangs. The baby came into the world feet first. When he opened his mouth, he had a complete set of teeth and he used this to bite off his umbilical cord. While everyone in Idunoba watched, he began to grow.

His arms became stout and his feet grew sturdy and he stood at over seven feet and he began to speak and command the villagers to take him to the well. When he got to the well, he used his bare hands to drag out the python and choked it to death. Everyone was happy including the king. He gave the boy his daughter to marry and they had seven brave sons and lived happily ever after.

Now, the wife was shaking the husband and asking him to wake up so he could go home. She had assumed he was sleeping. He rubbed his face, picked up his bag, and left for home.

When he got home he assembled the new crib that he bought for the baby from K-Mart and hung up a balloon on the doorway that said *Congratulations.*

The next morning he went to the hospital to bring the baby and mother back home. The wife had called him that night to tell him that the doctor had confirmed that all the tests were negative and that she was free to go home. The doctor told her to clean the baby's teeth with cotton wool and warm water.

There was a bit of a situation when they were about to leave the hospital. The state law required all newborn babies to be transported in an infant car seat. They did not have a car so they didn't have a car seat. The hospital loaned them one and they took a taxi back home.

The wife was happy on seeing the balloon when they entered their apartment and thanked him. She was happy because he was becoming American in his ways. She put the baby in the crib and he continued the sleep he started from the hospital. The woman told him she was tired and went to bed and slept off. He read for a while and also slept off. The baby woke up twice in the night and was suckled by the wife.

The child continued to grow and when he was a few months old, they bought him a toothbrush. Just because he had teeth they gave him meat to chew on occasion, but he always spat it out.

The hospital sent a social worker to visit them to find out if they needed any assistance. The wife became friendly with the social worker and it was the social worker who told her that here in America, people believed in something called the tooth fairy.

"You'll see when your son grows up and starts school, he will learn about the tooth fairy."

The wife was happy to hear this little piece of news and when the husband came back from school, she shared it with him.

"This means they are not so different from us," the wife said.

"Yes, they are not so different," the man agreed.

"I told my mother about it," the wife said.

"I thought we agreed you were not going to tell her," he said.

"I could not bear it anymore; I had to tell her."

"And what did she say?" he asked.

"She said it is a sign of greatness, she said her grandson is going to be a great man."

"For once I agree with your mother," the husband said, and looked at the wife with mischief lurking at the corners of his mouth.

They both began to laugh. Their laughter woke up the baby, who was taking a nap, and he began to cry.

Rhina P. Espaillat

LORD OF THE DANCE

This is Lord Shiva—gift of a young friend—
resting, in lotus posture, on my desk,
wearing three serpents and a rope, each hand
easy upon some weapon. Though his task
is dancing the universe to death and back
endlessly—for the joy of it!—he, too,
needs respite sometimes, and he takes this break
among unfinished poems and bills due.
They say he combs the Ganges from his head
down through his hair into its earthly grooves;
they say he'll whirl on graves to raise the dead,
uprooting what he sows; they chant his names—
"Destroyer," "The Auspicious," "He who moves
with equal grace to carnage and to games."

George Saunders and Jhumpa Lahiri: A Conversation

The following is excerpted from a conversation that took place at the Onondaga County Civic Center in Syracuse, New York, on April 5, 2006, as part of the Rosamond Gifford Lecture Series, sponsored by Syracuse Friends of the Library. George Saunders, a professor at Syracuse University, is the author of three critically acclaimed collections of short stories and the recipient of both a MacArthur Fellowship and a Guggenheim Fellowship for 2006. Jhumpa Lahiri is the author of two books: *The Interpreter of Maladies* and *The Namesake*. The first of these won the 2000 Pulitzer Prize in fiction.

GEORGE SAUNDERS: Let me start by saying—I teach at the Creative Writing Program here in Syracuse, one of the finest in the country, as you all know. This weekend we had the pleasure of taking our students to New York City on a trip to meet publishers and editors. During this literary tour of the city, we had three separate mentions of your work without any solicitation. It was interesting, because the first one cited you as proof of the vitality in the short story in America. The second cited you as proof that the huge epic big-hearted novel was still workable. And the third cited you, very movingly, as proof that at the heart of all fiction is love and compassion. I would like to pass on their love for you and thank you so much for coming to Syracuse.

JHUMPA LAHIRI: Thank you.

GS: So…that's not a question, exactly. But as a writer myself, I feel it's so fortunate to have you to inquisite. Let me ask you: starting with the short story collection, could you describe your writing process? When you begin, what's the seed you have to work with? How do you play that seed out into these beautiful stories?

JL: Well, there is no typical seed. Each story I've written begins in a unique way. There are stories I simply thought about for years without even daring to put them on paper or turning on my laptop. And those stories were about things I didn't even understand myself. It just took a lot of time to think about them, to meditate on what was going on.

There's a story called, "When Mr. Pirzada Came To Dine." It's set during the civil war in Bangladesh, what was formerly known as East Pakistan. It concerns a gentleman from East Pakistan, from Dhaka, who is in New England. He's a visiting scholar and friends with a family of Indian origin in this country. The story is told from the point of view of the daughter of that family. She herself is trying to understand what is going on in her living room and what her parents are talking about. That story was taken from my own life, in a way, because there actually was a gentleman who visited my parents in Rhode Island in 1971. I was four years old—and I know what that means now, because my son is almost four. I understand how small that is in the life of a human being. There was a photo in our family album of that man and I remember as I grew older asking my parents, "Who is that man?" They said, "Oh, he's Mr. so-and-so." And then I asked, "Where is he now?" And they said, "Oh, he went back after the war." And I asked, "What war?" So slowly I began to piece together what had happened.

It had happened in my own home when I was too young to understand what was happening. All of that started to turn up inside of me and the story came out. But it took practically a lifetime to even understand there was a story to tell.

GS: I teach my students from the *Anchor Book of New American Short Stories*, edited by Ben Marcus. That book tends a bit toward the dark—there's a lot of dysfunctionality and murder. That story is probably the seventh or eighth in the anthology. So, by the time my students reach yours, they've gotten used to these murders and killer penguins and so on. When we came to your story, all these kids were so happy. One girl said, "I love this." And I said, "Why?" She said, "Well, because it feels like how life feels to me." These students kept waiting for something catastrophic to happen, for Mr. Pirzada to turn out to be a terrible person, and they took deep pleasure when that didn't happen.

JL: It's interesting, because I write about things that, to me, do seem dysfunctional and dark. That story may not have killer penguins, but to me, you know—I write to understand and confront the painful facts of our existence, and the things that are inevitable. This new book I'm writing is a lot about family, and many relationships that aren't quite working.

GS: Maybe that's the wisdom of your work. In my writing, I'm a bit more simple. I'm always writing about the good guy against the bad guy. Then they fight. But what I'm learning from your work and what I'm so inspired by is that you have the mastery and control to have two people who are both basically good trying to act in a loving way. But often there's just a complicating factor that doesn't allow it.

One of the things I also love about your work is your physical description. There's a beautiful part in your novel, *The Namesake,* where a woman comes to meet her suitor for the first time, and she notices his shoes. There's such a great description of the shoes. When I read it, I literally smelled shoes. They weren't mine—I actually smelled those shoes. Then, you did a beautiful thing where the female character steps into his shoes. It was one of those rich moments where it's not just words on the page anymore. It's three dimensional. And when she steps in the shoes, it becomes almost four dimensional.

JL: Part of my attraction to writing is that I'm a very visual person. The way things look matters to me. I have always been very particular about how I live, and my space. I can't tune it out the way some people can. I'm emotionally affected by the way things look. I think that plays into my writing—Flannery O'Connor said that much of the writer's job is to look at the world.

So take the description of the shoes—that is actually a detail from life, from something my mother told me. When she was about to meet my father for the first time, she was on her way into the room and she saw these shoes. She stepped into them. I thought, "How did she do that?" So, when I was writing that scene, I was sitting in my old apartment. My husband's closet was in that room because we had only one closet in the bedroom and he occupied the closet in our second bedroom. I remember writing this scene and then looking behind me to the closet. He had these shoe bags all filled with shoes. I picked out a shoe and I put it on my desk. It was almost as if I were a painter or something. I put it there and I started to describe what I saw in the shoe.

GS: And that's the shoe.

JL: That's the shoe.

GS: Beautiful. That was actually the moment in the novel when I was totally won over. That was magician's work. There's another thing I noticed—a scene where the father is describing his ability to read while walking. Instantly, I could see him. Is that enjoyable to find those moments? Do you feel when a particular image is working or not working?

JL: I'm aware of all the things I don't like. By default I'm not as aware of the things I do like, not in a positive way. When I'm working on something, the flaws are so apparent. There are so many, and it's overwhelming, and so much of the writing process is trying to weed and weed and weed and weed, and make the ground smooth and clear—so I have my hands full of all the things I don't like.

GS: It's like cards; you drop them and pick up the big mess and an hour later you have a square pack of cards. Is that process similar with stories and with the novel? When you made the jump from these wonderful short stories, was there something profoundly different in your novel?

JL: Well, the idea for *The Namesake* grew slowly, slowly, over the years. It was in my head as a seed long before I consciously thought, "I want to write about this character." I don't know how to explain it. There's just some sort of filing cabinet back there in my head where stuff gets tossed. Not even things I experienced, but questions, curiosity. I just stick things back there. *The Namesake* really started from stuff that got tossed back there one day.

GS: So, if I could have accessed that cabinet a year before you wrote the book…well, I would have stolen it. But really, if I could have gone in there a year before you started the book, what would that seed have been?

JL: The seed was a boy named Gogol who I met. I remember writing in my notebook one phrase: "A boy named Gogol." I didn't do anything with it for years. But I had the phrase in a notebook. I didn't know why I wanted to write about it, I didn't know what I would write about it, I just knew I wanted someday to write about it. Eventually I did decide to try to write about that one phrase, and I just couldn't imagine it as a short story. I hadn't written the book yet, but I knew instinctively that it wouldn't obey the laws of any short story. I believe short stories are incredibly elastic and can be as effectively told in two pages as in 82 pages. But I just knew that it wouldn't be a short story. Something was telling me it had to be a novel.

So that's what it turned into. I knew he was named Gogol because he's my cousin's friend and he lived in a house very close to where my cousin lived. We used to go on long trips to India when I was growing up. And there, the name wasn't remarked upon. It was just a name. I imagined if the boy were brought up here, what would have happened? I mostly grew up with children of immigrants who have uncommon names, but there's some reason for them. They're a part of whatever world they come from. What was interesting about this character was that the name was yet another remove from who he was. He didn't even realize his name does have something to do with who he is, just by circumstance. That's what really got the book off the ground.

GS: It's amazing. And the book has such a beautiful ending, surrounding his name. It actually caused me to weep on a plane. There's another section in *The Namesake* when Gogol first sees himself as an immigrant. He suddenly seems to develop this double vision of the whole family. I thought that was one of the most beautiful things about class—and not simply immigrant issues—I've ever read. When you were writing that scene, could you feel that you were on to something? Are you aware of what you're doing, thematically, or just following the characters through the world you've created?

JL: I think I'm just trying to follow the character on whatever journey I'm trying to create for him. When I'm writing, I'm not thinking about those things. I'm thinking about a character coming from a certain place. He suddenly finds himself in another place. Then what happens? So much of this book is about a very basic life experience: What happens when we slowly leave the family that raised us? I think that this is a universal condition for anyone who grows up beyond the age of eighteen. For some people, it's much more exaggerated than for others. For people who are leaving their place of origin, it's the most exaggerated. To me, that's really what the book was about. How do we change? How do two people who are everything to us when we're little influence us? There's so much pain and loss in our growing up and forming into adulthood.

GS: So do you give a lot of thought to the purpose of fiction? If fiction as a whole were banished from the earth, would you be okay?

JL: No! But I have to answer that question from two perspectives. One is as a writer and the other as a reader. I'm one person, but those are two different aspects of who I am. There would be no writer without the reader.

As a reader, if someone said that from today, you can't read fiction, ever, I would be lost. It's so profound, I can't even imagine. It's really a scary question. I feel that literature has saved me somehow. It has made me, created me. It keeps me alive the way my organs do, and the way blood flows through me. It's that basic to me. To be able to read stories and novels—that's what I live for. It's like food.

From the point of view of writing it's like that also. It's so connected to my livelihood and my life. If I don't write, I don't feel like I'm living. I'm old enough to know what makes me happy, what keeps me bound as a person, and what makes me the best person I can be. And that person is one who reads and writes all the time.

GS: One time someone asked Tobias Wolff that question and he looked like he was hit in the head. And he didn't answer for a few minutes. Then he said: "I would be very sad."

Now, you mentioned earlier that when you were learning to write stories, you kind of looked at other authors' work. Who were they?

JL: When I was really starting to get serious about writing stories, in my early 20s, there were a few books that never left my bedside. There weren't that many, because I learned so much from these few writers. I remember reading the collected stories of Garcia Marquez to the point where the cover fell off. Now I just have the block of paperback pages, glued together. I remember a similar situation happening with *Dubliners,* and the Flannery O'Connor volume. And I feel like if you read those three books, you wouldn't really need anything else.

GS: There's a way that those early stories get into your brain in some structural way that helps you understand while you're writing: Here's how I might get out of this story.

JL: Yes! They serve as the basic road maps. Without them, I would have never gotten through my own stories.

GS: Now, let me ask you about your work with the *New Yorker,* and the process of editing.

JL: It's a really wonderful process. I'm so grateful to the *New Yorker,* and particularly to my editor there. She's an astonishing person. She really understands what I'm trying to say, and she helps me say it. She does it so tactfully, it's almost like she's not even doing anything. But she's doing so much. What typically happens with a story that goes to the *New Yorker* is that they say yes, and then I kind of jump around my house and feel really happy for a really long time. Then I go buy myself something really great. It's such a thrill. I admire so many writers who have published dozens of stories in the *New Yorker.* I can't imagine getting to a point where I don't feel absolutely elated when they take a story.

Then depending on what state the story is in, it goes to the galley. Then comes another sort of thrilling moment to see it in that column format. That's when you start working on it. Usually it's a process of taking away the surplus. Then it goes to fact checkers, who are amazing. A lot of fiction writers don't like working with the checkers. They feel like it's fiction, so what if they do something wrong? But I don't feel that way at all. Yes, I'm writing fiction. But I'm also writing about real life and real-life things. I want there to be some correspondence.

There's a story in *The Interpreter of Maladies,* "The Third and Final Continent." Partly, it has to do with the first moon shot. I'd written that, once the astronauts put the flag on the moon, they left it there. The fact checkers caught it. They hadn't left it there. And so we had to rewrite the whole thing. It's discombobulating, but it's great—I like being challenged. They also have the greatest copy editors. I'm so grateful for it all. I feel like my work that's been published in the *New Yorker* has a buff quality. The rest of my writing seems flabby. It's just sitting around on a couch, eating potato chips. The *New Yorker* stories are fit and trim and camera-ready—they've been on a zone diet. There's something sort of—I don't want to say perfect, because nothing is perfect, but it reaches that stage more than anything.

GS: Let me ask you this. We hear all these complaints about the U.S. literary culture, and complaints about how TV and other media are taking over. What is your assessment of the state of the American literacy culture? Has it declined, is it ruined, is there room for hope? That's not a multiple-choice question.

JL: Well, I see a lot of encouraging things. I see people going to readings. I see people going to reading groups. And I see some things fading, like independent bookstores. Which makes me sad. Nothing replaces a book in this world. No electronic version of it. Nothing. There's nothing that will ever replace the ability to crawl into your bed at the end of the day and pick up this thing that you can hold in your hand, and turn the pages and go into another world. I have small kids, and they live for books. I swear it's not my influence. They just love books. My son is constantly with his books. My daughter is one year old, and she sits there with her book and babbles over it. I don't know if it's because they see me reading—I feel like I barely read because I'm always taking care of them. My son's growing older; he can't read yet either, but I think about what's going to happen when he actually learns how to read. I can hardly restrain my emotion imaging that day. It will be the most thrilling thing in my life when my kids learn how to read. So I feel hopeful.

GS: I do too, now! So, you've written these two amazing books, one of stories and the other a novel. What do you aspire to in the next book? Jonathan Frazen said to me after *The Corrections* came out, "That book was not as kind as I am, and I want to try to address that in my next book." Is there something you feel driven to try to do in your next book?

JL: The book I'm working on now is another collection of stories. But they're different in spirit and in subject matter. They're longer stories. They're explorations of families and family relationships. Even though they're generally about characters of Indian descent, and though I have written a lot about families, these stories feel completely different to me. I feel I haven't gone deep enough in my previous books. Now I'm trying to go deeper.

I imagine that with every book I will feel that way—there will be something I haven't done successfully and I will try to do it better in the next book. And that's what will carry me forward to the next book and the next book, because there's always something, even when the book is finished and things that go into the *New Yorker* and seem so wonderful—there's always something you haven't said. What you're trying to do is so daunting and humbling. I just want to keep trying to scale up slightly higher on the mountain.

GS: Has having the kids changed anything in the way you approach work or your aspirations?

JL: It's mostly time. It's obviously a logical nightmare, trying to balance my writing and my other responsibilities. But on an average day it's fine. The help of a baby-sitter makes it possible. Without her, I wouldn't be able to write at all. Fortunately, I have someone to help me out and give me time in the day. I think that really the question is how a person changes after having children. So many emotions come with parenthood: the joy you never felt, never thought you would feel, the fears that you're suddenly besieged by, just because you're afraid of harm that could come to the children. Everything from that whole range—from the bliss to the dread and all of the things that make you lie awake thinking what if, what if, what if. I think that's the nature of having children. But that has affected me completely as a person, and so it's affected my writing. I think about things differently.

Selfishly, from the point of view as a writer, while raising kids it's necessary that you get on the ground, literally, and look at life the way they see it. I can go to a zoo with my son and feel wildly happy looking at a polar bear! I wouldn't have felt that five years ago. I went just last week to the zoo with my son and I saw the polar bear and my heart was racing because I knew my son was going to be so happy. That's what changes. I think that is the key for me as a writer: to have that kind of interest in life. To have that passion all the time for this world we live in. To have that freshness that children bring.

GS: I want to point out one more thing. We found out backstage you have a Syracuse connection through your father. Can you tell us a little about that?

JL: I just found out myself today. The first job my father was offered, to bring him to the United States from London, where he had been living and where I was born, was in Syracuse. Because of confusion in hiring and budgeting and certain waiting games, he ended up getting a job at MIT. But had he taken the job, I would have grown up here.

GS: If you had grown up here, what would you have thought about all of us here?

JL: I think I need a couple more days before I can answer that one.

GS: Reasonable. So, I hear there's a movie of *The Namesake* in progress. Can you give us an advance or idea of that?

JL: It's a great movie. I saw a rough cut in November and I was so deeply moved, I literally cried in director Mira Nair's arms for ten minutes. I didn't know what else to do. I couldn't believe she had taken this book that I had written and put so much life into it. I don't know much about making movies. I had never been on a movie set until I visited the set to play an extra along with my parents and my sister and some close friends.

GS: Which scene are you in?

JL: It's a scene where Gogol's younger sister, Sonia, is being fed her first rice. It's a tiny moment in the book. Mira asked me if she could use my daughter who was, at the time, five months old. I said okay. So we were around her and they filmed it. But for the movie as a whole, I was just moved. I'm told that usually authors feel disappointed or are made uncomfortable by a movie of their books. I can't possibly say that about this movie. It's a film made with such intelligence and care. Mira was true to my book, but she also made it her own. Some novels are written and you can almost see the movie, because of the dialogue and action, and you sort of can see the camera rolling before your eyes. I don't think my novel has that quality. I was very impressed that they could draw that quality out of it.

GS: There is another quality to reading, isn't there? A quality all its own. I know for me that after I read *The Namesake,* I felt like: Well, I hope they do justice to the book when they make the movie. I know with fiction, when you are done reading it, you are suddenly more aware of the world around you. You're more in love with the world. I put *The Namesake* down and I looked around me. I felt this: I have never seen this place before, or felt so much affection for it. It had that effect. I'm grateful for it. So, thanks.

JL: Well, thank you.

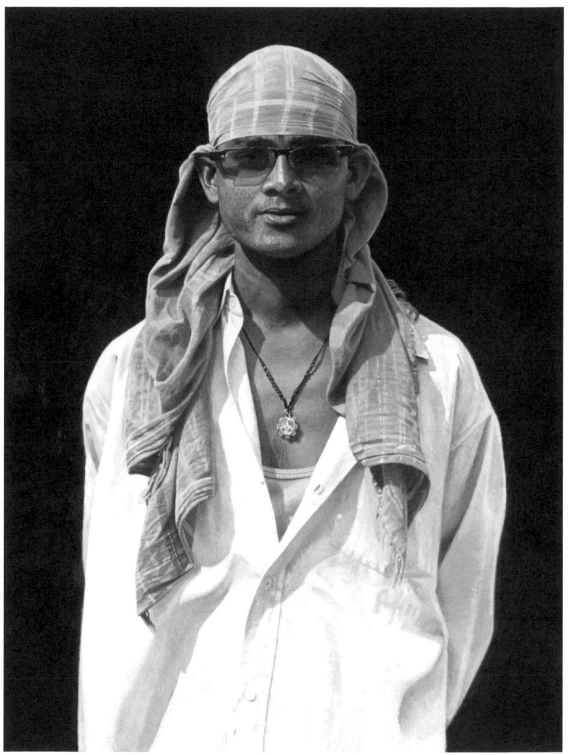

JOHN THOMPSON, *Young Man,* oil on linen, 2006

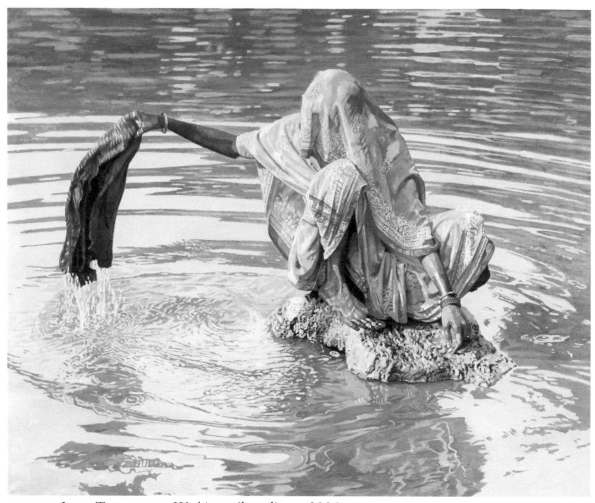

JOHN THOMPSON, *Washing,* oil on linen, 2006

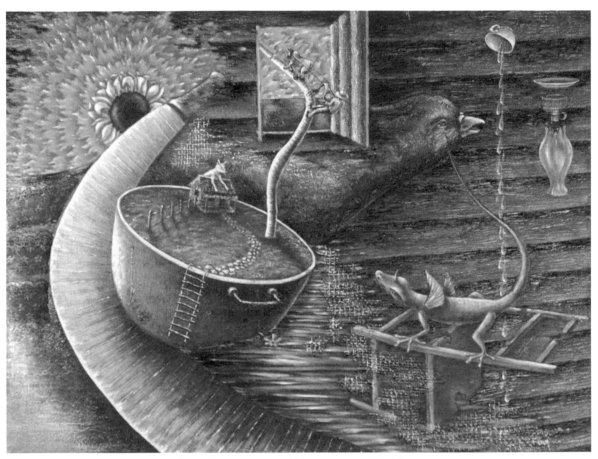

MARIO JAVIER, *Searching for My Sun,* oil on canvas, 2004

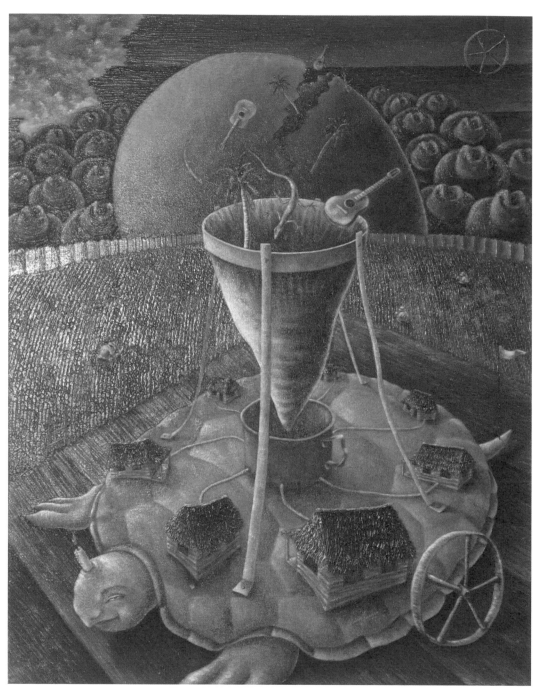

MARIO JAVIER, *Magical Visions: Utopia,* oil on canvas, 2004

John Bul Dau

HOPE IS NEVER LOST

The night the *djellabas* came to Duk Payuel,* I remember that I had been feeling tense all over, as if my body were trying to tell me something. I could not sleep.

It was a dark night, with no moon to reflect off the standing water that pooled beside our huts. My parents and the other adults were sleeping outside, so the children and elderly could all be inside, away from the clouds of biting insects. My brothers and sisters and I, as well as about a dozen refugees from other villages in southern Sudan, stretched out on the ground inside a hut that had been built especially for kids. I lay in the sticky heat, tossing and turning on a dried cowhide, while others tried to sleep on mats of *aguot,* a hollow, grasslike plant from the wetlands that women of my Dinka tribe stitch together. Our crowded bodies seemed to form their own patchwork quilt, filling every square foot with arms and legs.

I opened my eyes and stared toward the grass ceiling and the sticks that supported it, but I could see nothing. Inside the hut it was as dark as the bottom of a well. All was silent except for the whine of the occasional mosquito that penetrated the defenses of the double door, a two-foot-high opening filled with twin plugs of grass that were designed, with obviously limited success, to keep pests outside.

Silence. It must have been around 2 a.m.

Silence.

Then, a whistle. It started low and soft at first, then grew louder as it came closer. Other whistles joined the chorus. Next came a sound like the cracking of some giant limb in the forest. Again, the same sound, louder and in short bursts. I wondered if I were dreaming. As deafening explosions made the earth vibrate beneath me and hysterical voices penetrated the walls of the hut, I realized what was happening.

My village was being shelled.

I sprang up, fully awake. In my panic, I tried to run, but the hut's interior was so impenetrably black I slammed headfirst into something hard. The impact knocked me backward, and I fell onto the bodies of the other children. I could not see even the outline of the door. But I could hear the voices of my brothers and sisters, loud and crying as the shells began exploding, punctuated by the occasional burst of automatic gunfire.

*The name of the village as it appears on English-language maps is often shown as Duk Fawil, a variation from the Arabic.

"Is this the end of the world?" a woman screamed in panic somewhere outside the hut. There was a pause, and other voices repeated the question. I did not know the answer. Then I heard my mother calling my name. "Dhieu! Dhieu!" she screamed. Try as I might, I could not figure out where the voice came from. I strained to listen, but recumbent bodies had come alive all over the floor and children inside the hut started to scream, too. My mother shrieked the names of my brothers and sisters and cried, *"Mith! Mith!"* ("Children! Children!"). The village cattle joined in, mooing and urinating loudly, like a rainstorm, in their fright.

My whole being focused on the single thought of finding the door. I scrambled around the darkened interior of the hut, bumping into a mass of suddenly upright bodies. A group of us, a tangle of arms and legs, flailed around the room, trying to find the way out. We ran into each other, and all of us fell, a jumble of bodies on the ground. The hut seemed not to have a door, and in the chaos and darkness I felt as if I were suffocating. It was a living nightmare.

Suddenly, I felt a hint of a breeze. It had to be from an opening in the exterior wall. I stumbled, let out a cry, and strained toward the puff of fresh air. I found myself on top of somebody, but I could see the door's faint outline. I crawled through the two layers of grass that formed the door of the hut and emerged into the outside world.

I stood and watched the strangely red dawn of a world gone mad. The undergrowth in our village is as thick as a curtain in the rainy season, the eight-foot-tall grasses blocking the view of the horizon. On this night, though, fires had burned away some of the brush. I could see neighbors' huts normally hidden to me, ablaze like fireworks. A big *luak*—cowshed— in the distance, its squat brown, conical roof awash in crimson, resembled a miniature volcano. Shells landed in showers of dirt, smoke, and thunder. Bullets zipped through the air like angry bees, but I could not see who fired them.

I started to run but did not know where to go. Suddenly, my father ran from right to left in front of me. I pivoted and followed him. He ran between the huts, and I tried to catch up with him, but, after about a hundred yards, he halted and knelt, disappearing into the grass at the edge of a footpath. I kept running. As I started to pass him in the darkness, my father reached up, grabbed my shoulder, and pulled me down beside him.

He motioned me to be quiet, and we knelt together in the grass at the edge of the path. I crumpled awkwardly. My weight pressed on my right leg,

which had folded beneath me. I half-rose and tried to shift my body to get comfortable, but I had moved only a fraction when my father gestured to me to freeze.

Within seconds a line of shadowy forms, carrying automatic rifles, ran along the path toward the hut I had just left. There were perhaps nine men, dressed in dark clothes. They did not see us. They passed close enough for me to spit on them, if I had been so inclined. As they vanished beyond a curve in the path, I could hear them fire their guns. The shooting seemed to ring inside my head, and I clapped my hands to my ears. A bitter taste flooded my mouth. Perhaps the sourness of my tense stomach had overflowed. It's odd to remember such a small detail now, but the events of that night are cut into my memory as if etched by acid.

My father dropped low to the ground and seized me with one hand. With the other hand, he pulled himself deeper into the bush, dragging me behind him like a sack of millet. I started to crawl. We moved through the muck, smearing our knees and hands, until we reached the sanctuary of the forest. Inside the shelter of the trees, where the *djellabas* could not see us, we rested. My father did not speak, and I did not press him to do so.

The light grew. It was not daybreak, but the dance of fire on the huts and surrounding trees made it seem so. I heard more gunshots and more crying. I knew nobody in the village had a gun, so each report of the automatic rifles could only mean more death for those I loved. I recall having two thoughts. First, I convinced myself that the women in the village had been right: It really was the end of the world. Second, I wondered what had happened to my mother and my siblings.

After two hours, the sounds of attack faded. I took stock of my situation. I had just turned 13. I was naked. I carried no food or water. My village had been destroyed. I had become separated from my mother and siblings. Armed men who spoke a foreign tongue combed the forests and grasslands, and if they found me, they most likely would kill me. The only good thing I could imagine was that I might be safe for a while.

It was then that I realized the man who sat beside me was not my father.

In the 19 years since that August night, as one of the "lost boys" of Sudan, I have witnessed my share of death and despair. I have seen the hyenas come at dusk to feed on the bodies of my friends. I have been so hungry and thirsty in the dusty plains of Africa that I consumed things I would rather forget. I have crossed a crocodile-infested river while being shelled and shot at. I have walked until I thought I could walk no more. I have wondered, more

times than I can count, if my friends or I would live to see a new day. Those were the times I thought God had grown tired of us.

In some ways, my story is like those of tens of thousands of boys who lost their homes, their families, and in many cases their lives in a civil war between north and south that raged in Sudan from 1983 to 2005. In some ways, I represent the nearly 4,000 Sudanese refugees who found haven in the United States. But in other ways, my story is my own. I have a job, an apartment, a new family, and a wonderful new country to call home. I am studying public policy and world affairs at a university, and I plan to use my education to make life better in Africa and in America. I know I have been blessed and that I have been kept alive for a purpose.

They call me a Lost Boy, but let me assure you, God has found me.

———

John Bul Dau

DUK COUNTY PHOTOGRAPHS

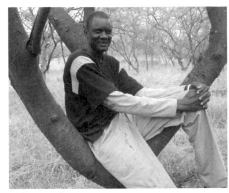

Currently a resident of Syracuse, New York, John Bul Dau returned to southern Sudan last year to start a project he has long dreamed of: the creation of a health clinic in his native Duk County. With the support of his professors in Syracuse University's Maxwell School, and the First Presbyterian Church of Skaneateles, which initially sponsored his move to the U.S., John formed the American Care for Sudan Foundation. He has

John Bul Dau

initially raised enough money to build the clinic and keep it staffed for a year. Visit *www.acsudanfoundation.org* to learn more about John's project.

John's trip home to Sudan reunited him with family and friends he had not seen for 18 years. He took these photographs during his visit.

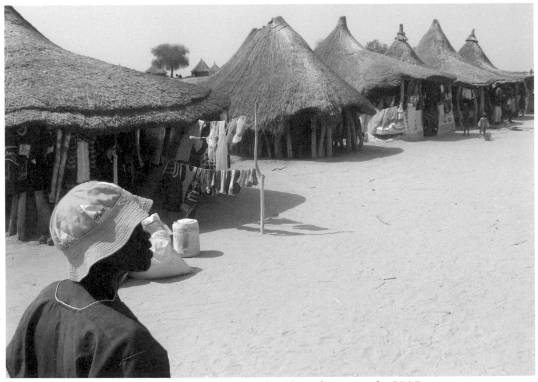

JOHN BUL DAU, *Downtown Duk Payuel,* color photograph, 2005

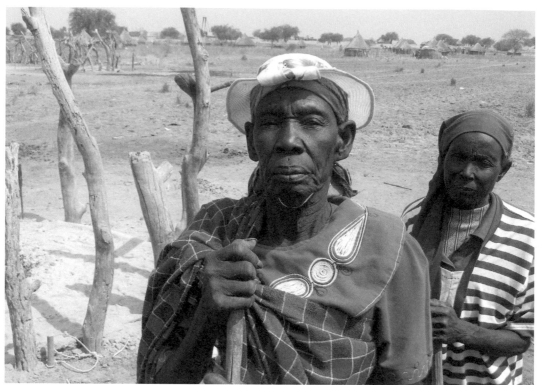

JOHN BUL DAU, *Adau-dit and her friend,* color photograph, 2005

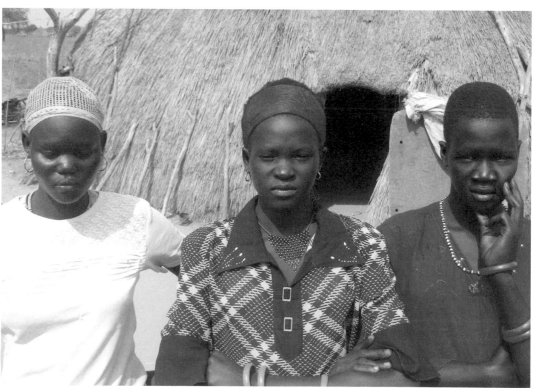

JOHN BUL DAU, *3 young women from Duk County,* color photograph, 2005

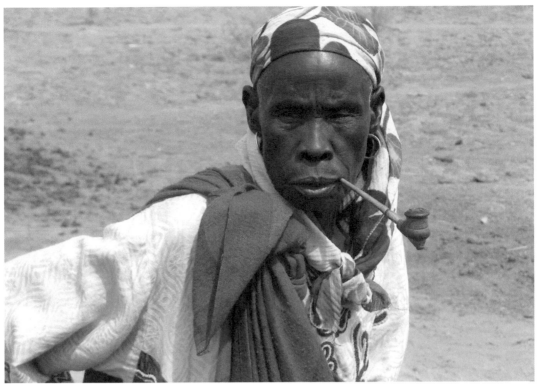

JOHN BUL DAU, *Aunt Adau Lual Goi,* color photograph, 2005

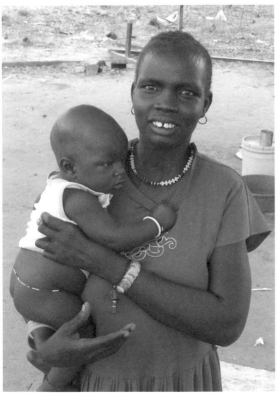

JOHN BUL DAU, *Uncle's wife Yar with daughter Agot,* color photograph, 2005

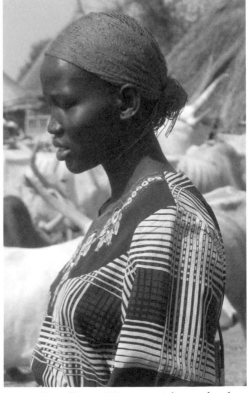

JOHN BUL DAU, *Woman with cow herd,* color photograph, 2005

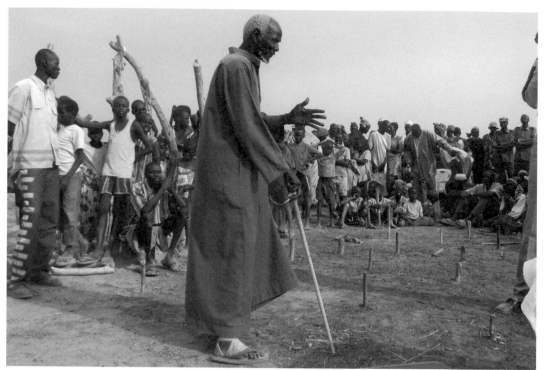

JOHN BUL DAU, *Leek Deng Malual, retired Paramount Chief of Duk Payuel,* color photograph, 2005

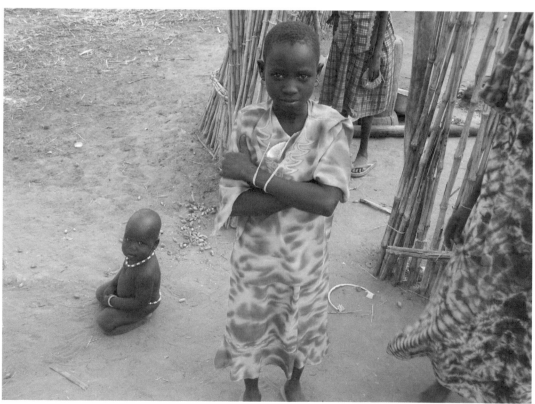

JOHN BUL DAU, *Young girl in blue,* color photograph, 2005

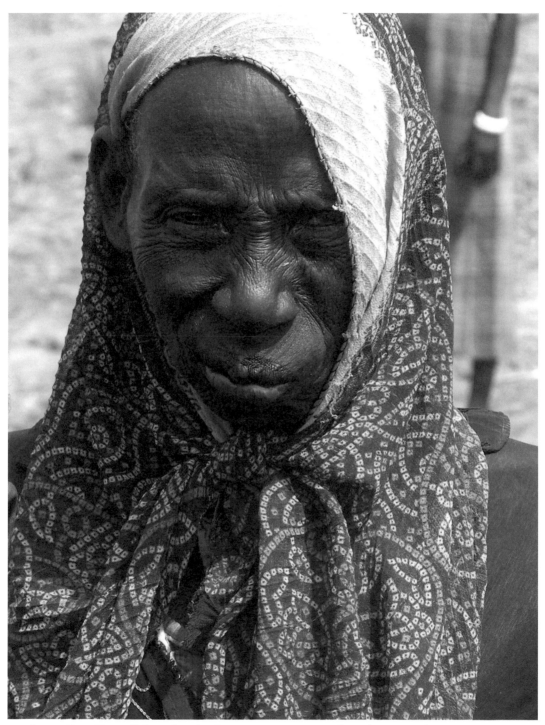

JOHN BUL DAU, *"Grandmother" Nyamoon Yuang,* color photograph, 2005

STEPHEN CARLSON, *Untitled #1,* acrylic, 2005-6

STEPHEN CARLSON, *Untitled #2,* acrylic, 2005-6

STEPHEN CARLSON, *Untitled #3,* acrylic, 2005–6

STEPHEN CARLSON, *Untitled #4,* acrylic, 2005–6

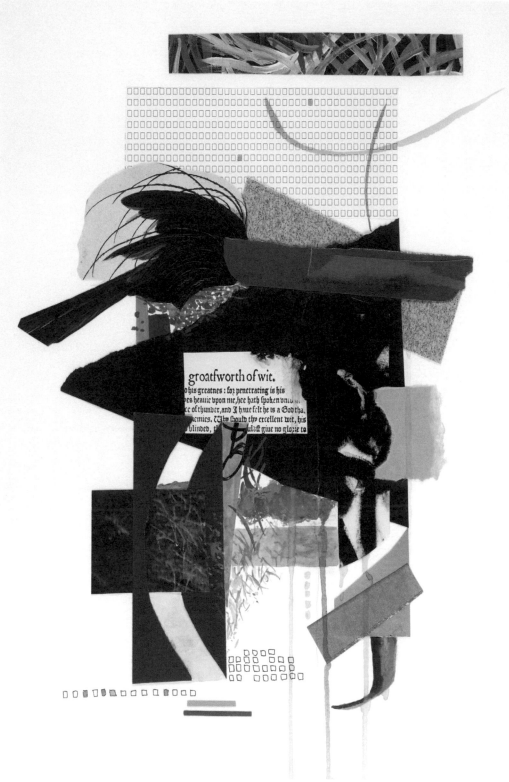

S. Ann Skiold, *For V,* mixed–media collage, 2006

Monk Rowe

'Long as the Music Plays

"So when somebody asks me about race, I say, what time does it start?"
—Jon Hendricks

I would like to think race doesn't matter in jazz. Or at least that we have outgrown a time when it did, and that the world of jazz is now as democratic as the music, by necessity, has always been. I also would like to believe, as jazz vocalist Jon Hendricks does, that race does not matter in politics, sports, obtaining an education, or in any aspect of American life. For Jon Hendricks, the word "race" is someone or something moving quickly around an oval track. While I have the utmost respect for his outlook, eloquence, and humor, I fear that it is not reality and probably never will be.

But I am heartened by the message voiced repeatedly by many of the artists I have interviewed for the Hamilton College Jazz Archive. Their stories inform us of the racial inequities that accompanied the bands in their cross-country tours, the ludicrous situations with venues, restaurants, and hotels, and the social mores of the time that were enforced by peacekeepers and bean counters. They also put forth a unified message that once musicians make it to the stage and studio, talent and personality trump age, gender, and race.

I've been told by more than one person that I have the perfect gig. Since 1995 I have had the privilege of conducting videotaped interviews across the country with America's jazz artists, both famous and unsung. As director of the Jazz Archive at Hamilton College, I have met most of my musical heroes and have become accepted as a confidante and fellow musician by more of them than I could ever have imagined. The person who most envied my gig was the same individual who made it possible. Milt Fillius, Jr., Hamilton Class of '44, had the vision and passion that made the Jazz Archive a reality. With initial blessing and assistance from Milt's friend, jazz singer Joe Williams, the effort has blossomed and has yielded 260 individual interviews to date.

Our interview strategy was simple and we had no agenda. We hoped to provide a comfortable venue for musicians to share their recollections and opinions that came from a life in music. Early on, it became clear that certain topics would appear frequently, including life on the road, learning to play jazz on the job, improvisation and swing, and the role of race in jazz. It is this last topic that I would like to shine a spotlight on.

• • •

The most beloved couple in jazz has to be Milt and Mona Hinton. The late Milt "the Judge" Hinton played bass on thousands of recordings, circled the globe with Louis Armstrong and Cab Calloway, and blessed us with photographs of his fellow musicians that only he could have taken. Mona and Milt opened their door and hearts to countless musicians and invariably could be found at the center of a circle of friends and admirers. Mona Hinton accompanied Milt on tours with the Cab Calloway band in the 1930s and spoke of those travels in this interview with Milt Fillius, conducted on March 4, 1995.

Milt Fillius: Tell me of the early days, when you traveled with the Calloway band. There were some problems, weren't there? Racial problems?

Mona Hinton: Oh, yes, big problems.

MF: Tell us about those.

MH: Well, unfortunately, due to the climate of our society, you know that we had, the blacks and the whites were segregated. And it made it very difficult, especially when we were traveling in the south. Because frequently we would run into Glenn Miller's band or Tommy Dorsey's band, or some of the well-known white bands. They were staying in nice hotels. And unfortunately, the black musician would have to stay on the other side of the tracks, usually in someone's home, or in a hotel that was not very good. And as I say, unfortunately, frequently the owners of the hotels, they would take advantage. I mean of the black musicians. They knew that we could not stay in places, and we'd run into places with rats and with the roaches and with the bed bugs and whatnot. So under those circumstances it was not good. Frequently we would go in towns and I would have to go out in the black community and try to help find rooms for the musicians in Calloway's band, and sometimes it was very, very…the places where we had to eat were just intolerable. And as I say, we made it.

• • •

Both Cab Calloway and Duke Ellington often solved this problem by hiring their own Pullman cars. The bands traveled, slept, and ate on their own terms. Sometimes just arriving at the gig could become an issue. Trumpeter Joe Wilder was a member of the Lucky Millinder Orchestra in 1947. Like Milt Hinton, Joe Wilder emotes a sense of dignity and class along with a wry sense of humor that served him well in his career. I asked Joe about touring the south with Lucky's group in this interview from October 12, 1998.

Monk Rowe: You had told me about an incident with one of the bands you were with in the South, I think it was South Carolina?

Joe Wilder: Oh, Lucky Millinder, yeah.

MR: Yes. And it was the first time you'd been down there with an integrated band?

JW: Yeah. We were in South Carolina. And Lucky Millinder, Lucky was a very nice fellow. He was not a musician, but he had a lot of natural talent for selecting the right kinds of tunes and tempos and things of that nature. But we had—I think six of the members of the band were white. And we arrived early in South Carolina at this hall where we were going to play, and suddenly up drove the sheriff with his deputy in the police car, and he says, "Who's in charge here?" And so Lucky said, "I am." The sheriff said, "Well I'm just here to tell you there's not going to be any mixed bands playing down here in Charleston. And Lucky looked at this guy, and Lucky—you know the reason I think they called him Lucky, he would take a chance on anything—he looked this guy dead in the eye and said, "This is not a mixed band." And some of the guys were blonde with blue eyes you know; there was no way in the world anybody would have mistaken any of these guys for being blacks you know. And so he went to each guy. I think if he had said, "Are you black?" he might have gotten a different answer. But he went to each of these guys and asked, he said, "Are you colored?" And each of the guys, going along with what Lucky had said, would say yes. And so he would shake his head. And finally the last of the guys he asked was Porky Cohen, who was our first trombone player. And he had a slight lisp. And when he asked him, now Porky is responding more emphatically than the other guys, and he said, "Why thertainly," with this lisp. And at this point we had all been starting to chew on our tongues and everything, trying not to break up because it was so ludicrous. And you could see the ground tremble, we were trying not to let the sheriff see it. But anyway he turned to the deputy and he said, "Well I guess if they all say they're colored, there ain't nothing we can do about it, is there, Jeff?" And so he said, "No, sheriff." And they got in the car and drove off. And we played that dance that night. It was very funny. And it might, as I mentioned to you, it might have been the first time that an integrated band played there. It's very possible that that was the first time.

• • •

Despite the best efforts of law enforcement and promoters, the music had a way of overriding the rules, both written and understood. Vocalist Ruth Brown has made her mark in jazz, blues, and R&B. As a band leader, she experienced her share of troubles on the road. Arriving at the gig did not mean those situations had ended for the night. On March 4, 1995, Ruth related what a typical gig could be like in this conversation with Dr. Michael Woods.

Ruth Brown: Well most times, as I said, we worked warehouses and barns, and nine times out of ten they didn't have what you call the "second balcony." If we were lucky to play a county hall or an auditorium sometimes, they had a balcony, and in that balcony was called the spectators. These were the whites who bought tickets to come in to hear the music but were not allowed to come on the dance floor. Sometimes it was vice versa. The whites would be down and the blacks would be up in the balcony and not allowed to come down. But in places such as barns, warehouses, where there was just one level, they would separate the races with a rope, and I say, a clothesline was what it was, an oversized clothesline. And most times someone had taken a huge cardboard and written "colored" which was the definition of our ethnic group at that particular time, and on the other side the card would say "white." And the white spectators were allowed to dance on that side of the rope, and the black on this side. But what they did not anticipate was that the music generated such a joy, people got to dancing, the ropes would fall down, I seen it happen many times. And people would continue to dance, and just wander in to each other's space. Nobody would say a thing for a moment, and then it would occur to some official that, uh oh, the rope is down and they're dancing in the same space, and we can't have that. And then somebody would run up on the stage and say, "Stop the music," you know, and they'd just stop the music and go back and put the rope in place, and you had to go back on your given side.

• • •

As drummer Louis Bellson learned, the race demon did not play favorites. He was the only white player in Duke Ellington's Orchestra in the early 1950s and was asked to become "non-white" so the band could keep him on stage. His quiet manner only gave more weight to the wisdom of his words when I met with him on April 12, 1996.

Monk Rowe: Was there ever any problem in certain parts of the country with any racial subjects coming up?

Louis Bellson: Well yes, we did have. In 1951 they had the Big Show of 1951, which consisted of Nat King Cole, Sarah Vaughan, and Duke Ellington's band. They were the three big stars. Now besides that they had Peg Leg Bates, Timmy Rodgers, Stump and Stumpy, Patterson and Jackson, all these wonderful acts—tap dancing acts, you know. It took us a week to rehearse that whole show, playing with Nat King Cole and Sarah, Duke, and all these acts. So after we finished rehearsing for a week, Duke finally discovered that hey, we're getting ready to go down to the deep south you know? And in those days, you had segregated audiences. And we couldn't, the whites couldn't, play with the blacks at that time, you see. And in those days it was colored; you didn't use the word blacks, see? So now the big problem is, Duke called me in the dressing room and says, "What are we going to do? I can't find a drummer to take your place, because it would be a week's rehearsal and the guys that can do it, they're all busy." So Duke says, "You mind being a Haitian?" I said, "No, okay, that's all right," you know. So we got through it okay. It was a little tense, because the situation was still down there, and the audience, because they told Jack Costanzo, with Nat King Cole, he couldn't appear because of the racial thing, you know. But some spots it was a little rough, you know. But we got through it. I think through Ellington's peaceful ways and the wonderful attitude that the band had, you know, kind of rubbed off on everybody. But still it existed.

MR: Well it's nice that the music had a part in helping that situation to move along a little faster I guess.

LB: Well you know we played a gig in Mississippi and there the townspeople were wonderful, they came to the rescue, where we couldn't stay in certain hotels and so forth. I mean these people came from wealthy families too. They had Strayhorn and Duke and Clark Terry stay in one house, and Carney and Russell Procope and myself in another house, and all on down the line. Beautiful homes and they fed us. So, you know, along with the bad there's some good too, you know. And these were situations that we got over, we dealt with it. Sometimes it's almost like a slap in the face but you realize what the situation is and you go straight ahead because you've got something to do that's valued, and I think when you do that you realize that none of those things should bother the musicality of something. It's the fact that whoever's playing that music doesn't make a difference, let's play it and show where the peace and love is.

Trumpeter Red Rodney pulled off a similar ruse when he became an albino for his Southern tour with the Charlie Parker Quintet.

• • •

Frank Foster, saxophonist and former leader of the Count Basie Orchestra, offers his observation on the inherent ability to improvise.

Frank Foster: I don't think every person born into this world is a jazz musician, and I don't agree with what somebody's got out that says anybody, everybody, can improvise. I don't go with that.

Monk Rowe: Oh that's right, there's a series, "Anybody Can Improvise."

FF: Yeah. I don't subscribe to that. But it's an individual thing, it's not a racial thing. We have such a melting pot here, we're all into each other's culture. Okay, I contend that jazz was born in America as a result of the black experience. Now, nobody in the world could ever convince me that that isn't true, okay? But now as I said before, we've got this melting pot where we're all into each other's culture. We can emulate one another, and we can relate to one another, and talent wasn't just given to whites or blacks or Latinos or Asians, or whatever. Every racial/ethnic group has talent. And all God's children got rhythm, some more than others. Look man, I know some black folks who can't clap on two and four. One-two-three-four. ONE-two-THREE-four. I know some cats who can't do this [claps]. On the other hand I know some white folks, every time will say [claps] and vice versa you know. So we've all got talented people and we've all got some no-talented people. Every ethnic and racial group has somebody blowing a horn that should put it down and forget it and be a plumber or a postman or something. But when I hear somebody who's not black perform on an instrument and that person is good, they are good, regardless of what somebody else black might say—oh he can't play, she can't play, that's it. Man, it hurt me years ago, one of my trumpet players, are you familiar with Lou Soloff? Well this guy just put Lou Soloff in the garbage can: "He can't play, he never could." And Lou Soloff is a monster. Lou Soloff can play anything, can play jazz, can play lead trumpet, he can play in a section, you know, he can just do anything that's necessary for a jazz trumpeter to do. Big band, small group, whatever. So when one of us can do it, give us the credit. When one of them can do it, give them the credit. I don't feel threatened by anybody. If you can play and you're white, great, let's play together. If you can't play and you're white....

MR: Go play with someone else.

FF: Yeah. If you can't play and you're black, get out of here.

MR: Go play with that white guy that can't play.

• • •

In the 1930s, when big-band jazz was the popular music of the day, an important breakthrough occurred. Pianist Teddy Wilson would often play intermission piano between sets of the Benny Goodman Orchestra. Because he was black, he left the stage when Goodman's musicians entered. At the urging of jazz promoters Helen Dance and John Hammond, and despite warnings from his management, Benny Goodman thwarted convention and hired Teddy Wilson and Lionel Hampton. With drummer Gene Krupa, this quartet became one of the most recorded small groups of the decade. Jackie Robinson's entry into major league baseball nine years later drew more press. But Lionel Hampton and Jon Hendricks touted the event in their interviews, conducted back-to-back on October 18, 1995.

Lionel Hampton: Yeah. Real big. And about the big band, you know I joined Benny Goodman after Louis Armstrong. And we were the first integrated group, the first black and white group.

Monk Rowe: Was that ever a problem, playing in certain parts of the country?

LH: No, no. People [inaudible], because we all played good music. And Benny presented us in a professional way. We were a four in his organization, and it would be noticeable that we were soft. And the people liked that. Some of the ovations that he used to get, it was the sound.

MR: I thought it was interesting that that quartet didn't use a bass player a lot.

LH: No. Because Teddy Wilson played it in the left hand.

MR: He had a left hand like crazy.

MR: And it's so important because jazz, especially, was so important in breaking some of the racial problems down.

Jon Hendricks: Absolutely. Benny Goodman is an American social hero. He is a hero in the development of American society. Outside of music, Benny Goodman is a social hero. Because his love for the music was so pure that he just did not understand why he couldn't have Lionel Hampton in his band, and then Charlie Christian and then Teddy Wilson, you know. He just didn't understand that. And the bean counters and the accountants and the lawyers, they tried to explain to him, "Benny, you'll lose your show, they will not renew you on the 'Camel Caravan' if you do this." So they gave him all those very hard and fast business reasons. But he refused to understand it. He said, "I like those guys."

MR: They play the music I want, so they stay, right?

JH: So he did what people have to march now to achieve. And it's because of the power of the music, a love of the music. I was just talking to Lionel's man over there. And I asked, "How's Lionel doing?" He says, well he's okay but he got this gig next week coming up at the Blue Note. I said, "That's no problem." I said, "'Long as the music plays, he's all right, he'll be cool. It's when the music stops that they have to worry."

Victor Oshel

THE ART OF SILENCE

Just like a real war, I might have whispered
Then shown them some samples
Of proverbial mud, pieces of buried treasure,
Remains of a bridge that wouldn't stop collapsing,
A hero surrounded and then cut to ribbons.

Or: Yes, no. Maybe, maybe not.
Who cares? What's the difference?
Each time they became angry
I forced myself into feeling
As if I were making them go away.

Once, for a while, there was chess in the afternoon.
We made up our own rules. And cheated.
On the most special days
All the colors would gather in a circle.

I'd dream of going somewhere and not being
That small anymore.
Somewhere with trees and water and horses.
A place where people could
And then they did.

PLAYROOM

It was nearing the end of things.
The silly people had been put away.
The emergency squad had disbanded.
The inmates had finished tearing down the placards.

Inside, the special agents were busy frisking
 last year's homecoming queen.
An ostrich was making faces at a one-legged ballerina.
The sign over the door read, "How Are You Feeling Today?"

Desirae was aware that she had nothing to feel
 guilty about.
The official diagnosis had been conflict of loyalty.
"In a way it's been happy and in a way quite sad,"
 she said matter-of-factly.
"As for you, you're wrapped up in your own sorrows."

On a nearby wall, the freshly crowned messiah
Looked as if he understood everything.
Even though someone had painted his eyes dayglow orange.

Georgia Popoff

27 NAMES FOR TEARS

5. *Blindfold*
 An imposed
 and inescapable despair
 A horse whose eyes are bound
 from ravenous flies

9. *Drought*
 All that survives the sere
 territory of grief is salt
 The awkward trickle of rainstick
 an alien rhythm

13. *Lavender*
 Spikes of green sadness
 reach for sun
 Purple relief spikes
 a storm

18. *Bomb*
 Thunder is more compassionate
 It leaves no crater
 If rain is red flesh
 how does one reconcile bone

18A. *Suicide*
 The fear of all mothers
 A head suspended like a satellite
 The child who escapes
 no matter how many times scolded

27. *Starfish*
 A cave stippled at low tide
 Little galaxy of orange
 and yellow arms
 sure to regrow if sacrificed

JoEllen Kwiatek

AUGUST BURIAL

Make haste slowly
under the sun, bower
of hallucination—*I*
die because I am not dying.
…Form of the dark
pine, a towering
dress of dark bees.

VICTORIANA

I took a nap
in the sea,
in the bright water, coddled
by smithereens of brightness.

Dark as a vole, accordion-
pleated—that's how I
thought of consciousness,
as a *thing* from another era.

Mary Gaitskill

THE MAN WITH THE HAMMER

One night last September I was reading in my Syracuse apartment when something very large thundered down the street and stopped with a loud grinding of gears. I looked up; long pulses of light were coming through the blinds. Parting the blinds with my fingers I peeped out; there seemed to be a car parked in the air across the street. I opened the blind and saw that the car was actually mounted on a metal apparatus hauled by a mightily blinking truck cab. As I watched, the driver got out carrying what appeared to be a very large wrench and, stopping at various points on the contraption he had hauled, expertly unfolded it so that it formed a ramp from car to street. It was a fascinating sight, the car like a toy held by a giant robot hand, and I went out onto the sun porch to better see it. There is a park across from me, and from its leafy darkness I noticed several people emerge so that they too could see better.

I am an associate professor teaching full time in the English department at Syracuse University, but I don't live in Syracuse full time. My husband and I live in Rhinebeck and I commute up on the train. Because I haven't got a car with me in Syracuse, I rent an apartment within walking distance of campus. This means I rent in a building on a block of buildings which caters primarily to students, mostly undergrads whose parents pay their rent. (I say they're undergrads because when the school year started and everybody's windows were open, I found myself squeezed between Britney Spears on the left and death metal on the right; if they're not undergrads, something is very wrong.) Walking to school is no problem, but groceries are. Since the nearest store is a $15 cab ride (one way), I count on a particularly gracious colleague to take me shopping, and I eat out a lot.

Because I walk a lot I am perhaps more aware than some of my colleagues of the frequent "Crime Alert" bulletins that regularly appear via e-mail and posters: many of the muggings, snatchings, and assaults occur near my neighborhood. Most sound relatively harmless and inept; many sound very bold, occurring as they do in the middle of the day—for example when a student was pulled off the sidewalk into an abandoned garage and raped this past July. Hearing about these attacks so regularly makes me very aware of my surroundings, which are, for some blocks, broken-down and poor—as are many of the people haunting those blocks, hitting passers-by up for money, or trying to. In cold weather they pretty much disappear, but when it's warm, they're always there.

I've lived in large cities for most of my adult life—New York, San Francisco, and Houston—where large, sometimes volatile homeless populations are the norm, and where the comfortable and the wretched exist together, in some neighborhoods closely so. But to see the same opposites so thoroughly and baldly mixed together in a much smaller city makes me more aware of them, partially because I'm so dutifully informed of every crime that takes place anywhere near me and so continually advised to use the University escort service whenever walking after dark. My awareness makes me feel freshly troubled by the disparity, and strangely, freshly amazed by it. I had been teaching at Syracuse for one semester when Katrina hit the Gulf Coast and while on one hand the lack of government response was shocking to me, on the other it seemed absolutely congruent with what I saw around me every time I walked to work.

I was thinking of this when I taught Chekhov's "Gooseberries" to an undergraduate class during my second semester. I did not choose the story because I thought it was in any way topical, but the devastation wrought by Hurricane Katrina was fresh in my mind when I chose to read aloud this famous passage:

> "You look at life: the insolence and idleness of the strong, the ignorance and brutishness of the weak, incredible poverty all about us, overcrowding, degeneration, drunkenness, hypocrisy, lying. . . . Yet all is calm and stillness in the houses and in the streets; of the fifty thousand living in a town, there is not one who would cry out, who would give vent to his indignation aloud. We see the people going to market for provisions, eating by day, sleeping by night, talking their silly nonsense, getting married, growing old, serenely escorting their dead to the cemetery; but we do not see and we do not hear those who suffer, and what is terrible in life goes on somewhere behind the scenes…everything is quiet and peaceful, and nothing protests but mute statistics; so many people gone out of their minds, so many gallons of vodka drunk, so many children dead of malnutrition…."

It was toward the end of class and I had to shout over the sound of a jack hammer outside—that may've been why about half the students seemed indifferent. I can imagine too that if they were indifferent (and sometimes it can be hard to know what students feel until they tell you) it was because the passage seemed hopelessly dated, not only in style, but in content. After all, very little now seems to occur behind the scenes except for the exercise

of power: images of suffering people have become so routine (I'm thinking of Katrina again) that you can't help but see them even if you don't live in a neighborhood where you encounter them in the flesh. I think though that the students' very indifference, if that's what it was, indicates that Chekhov is still right, that no matter what we literally see, on television or in life, we nonetheless will ourselves not to see what we don't wish to see—or to feel. Sometimes too, you don't know exactly what you feel.

The night that the car appeared in the air outside my apartment, I had earlier been hit up for money by a ragged middle-aged woman who I'd seen a few days before screaming obscenities at some students driving past in a car. I was walking home after having dinner and wine at a student joint, and I was feeling the wine as I opened my wallet. "You are so beautiful," I said a little drunkenly. "I thought you were a student when I first saw you."

It was an inane comment; it was also true. Her large, wild eyes were hot blue, and her blond hair was sun-bleached and thick. Her face was regal, even with three front teeth knocked out. Inane or not she didn't care—her eyes were glued to my wallet which she might've snatched if it weren't for the students driving past. "Can I have another dollar?" she asked. "Not today," I said. "But next time. I know I'll see you again." She actually looked at me when I said that.

Because she looked at me I remembered her. I wondered if she knew the people who emerged from the park to watch the truck driver climb the ladder on the side of his rig and begin to unbolt the car from its fixed position. I couldn't see them clearly in the dark, and it's possible they were students—but I doubt it. The truck driver got into the car, and drove it down the ramp and into the street, executing a sharp U-turn. One of the people in the park clapped; the others stared at him. The car, looking brand-new and fancy in the flashing light, pulled into my driveway. I said aloud, "You've got to be kidding me!" The driver got out with papers on a clipboard. He stood on the sidewalk for a moment, looking from house to house until a young woman of maybe 19 came out of the building next to me. She looked very pleased to see the car. The driver presented her with the papers on the clipboard; she signed.

"You little fucker," I said. I said it in wonder rather than anger, but I said it. I don't know exactly why. There was nothing horrible or outrageous about the sight of the car being delivered—but I found it ridiculous, irksome, and saddening at the same time. Did the girl who had just signed for the car know what a spectacle this was to the people in the park across the street? Did she even see them? Did it make any difference at all that I did?

When I read the speech from "Gooseberries" to my students, I did not finish it. I stopped before I got to the part that expresses an old idea, now very much out of fashion:

> "There ought to be behind the door of every happy, contented man someone standing with a hammer continually reminding him with a tap that there are unhappy people; that however happy he may be, life will show him her laws sooner or later, trouble will come for him—disease, poverty, losses, and no one will see or hear, just as now he neither sees nor hears others. But there is no man with a hammer; the happy man lives at his ease, and trivial daily cares faintly agitate him like the wind in the aspen-tree—and all goes well."

The man who makes this speech is revealed by the end of the story to be an ineffectual, foolish, and perhaps envious person, who admits that he can do nothing about the state of the world and implores his younger friends to take action they've no interest in taking. By modern standards, the speech is too simplistic anyway. And yet, in spite of the simplicity and impotence, the reader feels the truth of what is said.

My 19-year-old neighbor may or may not have called herself happy; it seems that very few people call themselves happy now. Arguably, few live at such ease that "trivial daily cares faintly agitate" them. But to me, and I'm sure to the people across the street, she looked the picture of satisfaction as she got into the car and drove it into the small lot behind the building. I continued to watch, fascinated, as the trucker methodically re-folded the ramp. By the time he drove away the girl was back inside, and the people from the park were gone—or at least I couldn't see them anymore.

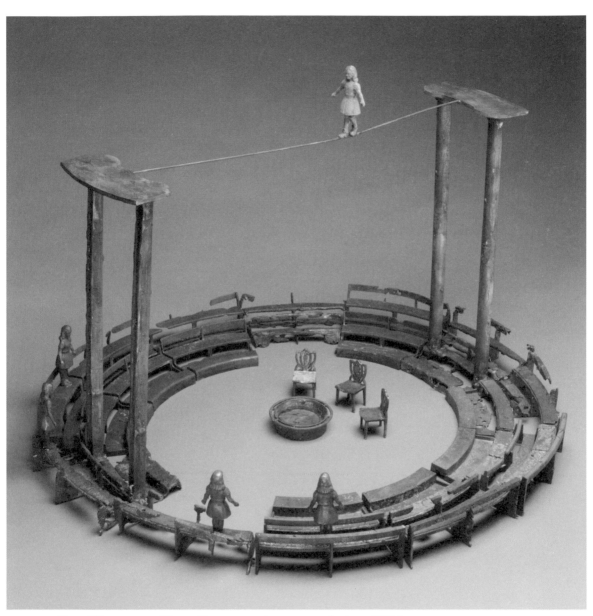

GAIL HOFFMAN, *Circus Event,* cast bronze and glass, 2006

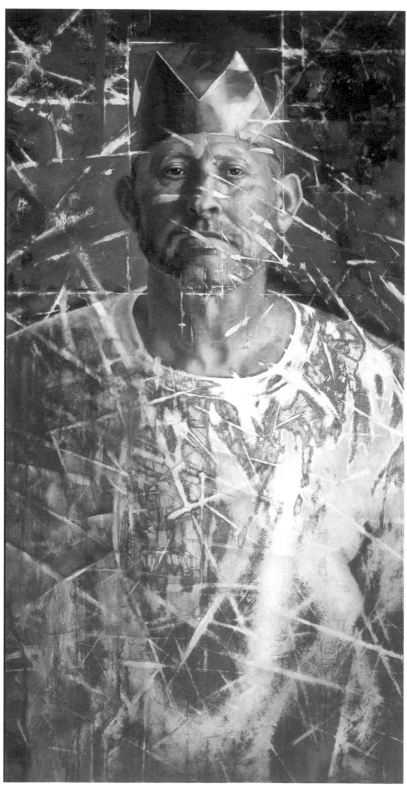

ELENA PETEVA, *The King,* oil on panel, 2002–04

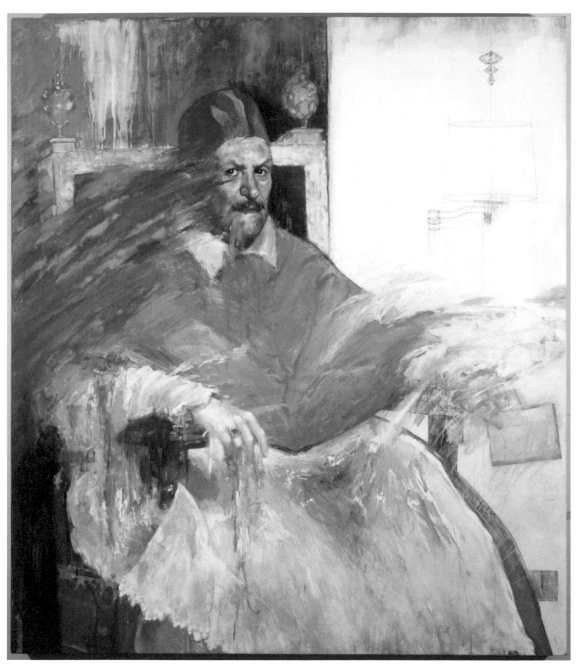

Elena Peteva, *Church and State I,* oil and acrylic on panel, 2006

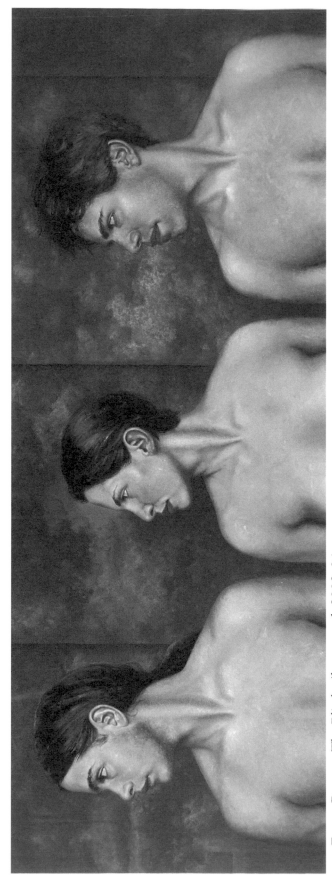

Elena Peteva, *The Blind*, oil on panel, 2002–04

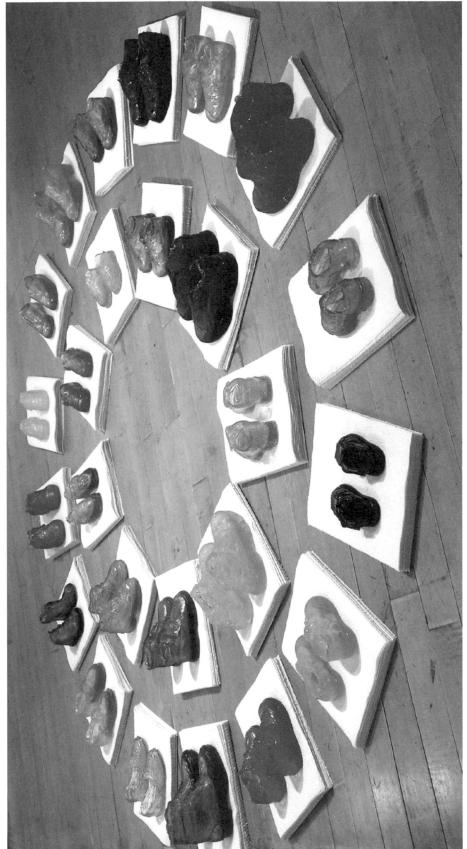

MARY GIEHL, *Sweet*, cast sugar, corn syrup, and paper installation, 2004–5

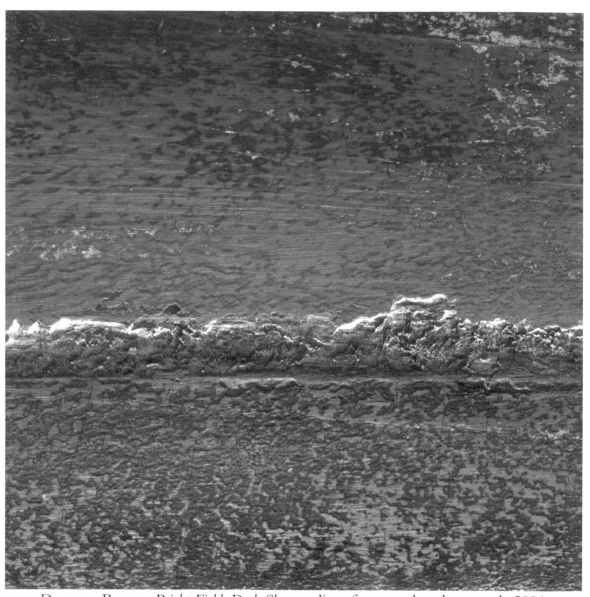

Douglas Biklen, *Bright Field, Dark Sky,* medium format color photograph, 2006

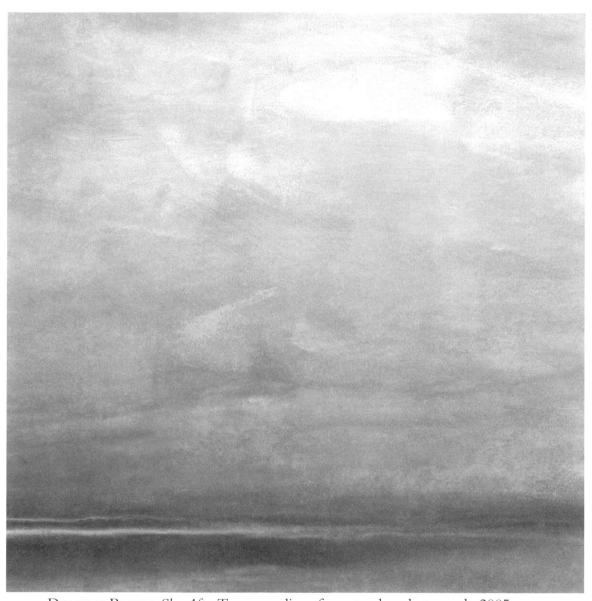

DOUGLAS BIKLEN, *Sky After Turner,* medium format color photograph, 2005

BOB GATES, *Winter Playground,* color photograph, 2004

BOB GATES, *Shadows,* black and white photograph, 2003

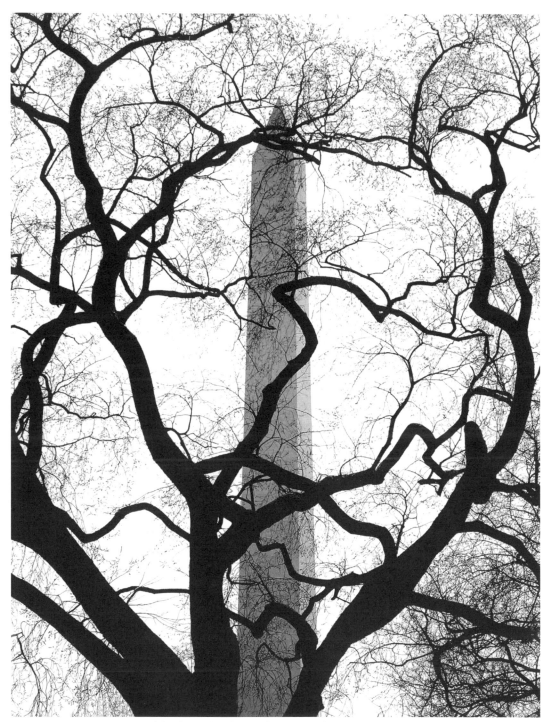

BOB GATES, *Duet,* black and white photograph, 2005

Elaine Handley

DEEP RIVER

Fog smothered the familiar world when they started out in the middle of the night. Dampness prickled her skin, and Maizie pulled her shawl tightly around her. They were lucky for the fog, she thought. Isaac sat in the back of the wagon with the dog, ready to climb into the coffin if necessary. Maizie was glad for the company, even though they did not talk much. Their voices could carry to anyone who happened to be about in the night.

One of her headaches was coming on, the ache beginning to bloom over her left eye. She felt slightly light-headed. Isaac had watched her mix a tincture in water before they'd left the house and suggested they leave after she felt better, but she shook him off, saying headache or no, they were going. But, in fact, she felt unwell and suddenly vulnerable. What would become of them? What experience did she have in this kind of travel or subterfuge? What if they were caught? Anyone aiding or abetting a runaway slave would be fined and imprisoned. And Isaac—she couldn't allow herself to imagine. Had the loneliness of her solitary life brought upon her a kind of madness? Or had she let her passion for the cause override her reason?

She had not wavered in her decision to leave with Isaac, until now. Her barn burning was a clear warning, and the news of Chloe's violation and her murdered baby gave her little time to think it all through; she'd had to act quickly. Now the reins shook in her hands, from fear or headache, she knew not which. But there was also relief in driving away—hopefully from Smythe, who sensed that she was part of the underground movement, and who seemed intent on pursuing her for one purpose—or another. She shivered again.

The fog dissipated with the dawn, and they stopped and ate the biscuits and ham. Fingers of rose and peach light backlit the woods to the east, and the morning doves began their lament. Isaac stood to get into the coffin. He paused and faced her. She knew instantly what he was going to say and spoke first.

"We're going to do this, Isaac—rescue Chloe and get you both to a safe place." As if satisfied by the resolve he saw in her eyes, he touched her hand and then lay back and pulled the lid over the coffin. Maizie stood and stared at the coffin. She wanted to wrench the lid open and make him come out.

A choking feeling rose from her chest, and she sat with her head down until she started to breathe regularly again. Then she got out of the wagon and covered the coffin with the tarp.

By the time she stopped a few hours later at a stream to water the horse and let the dog exercise, she felt the full force of her headache. The glitter of the water made her wince. Her veil helped reduce the glare, but the hard jolting ride of the wagon knocked her brain about inside her head. Her wool mourning dress was heavy and hot. She unbuttoned the bodice and placed a cold cloth on her chest and then bathed her face in the cold stream. Making sure that there was no one about, she drew back the tarp and called to Isaac to get out. When he saw her, pale and frowning, with dark moons under her eyes, he told her she really did look like a grieving widow transporting her husband's coffin to its final resting place. She laughed ruefully and then winced from the exertion of the laugh. He stretched and splashed cold water on his face and waded into the stream. Mozart barked with excitement, but they quickly hushed him. There was nothing to do but go on. She fantasized about a feather bed and hoped there would be one for her at the end of the day, and then felt the tickle of guilt when she realized that Isaac could not, and indeed never had, hoped for the same.

The morning was interminable. By noon the sun was murderous, and Maizie was gritty from the road dust; she drove in a kind of delirium of pain and exhaustion. Her headache had not dissipated, despite small ministrations of feverfew leaves, tincture, and frequent sips of water. She longed to put her head down. At last she pulled the wagon over into a copse of willows by the Mohawk River, near the Erie Canal on which with luck they'd be traveling the next day. Maizie flung off her bonnet, climbed out of the wagon, got a pail of water for the horse, and whispered to Isaac that she was going to rest just a few moments. She lay down in the shade and immediately fell asleep. Mozart's barking woke her, and upon opening her eyes she found herself looking up into a small freckled face.

The puckery mouth was saying in a high voice, "Missus! Missus! Are you all right?"

Disoriented for a minute, Maizie sat up and looked at the boy. Her head pounded, but then she remembered where she was. "I thought you might be dead, too." The towhead boy stood before her in cut-off britches and bare feet. In his hand he held a stick—had he prodded her with it? He was probably a local farm boy. He looked from her to the wagon.

She saw at once that the tarp had been pulled back from the coffin. She tried to smile at him. "Hello. As you can see, I was just taking a short nap. It was kind of you to check on me."

"That's good, missus. But who's dead in your wagon?" The boy pointed to the coffin. So this would be the first person she'd lie to—a child.

"My husband died—he had an accident," she said. People were still anxious about cholera, and Maizie was sure the boy would be telling someone about their encounter.

"Sorry, Missus! You gonna bury him? Was that his dog? That's a mighty fine dog. He looks like a wolf."

She might as well try out her story, she thought. "Yes. My husband's dying wish was to be buried near his family, so I am taking his body back to where he grew up." The boy opened his mouth to ask another question, but she cut him off. "I feel much better for my nap, and I must be going. Thank you for your concern, young man. Enjoy your day."

With that she pulled the tarp back into place, signaled for Mozart to jump up into the wagon, and then climbed up onto the driver's seat. She was praying that Isaac was inside the coffin. Attempting another smile, she waved at the boy as she pulled away from the river and back onto the road. When she thought she was far enough away she called softly to Isaac. There was no response. She called again—nothing.

Trying to think what to do, Maizie had just decided she'd wait and then circle back when she saw something moving in the trees to her left. She feared the boy had followed her, although he would have had to run to keep up. But Isaac stepped out from the trees, glistening in sweat and panting. He slid under the tarp and urged her to move on. A mile or so down the road she told him she thought it safe for him to get inside the coffin. She heard the creak of the hinges, then Isaac called that he was inside. She felt tears come to her eyes—she had almost lost him. She urged the horse on a little faster.

• • •

They drove into Manny's Corners, just outside Amsterdam, about suppertime. Maizie had never been so glad to see a sign in all her days. Just beyond, houses were clustered together like mushrooms, close by the road, some with folks sitting on their front porches watching as she drove by. Soon she came upon a simple white clapboard church with a sign announcing the First Presbyterian Church of Amsterdam and next to it a modest house that she figured for the

rectory. She pulled up in front and alighted from the wagon. She smoothed her skirt and straightened her bonnet, then patted Mozart and told him to stay, saying (for Isaac's benefit) that she would be back as soon as she spoke to the minister.

At the house an older man answered her knock.

"Reverend Jukes?" The man had a kind, but fierce face. He seemed to smile and frown at the same time.

"My name is Maizie Booth," she said, "I was told you could help me. You see, I have some…cargo." The reverend's eyebrows shot up.

"Yes?" He peered around her at her wagon. Maizie could not tell if he was alone in his home, and she was trying to decide how explicit she could be. He drew her inside.

From the foyer of the house she could see into the parlor, where an older woman, likely Mrs. Jukes, looked up from her knitting. Maizie lifted her veil.

"Tell me more, Mrs. Booth."

She spoke quietly: "Miss Booth, Reverend. I have an African with me—in a coffin—a live man. We mean to get on the canal and head west. I was told you could help us…."

"Indeed? Let's get that man out of there." He hesitated. "Are you all right Miss? You do not look well." Maizie explained that she suffered from a sick headache and traveling in the heat. "We must take care of you, too. But first, can you drive your wagon to the back of the church?"

She nodded.

"I will gather a few men to help us take the coffin into the church, where we can liberate this man." The minister stepped into the parlor, then brought out his wife, who insisted Maizie have a cold drink and take a minute to refresh herself. Mrs. Jukes was a plump, birdlike woman whose habit of cocking her head made Maizie think of a chickadee. The minister pointed out where she should park her wagon, and then he left to find some helpers.

Behind the church Maizie threw back the tarp and so as to appear a grieving widow, placed her hand on the coffin and murmered to Isaac what was about to happen. He tapped to signal that he'd heard.

A short time later the minister appeared at the back of the church with four men in tow. He introduced them to Maizie and directed the men to carry the coffin in through the back entrance of the church. The men pulled the coffin from the wagon and then hoisted it to their shoulders. Mozart barked as they took Isaac away. Maizie hushed the dog, and then followed, with her head down, thinking someone must be watching—this was too interesting a scene in a small town for someone not to be observing.

Once inside the backroom of the church, the minister locked the back door, as well as the door to the sacristy proper, and the men bent down and opened the coffin. Isaac sat up. Fear flashed across his face as he registered that five white men closely surrounded him, but Maizie caught his eye and nodded assurance. Jukes offered him a hand up and Isaac rose. He swayed slightly and one of the men offered him a chair, which Isaac took, but after a moment he stood again, and remained standing, shifting from foot to foot and staring at the wall ahead of him, with an occasional flickering look at Maizie.

The minister asked Maizie what she needed and she told the men that their plan was to go by canal—Isaac in the coffin, she posing as the grieving widow—to Rome. She did not want to reveal the whole of her plan, but simply asked that they help her secure passage on a packet and provide her with any names of people on the Underground Railroad who could help Isaac once they reached Rome. Admitting that she planned to travel farther with a man of color would be to invite outrage, even from these sympathetic men.

"You decided it was too chancy to go down the Hudson, eh?" One of the men asked.

Maizie nodded.

"We heard that there are many bondsmen on the river of late. It makes sense that you send your fugitive west rather than north through the mountains—even in good weather that's a hard trip. If he can get a boat on the Ontario shore, he will be in Canada inside a week."

Easier than returning to Virginia, she thought, but she knew Isaac was determined to rescue Chloe.

The men talked quietly among themselves, deciding how to proceed. Suddenly there was a light knock on the door, and after looking out Jukes unlocked the door and Mrs. Jukes entered bearing a tray of food and set the food on the floor near Isaac, and then backed away, looking at Isaac with a cock of her head. She stood close by her husband.

Jukes said Isaac could spend the night in that room, and Maizie would stay at the rectory as their guest. Mrs. Jukes insisted that Maizie must come and eat right away and leave the menfolk to finish up.

She was reluctant to leave, as she longed to talk with Isaac, reassure him—or was it she who wanted reassurance from him? For his sake, she knew she could not reveal any misgivings. He had not uttered a word so far, nor had he been addressed, and no one, except Maizie, had noticed.

• • •

The next morning Maizie was greeted in the kitchen by Mr. and Mrs. Jukes. Her black dress hung in the corner, looking as insubstantial as she felt, where Mrs. Jukes had left it to air after giving it a good brushing. The Jukes commented that she looked much less peaked than the night before, and indeed, she did feel better—the pain in her head had lessened to a dull ache. But she was left feeling slow and mentally scattered as she always did after a bad headache. On the table was a hearty breakfast. She sat and joined them, picking politely at what was offered her. Just then there was a knock on the door. Jukes answered it and admitted Gilbert Conner, one of the men from the night before.

Conner removed his hat, accepted a cup of tea, and turned to Maizie.

"Miss Booth, the packet that it would be best for you to travel on got held up down the line near Albany and won't be in Amsterdam until later today.

I suggest you wait for this particular packet as we have a canaller who will help you. We believe the captain is sympathetic to our cause as well."

After some discussion she agreed, and Conner left, promising to return to take her and Isaac to the canal in the afternoon. He urged Jukes not to come with him. Mrs. Jukes nodded and patted her husband's shoulder.

Jukes peppered Maizie with questions about the Greenfield Anti-Slavery Society and the situation in Saratoga Springs, and told her about the Amsterdam Anti-Slavery Society, which he had helped form.

When Mrs. Jukes could stand it no more, she burst in, "There are unsavory people who know of my husband's activities." The cast iron pan she was washing clattered against the soapstone sink as she set it down on the washboard with more force than necessary. "But he continues with this work."

"Now, dear!" the minister looked suddenly weary. "You know that I feel it would be for me irreconcilable with the spirit and principles of the gospel of Christ if I did not do this vigilance work."

Mrs. Jukes came and sat across the table from Maizie. "He is endangering his own life, as well as his family's. This parish needs him—if he is jailed, or hurt—these are desperate creatures he is helping. There is no telling to what extremes they might go—" Her voice rose and there was a slight quiver in it.

"Mrs. Jukes, it wasn't until I became involved myself, and came to know people, like the good man who waits in the church, to understand how important it is that we help them." Mrs. Jukes sat listening, twisting her dishcloth. "What have these African people done except feed our babies, plant our fields,

cook our food, and for their effort suffer assault of the body and spirit? Some of us must risk our own safety since our government is doing nothing to help these people."

Although Maizie spoke quietly there was such intensity in her dark eyes that Mrs. Jukes was rendered speechless for a moment. She blew her nose on a handkerchief she pulled from her apron pocket. "But dear, aren't you afraid? Here you are a young woman traveling alone—well, traveling with a…a…Negro. What will happen to you if he is discovered? Are you ready to face incarceration? Are you not worried about your safety? Indeed, your respectability?"

"I think, I hope, I have the strength to endure incarceration or worse, Mrs. Jukes," Maizie said. "As for my respectability—well, I must rely on my respect for human life, for the quality of it, to give me respectability, even if folks deem my actions improper."

Mrs. Jukes shook her head and patted Maizie's hand. "I think you should be more concerned with your own future, Margaret. Are you being courted, my dear? I suspect not, as no suitor would allow you to go off with a—"

Maizie turned to Mr. Jukes, who sat observing the exchange between the women. "I should like to see Isaac, Reverend."

He nodded and rose, taking a ring of keys from a peg on the wall. Mrs. Jukes stood and asked them to wait while she wrapped up some muffins and poured a cup of tea for them to take to Isaac. Mrs. Jukes gave Maizie an apron to wear, so Maizie could carry the muffins undetected in the apron pockets. The minister took the tea to carry as if it were his own.

Maizie put her hand on Mrs. Jukes' arm and said, "This work you do—feeding and caring for people such as Isaac, is important. Where would we be without your kindness?"

Mrs. Jukes, slightly mollified, nodded, and Maizie followed her husband out into the back yard. "My wife worries," the minister said simply. "She's nervous because there's been a slave catcher in these parts sniffing around." Maizie's stomach clenched. She said nothing, but the image of Smythe was there before her.

"Do you know the man's name?" Maizie asked.

"No, never asked," the minister replied. As they walked toward the church he turned to her and said, "May I ask why you are accompanying this Negro? I admit it is a particularly excellent ruse, but why do you risk so much when you could send him on his way, station to station?"

She told him of her barn burning and her impression that it would be good for her to leave the area for a while. She thought it unwise to confide any more—certainly not about her plans for heading south with Isaac.

"Please don't tell my wife about your barn—it will frighten her even more," he said. "But I beg you to be careful. You are taking a rather great gamble. But I expect you understand that," he added when he saw Maizie's face tighten.

Isaac stood as the minister and Maizie entered the back room of the church. Maizie let Mozart out and then gave Isaac the food and encouraged him to sit and eat. Jukes and Maizie sat with him, and the minister asked Isaac about his life as a slave. Isaac sat poker straight and answered without elaboration. Finally Jukes asked, "Do you read, my good man?"

"Yes sir, some, thanks to Miz Booth."

Jukes nodded in approval and stood up. He opened a nearby closet. "I offer you this Bible, which as I am sure you must know, holds great comfort and instruction." Isaac thanked the minister, grateful to have something to do in the hours that remained before they would be taken to the canal. Maizie informed Isaac of the plan: he would be taken out of the church in the coffin and put on Maizie's wagon. Mr. Conner would drive them to the canal and see that they got on the right packet. Isaac would be placed in the hold of the packet, while Maizie would be one of the passengers in the cabin. Maizie's ticket would include food, and she would somehow have to get some to Isaac. Jukes assured her that the steersman would help. He rose, saying he had things he needed to attend to, and waited for Maizie to follow, but she said she wished to sit with Isaac for a few moments. Jukes paused—worried that it wasn't proper for him to leave them alone. But then he nodded and left her the keys to lock the door behind her.

• • •

Later that afternoon Maizie donned her black dress and veiled bonnet and sat beside Gilbert Conner as he drove them to the canal. He was a lively talker and she was grateful for the conversation, which helped distract her from her growing anxiety. Once there, he left her in the wagon while he went to make arrangements for the crew to load Isaac's coffin into the boat. Maizie could see tied up along the canal a long squat boat painted a bright blue and yellow with several people on its roof, which served as a deck. Laughter floated over from the boat and on the shore there was constant movement, as people bought supplies and cargo was loaded and unloaded from boats.

Maizie had the sensation that she would be joining a party. She sat with her hands folded to keep them from fidgeting.

When Conner returned he drove the wagon up to the edge of the canal where five crewmembers met them. He introduced Maizie to them as "Mrs. Booth" and they each offered their condolences. The last man added, "Please let me know if I can do anythin' for ya missus. Draper, Red Draper at your service." Conner caught her eye and nodded, so she knew this man was her aid. The people on the deck of the packet grew quiet as they watched the coffin being taken off the wagon and carried into the hold, with Maizie, her head bowed, following behind the men, and Mozart trotting after her. She stood at the top of the stairs, wondering if she should follow the men into the hold, but they emerged shortly, and the canaller who told her to call him Red urged her to take a seat in the cabin, promising that once the boat was under-way he would come back to check on her. He was a small, wiry man with a shock of red hair and freckles everywhere. She liked his open, agreeable face and especially his green eyes that held a look of constant surprise.

Only a few people were in the cabin. It was a long plain room with built-in benches on either side. Obviously supper had recently concluded; she could hear the clatter of crockery as dishes were being washed at the far end of the boat. A woman was turned away from the door nursing her baby, while two small girls, who looked to be twins, sat at her feet playing. An old man nodded off in the corner. Maizie took a seat in the middle of the room, near a window, and looked out onto the grassy bank of the canal, opposite from the town. The crown vetch had crocheted the bank in lavender. The late afternoon light reflected off the water, dappling the cabin walls. Mozart sat at her feet; she was grateful for the dog's company and patted him. She took a deep breath— so they had gotten this far.

A man came into the room, bowed, and introduced himself as the captain. Though his beard and hair were scraggly, and his clothes were homespun, his attitude was solicitous. He too offered his condolences and said that he was at her service if she needed anything, anything at all. Maizie wondered if in-deed he would help her if her mission were detected. She thanked him and he retreated. A few moments later she felt a gentle rocking motion as the boat began its glide down the canal.

Red, as he promised, found her a few moments later. "I expect, Ma'am, that you might rest easier if you could see where your husband's remains are resting in the hold," he said. At this the woman nursing her baby looked up. About the same age and coloring as Maizie, the woman looked tired and

worn, but her eyes held a fierce light. She nodded at Maizie and turned back to her babe.

"I would rest better if I could spend a moment there and see that all is well," Maizie replied. She and Mozart followed Red out of the cabin where he lit a lamp and then descended to the hold. Once inside the hold they had to crouch down. There were several bags, barrels, and crates in the low space, but Red led her to the left wall where Isaac's coffin lay.

Red whispered that he was going to put some barrels up around it so the coffin would not be in view if anyone came down into the hold. By blocking off the coffin, and leaving space near the wall by which it lay, Isaac would be able to slip in and out of it undetected. Red knocked softly on the coffin.

"It is safe for you to come out, brother."

Maizie whispered, "I'm here too, Isaac."

Isaac pushed the lid open a few inches, pausing to let his eyes get accustomed to the light from the lamp. Red bent down and pulled the lid open for Isaac, who sat up, blinking at them. Mozart began to lick his face.

Red showed Isaac how much space he'd have to sit and move about in. He promised to bring him food and water and offered to relay any messages between Maizie and Isaac. He told Maizie that it would not do for her to come down to the hold again. There were too many people on board and someone was likely to notice and follow her, worried that she was not right in her mind. Red warned Isaac to be aware of when the boat stopped, because crewmembers would be in the hold loading or extracting cargo, and if Isaac was not in the coffin, he could be detected. Explaining that when he was steering for his six-hour trick, he was not able to leave his post, Red nevertheless promised that he would be there to help them get off at Rome.

"Will there be people who can help us there?" Maizie asked, trying to keep anxiety out of her voice.

He nodded.

"Some mighty good folks there will be a help."

Before they left him, Maizie asked Isaac if she could borrow the Bible that Jukes had given him. It would be appropriate for a new widow to be seen reading the Bible, not the novel she'd brought with her. As he handed it to her, their hands touched. She drew his warmth into her and hoped that her own provided him some comfort. She regretted leaving him there in the dark and dampness.

It was almost 7:30 when Maizie and Mozart joined the others on deck. A beautiful evening had unfolded and she marveled at how soundlessly the

boat slipped along in the water under the overhang of giant oaks. Besides the passenger voices, there was the slight sound of plod and jangle from the mules pulling the boat. Birds warbled evening vespers and the rich smells of grass, dung, earth, sweat, and flowers scented the air. Maizie liked all the smells and the slight rocking of the boat as it was pulled along. Grateful for the evening, she looked forward to being able to relax until she sat down and was accosted by her neighbor. Mrs. Whittaker, a large and overbearing woman in her forties, introduced herself and began questioning Maizie as though she'd been preparing to interview her ever since she saw her board the boat.

She declared in a voice that was too loud, "My dear, my dear—you've had a loss, a terrible loss." The woman took Maizie's hand into her own. Politeness kept Maizie from snatching it back.

"Your husband was a big man, a very large man—why his is the largest coffin I have ever laid eyes on. I hope he wasn't taken ill?" The other passengers, engaged in quiet conversation, stopped at once to listen.

"Pardon me, Ma'am, but I've had a terrible shock due to my husband's accident, so I am not available for social discourse at this time. But I thank you for your concern." She allowed a slight quiver to enter her voice. Several people who had turned to look at her looked away, not wanting to intrude on her grief. Maizie looked down at Isaac's Bible that she had on her lap, hoping she'd dissuaded Mrs. Whittaker from further interrogation.

"Oh, I completely understand—may I call you Margaret? You must not hesitate to find me if you need to empty the contents of your heart. The Lord knows we women must be a comfort and support to each other in times of trial. That's what I tell my Cecilia, yes I do." She launched into a monologue about her Cecilia and the minutiae of her daughter's life. When Maizie thought she could bear no more, Red appeared and told her the captain wished to speak to her. At that point she would have volunteered as a hoggee, leading the mules on the towpath.

Red took her into the cabin, where there were now no passengers. "I was about to help the cook ready the cabin for sleepin' and I could hear the missus jawin' away, so I thought I'd try to spare ya. She has worn out everybody else's ears on this boat, and I figured you was fresh meat to her." He grinned at Maizie.

"You are a friend indeed."

"Pity the rest of us. We all soured on her an hour after she boarded in Albany."

"I did want to ask you—is the captain sympathetic to the…cause?"

"Captain? I 'spect he is, although we've never spoke a word of it. One day this spring I helped a stowaway—a Negro boy—hide in the bilge. Captain must have seen me bring him aboard 'cause later that night he made a joke about the cargo breathin'. I never see'd him extend a hand to a Negro, but I never see'd him mistreat one either. The word is his wife is a mulatto, who used to cook on this here boat, which would lead a body to conclude he'd be sympathetic."

Maizie found this interesting information. She wondered what the captain's personal life was like if he was married to a Negro. "And what about you, Red? What makes you a friend of the Negro?"

He cocked his head and looked at her. "Well, my daddy helped dig this ditch in the twenties. He got the job soon after'n he got off the boat from Ireland, as hungry and poor as they come. All he had in his pockets was holes. While he was diggin' he become friends with a black man, Dewey Smith, he worked long side of. Dewey done saved my daddy's hide more than once to hear Daddy tell it. I guess they was fights nearly all the time amongst the fellers diggin'. Well, Dewey was a far better fighter than my daddy, who was a runt anyway, and used to get a thrashin' by the bigger men, so's Dewey fixed those men's flint for my daddy agin' and agin'. But then one day Dewey goes off to town on his own and he don't come back. Daddy starts lookin' for him. Come to find out, some old hag had sicced a slave catcher on him. Daddy tried to find Dewey, but bein' a poor, dumb Irishman, nobody listen to him, nobody tell him anythin'. All he learned was Dewey ended up in a slave pen in Maryland. I don't think my daddy ever recovered from losin' Dewey—he mourned him all his life. He always tell us to help any Negroes we could, it was the only way to repay his debt to Dewey. When he was dyin' and out of his mind, he was talkin' to Dewey—he must have been some kind of special feller. I know how much of the blazes us Irish still catch, so it ain't hard to figure all the ways it hard to be in a nigger's skin.... You best go back up on the deck—I gotta set up this here room for sleepin' now."

Maizie stood by the bow, watching the fireflies wink in the grasses beside the canal, and thought of Chloe. All the limitations put on women were hard enough, but what of a woman who was colored as well?

A short while later there was a major exodus of passengers from the deck into the cabin, where women began to prepare for bed behind the red curtain that divided the men's and women's sleeping quarters. Maizie followed the women. As there was only a handful of them and about as many children, no one had to sleep on the top of three bunks, save for one of the children. The

bunks that extended from the wall were narrow and made of canvas. Maizie couldn't help glancing at Mrs. Whittaker, who was talking incessantly to the woman who had been nursing her baby. Maizie wondered how she ever would manage to compress her girth on the narrow bunk and straw mattress allotted her. The woman helped her children undress and, turning her back on Mrs. Whittaker, took off her dress and readied her own resting place. Maizie was careful after that to also keep her back to Mrs. Whittaker. Maizie had procured a bottom bunk, and laid out her belongings below it so she could easily rise and dress if she wanted to escape and go up on the deck. She would have much rather spread her blanket there and laid looking up at the stars, but suspected some of the men would elect to camp out on the deck and it would be unseemly for her to join them.

She crawled into her bunk. Mozart lay down on the floor next to her. She turned toward the wall, to insure that she would be left alone. The room went silent, but soon Maizie heard great snores coming from the other side of the cabin. It seemed that, even in sleep, Mrs. Whittaker was going to be the source of irritation.

Maizie slept restlessly in the confined space and finally rose, dressed, and sat on the steps to the deck to wait for the day. Other passengers finally appeared and sat on deck while the bunks were stowed away and the cabin made ready for breakfast. She carefully sat a distance from Mrs. Whittaker. The other passengers seemed to respect her reticence to socialize, as was befitting the newly widowed, and only spoke kindly as needed at the table.

After the meal, when the packet stopped for fresh mules, Maizie got off with Mozart and walked the towpath. She always did her best thinking while walking.

She walked until they got to Mohawk, a busy little port town. Just after she had boarded again and turned to make sure Mozart had followed her, she caught sight of a face in the crowd of people milling by the canal, and she stiffened. When she looked again the face was gone. She went up on the deck and searched the people clustered nearby, but she didn't see the face again and told herself that it was just her imagination.

Before dinner, after the passengers remained on the deck so the cabin could be readied for the meal, Maizie was able to confer with Red briefly. They would be in Rome late that afternoon and he told her that upon docking he would make arrangements for the coffin and come to get her. He assured her that he would take some food to Isaac and alert him that they'd be getting off the boat that evening.

Despite her long walk she felt restless. After the meal it clouded over and began to rain, which meant everyone was crowded into the cabin to stay dry. Some of the men played cards or checkers and Maizie envied them for having an activity to distract them.

Maizie found herself sitting next to the woman with the three children. The baby was fussing and the woman was trying to comfort her. The twins looked as if they might join their sibling in a good howl. Maizie felt sympathy for the woman traveling alone with three children. She squatted down and began to talk to the little girls, asking them if they would like to pet her dog. The children were fascinated and chortled delightedly as Mozart patiently endured the little hands patting him everywhere. The baby fell into a fitful sleep. The woman thanked Maizie for distracting her children. Maizie noticed that the woman moved as if she were in pain. When she reached to brush the baby's hair away from her eyes Maizie saw that her wrist was bruised.

"It must be very hard traveling with little ones," Maizie offered.

"Ach, at times it is…. I'm sorry for your journey," the woman said.

Maizie realized the woman was referring to her widow status. Maizie nodded and bit her lip—she didn't wish to spin any more tales.

"I think my babe be teethin'. She's a good-natured babe, but she don't sleep easy these past few days and she pulls at her mouth."

Maizie was relieved to have something useful to talk about. She offered to make a paste of slippery elm bark and chamomile from her supply of herbs and tinctures to soothe the baby's gums. The baby woke irritated a short time after Maizie had prepared the paste. The mother rubbed the mixture inside the baby's mouth and the baby soon fell back into an easier sleep.

It was almost suppertime when they approached Rome, and Red jumped down from the boat and walked away. What if Red couldn't find someone on the Underground Railroad to help her? What if they had to rely on a real undertaker—how would she engineer an escape for Isaac? He would be so glad to be rid of the coffin. She almost laughed aloud—who wouldn't be? So far, though, it had been the perfect strategy—no one suspected.

Finally, she saw Red hurrying back toward the boat and disappearing down into the hold. After looking to see if anyone was watching, she followed him down the narrow stairway. He was over by Isaac's coffin and he waved her over.

"It ain't safe for you two to get off here!" he said. He was out of breath.

"What do you mean?" she said.

"This man comes out of a rum-hole and up to me and demands I tell him if'n there's anybody on the packet that fits your description. I reckon it really

is somebody lookin' for you, because he's rantin' about a woman your age with light hair. Anybody can tell he's savage as a meat axe, so's I'm thinkin' he's probably a slave catcher."

"What did the man look like?"

"A rough lookin' character. Taller than me—ornery lookin' and all corned up."

"What did you tell him?"

"I told him I seen a woman that fit the description in a boat we passed down the line this mornin.' You need to stay out of sight. Stay here in the hold until we're on our way again."

"But where will we get off?" Maizie said.

"I'll figure that with you later. Stay put and I'll be back. If'n I don't get up there soon, the captain's gonna have my hide. But look sharp—one of the crew members could come down here while we're stopped."

"Yes, go, Red," she said. "And thank you for what you did."

He crawled out of the space and was gone. Despite their cramped quarters, Maizie was very glad to be with Isaac. They spoke in whispers.

"You think it's the slave catcher that came to yo' place?" Maizie could hear the fear even in his whisper.

"If indeed someone is looking for me—who else could it be? But how could it be? How would he know I'd gone west? How could he have found me? It doesn't make sense."

"Somebody musta tipped him off!"

"But who? The only people who knew where we were going are Asa and Samuel, and they wouldn't tell anyone—it can't be Smythe. This is just some strange coincidence—although this morning—I thought I saw him on the shore." She shook her head as if to clear it. "No, it couldn't be him."

They sat in silence for a time, listening to the moving about of passengers on the floor above them. Then they heard footsteps on the stairway to the hold. There was time for Isaac to get into the coffin, but not for Maizie to shut the lid or extinguish the lantern before a crewmember came in the door. He saw Maizie with the open coffin and stood speechless for a moment. She shut the lid, and let out a long sob.

"I just had to look upon him one more time!" she cried and began to weep into her hands. The man seemed to come to himself, although his face didn't quite lose its horrified expression.

"There, there missus. You've had a great loss. Don't you want to come up to the cabin and I'll have cook make you a nice cup o' tea?" He didn't move from the doorway.

"Oh, you are so kind. By and by I'll come up. I just have to sit a spell with my dear husband."

She looked at the man soulfully. "I just can't get use to him being gone." The man nodded, grabbed the wooden box he'd evidently come for and backed out the doorway. When she was certain he was gone, she opened the lid again. Isaac lay there grinning at her.

"You sure are some possum!" he whispered.

A short while later they felt the boat begin to rock. She was in a quandary—was she still officially a passenger on the packet? Her ticket was good as far as Rome. Why did Red not come? She could hear the pans banging about above, and she knew that supper would be served soon—but no Red. Could the person looking for her be on the boat? She could only wait.

It was after supper that they again heard footsteps on the stairway. Isaac lay flat on the floor next to the coffin, and Maizie rose up and started to make her way toward the door. When it opened she was surprised to see the captain standing there. "Missus! Skully told me you was down here. You've missed supper! I think you'd better come above—this kind of mournin' ain't healthy." He reached out and took her arm. Maizie's bonnet hung down her back, her hair was mussed, and her skirt was askew from crawling about in the hold; indeed, her appearance was that of a distraught woman.

"Yes, Captain. I feel better for having communed with my husband. I didn't mean to cause you any concern." He steered her up the stairs and into the cabin, where the tables were just being put away.

"Cook! Give this woman something to eat." He said. He turned to Maizie.

"Missus, you must get ahold of yourself—it won't do you no good to get this upset."

She nodded and looked at the floor. The cook brought her over a plate and the captain stood there a moment longer, as if he was trying to find words but he merely patted her arm and left her. After she ate she went to the cabin door and looked out onto the towpath. There was Red walking behind the mules. He looked up at the boat and saw her, and shook his head, as if in apology. She nodded and decided to go up on deck. She was relieved that the captain hadn't asked her why she hadn't gotten off at Rome. What could she do but wait on Red?

Once the boat was tied up at the next stop there was a great commotion. Maizie had positioned herself and Mozart at the far end of the boat, to avoid conversation with the other passengers. Suddenly a horse neighed, followed by yelling and sounds of a scuffle, then running, and a man in a rage

burst onto the deck. He looked wildly about. Red was soon behind him, pulling on the man's arm, trying to reason with him.

"I know she's here! Leave me be!" the man shouted while trying to throw Red off. And no sooner were the words out of his mouth that he spied her, and stormed down the deck.

Maizie began to stand, but the man stopped in front of the woman with the three small children and jerked her to her feet.

"What do you mean cuttin' out on me woman?" he roared. The woman Maizie had befriended cowered in front of him, turning to protect the baby in her arms. The other two children, who'd been playing at her feet, grabbed onto her skirt and began to whimper. The man did not let go of the woman's arm and began to drag her toward the stairs. The woman cried out. The other passengers were startled into silence for a moment, but then one gentleman stood and blocked the way.

"See here man! That's no way to treat a lady! Calm yourself. Surely this can be worked out—"

"Lady? Lady?" the man spit the words. "No lady leaves her husband while he's out workin' in the fields. This bitch is my wife. I own her and she is coming home with me right now. I'll see to it that she'll never leave home again."

The man raised his fist and Mrs. Whittaker shrieked.

Two more men stood and began to argue with him. Maizie looked at the woman, who by this time was shaking and trying to hold back tears. The children were now wailing. Maizie's eyes met the woman's and in that instant she saw as much terror and grief as she'd ever seen in one glance.

Soon the captain joined the fray and managed to take the man to the stern, to try to calm him down. The man could be heard asserting that he'd not leave without his property. The woman sank to a seat and tried to comfort her children, despite her own shaking and crying. Maizie went to her and kneeling before her, gave her a clean handkerchief. Maizie then said so only the woman could hear, "Get away the next chance you can. There are people who will help you. Don't let him subject you to a life of misery."

The captain returned. "I'm very sorry Ma'am. But you must go with your husband now." The woman drew back. "He is your husband and by law he has the right to take you home." The woman began to weep again, but stood up and signaled to her children to follow.

Maizie faced the captain. "You cannot consign her to a life with that brute! What will become of her? Of these babies?" The captain shook his

head. The woman put her hand on Maizie's arm and then pushed past the captain and disappeared down the stairs.

The man pushed his wife and baby into a wagon and lifted the two children onto piles of hay in the back. The woman raised her head and looked at Maizie, still weeping. The man jerked the reins and the wagon pulled abruptly away from the water's edge.

Maizie slipped down the stairs and into the dark hold. After a time she found her resolve and felt her way over to the coffin. Isaac was not lying next to it, and when she lifted the lid and put out her hand to touch him the coffin was empty.

Marion Wilson

ENTERING JOHN JAMELSKE'S HOUSE, 2006

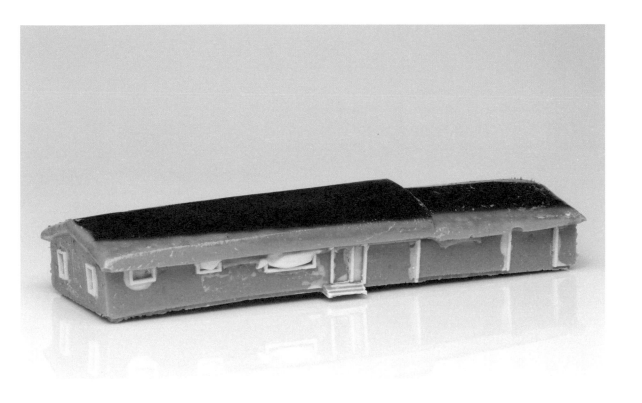

MARION WILSON, Cast resin house, 3″ x 18″

MARION WILSON AND MELISSA PEARL FRIEDLING, Video stills

MARION WILSON, Painted wood panels, 24″ x 32″

EACH OTHER

1

I saw you, I saw you there, De Witt, N.Y.
I drove by the blue house
everyday to work when the mile-long FBI truck appeared
and then disappeared.
It happened over a period of months
fall then winter, driving by I watched
like the rest of us.

I saw you there too, I was there.
Then a sign, an invitation almost
like a note personally sent—
for serious buyers only.
Dan, my friend's husband who was a realtor
for the time being, the architect's assistant
who speaks no English, and the snow—
we accepted his invitation.

I was there too, I was there with you,
the green formica countertops, rotting wood panel
1950s guy's neglect—a man lived here,
most recently alone.
Entering, then entering, we entered again,
one, two, three, four, five, six, and then more, seven.
Not a two-car garage but three,
nothing was quite right about the entrance
as we entered John Jamelske's house.

2

Watching you
I remember the sensation of
being there but I don't easily
remember his things—unlike
the brown house in that way.
We came here not as voyeurs
exactly—more to know the man

who would do such a thing.
There are few clues other
than his obsession with entrances.
To be honest, maybe we are
fantasizing what it would be
like to enter here as one
of his girls. Dan is as curious
as me and glad that I asked.

 3
I was watching you too.
The architect's assistant quickly gets to work.
He draws, he measures, he stays upstairs
down on his hands and knees.
Dan and I know better.
I feel him as we enter the basement.
He's here, I know he's here
he's watching us, entering us
as we enter him.
We pick at each other, we sniff, and smell and feel
for each other in the air.

Serious buyers only, he mocks us.
He beckons us from the paint, from the shadows
on the wall, from the broom, from the blue
turquoise concrete squares and the brush and the
roller he fingers for me, reaches out to me and I am afraid
but I accept.

P.S.
I saw you.
I saw you there.
I saw you there too
I was there.
I was there too.
I was there with you,
watching you.
I was there watching you too.
I was there with you watching you.
I was watching you too.

JACK WHITE, *Totem (OBO) I,* (Liberation
Revisited), acrylic, copper, wood, 2005

JACK WHITE, *Totem (OBO) VI,* (Liberation
Revisited), acrylic, copper, wood, 2005

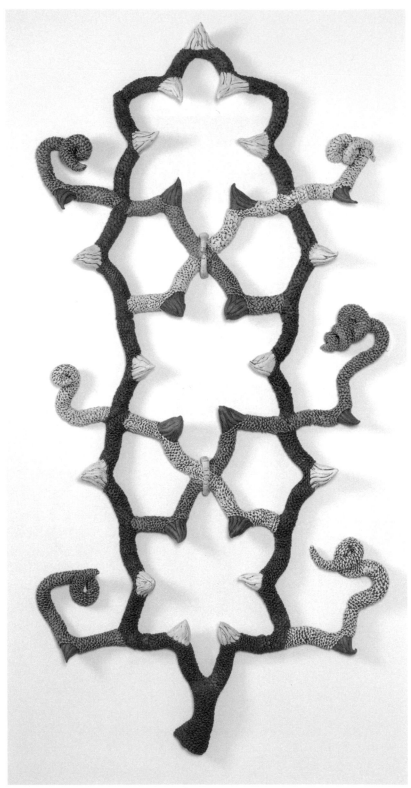

ERROL WILLETT, *Islamic Espalier,* ceramic, 2005

Thomas Glave

MILK/SEA; SENTIENCE

The story, as it has been passed down to us, has always gone like this: all the women in that village were dreaming, still dreaming, and in fact had never once ceased dreaming in over one thousand (at least) years. Their village—this one, of course—was, indeed, that old. As everyone who knew the story knew, the village had been that old for a very long time; for much longer than most in our time could possibly imagine. It was known by all far and wide that the women really could not stop their dreaming, for if they ever did so, or tried to—well, what would happen instead? What would they face? What would they become, and how soon? Where would they live? And how—yes, the most pressing question—how would they live? For the village (and by this time, our time, everyone in the waking realm knows this; by this time everyone in the waking realm has heard) was one of utter dryness, total ash; devastation, to be sure, of course, and much starvation. Little from the realm of the living could sustain itself there, except the wavering figures of those in dreams—shadows, mostly, wandering without place or claim—and spiders, cockroaches, and (now and then) various forms of mold. Soldiers from a powerful distant country had invaded us some time ago, as soldiers from that country were always inclined to do, and decimated most of the men. The men who had not been killed—flayed of their skin, incinerated, or simply shot dead through the eyes, through the back of the head—had in most cases been run off to the outskirts—the *very* outskirts: the highest hills to the north and west of the village, where, as everyone knew, they were certain to be killed by the enemy guerrillas who instantly targeted for annihilation anyone who came into their midst. In a few other cases, the men run out of town by the invading soldiers were simply forced into the hands of varying bands of mercenaries, who used them for their own ends (rectums, mouths, and any other possibilities) and then discarded them in a storm of bullets.

And so the women dreamed. Dreamed with their children clutched fast in their arms. Perhaps better to dream for all time and evermore than to awaken out of those depths and find that *that* was being done to you again—done to you in the same laughing way they had done it to you before, using everything they could. Using even—no, especially—things with sharp edges. Very—sharp—edges. No, don't try to describe it. How could you possibly make anyone understand that? How could you possibly make them

understand the feeling of the laughter outside, then the feeling of all those things moving, moving inside? Then only to find, because you were awake, not dreaming, that the same thing, or worse, was being done to your most precious thing: to your daughter; to your son. You would remember then that some had been stretched; others carved. Knowing all that, it would be better, wouldn't it?—to stay? To stay in the dream where it was safe? *Where it was safe,* many of them murmured among and to each other in those twilit realms, still clutching to their breasts their also-dreaming children. There, in the indefinite region of not-quite memory, not-quite sentience, where all things remained mostly deep blue-tinged, where the skin could rest intact, where the softest parts could relax uncarved, where the hour just before sundown never ended—*never* ended—and the sky, up there, way up there, always bore one of the steadfast colors of the sea—there, where no one would ever look up into midday's harsh light to see unimaginable things (Is that a part of my child, now lying in all that mud at the side of the road?). *Stay here, stay here,* the women intoned in their dreams without speaking among each other; and stay there they did, for—as the story has faithfully recounted after all this time—more than five thousand years. The "story," of course, is much more than a story. We know—and all should know—that it is—always has been, of course—much more than a village tale. It is in fact a known reality. A documented reality, the core and substance of which need not be questioned by those who know nothing of our village, nothing of the we who are "We," and nothing of how all this dreaming, and so much more, ultimately came to be.

But then here is another fact, little known to those who have passed the story down through time: a fact that has to do with the oldest, most ravaged woman of the village, who had borne to men—it is still unclear how many—not two children but twenty; who had lived in that village not forty years but over one hundred and fifty. An old woman who knew well the taste and texture of salt, whose thighs had (but unwillingly) rubbed up against the brutality of tree trunks, and whose fingers knew secrets unimaginable even by the shrewdest sage. A woman who, for reasons of her own and more, dreamed like all the rest. Dreamed with as many of her grandchildren locked against her voluminous chest as she could manage; with as many of her children, though most of them long grown into vaulting saplings, as she could possibly manage. They all slept in a pile, breathing deeply against her withered breasts. And so, all sleeping, all moving as far as possible from the sentience of actual memory

into the safer, calmer regions, how could any of the other women, eyes tightly shut, with their children so tightly clutched against waking, possibly understand her awareness, even in those twilit depths, of great thirst? *For the village is thirsty,* she dreamt, *and has been ever since, ever since. . .*but she could not recall a time when it had not been terribly thirsty. *And the ground,* she dreamed (but here she turned, tossed; briefly clutched, in sleep, the air made misty, thick, by dreams) *is dry. Dry, dry. The ground is dying,* she dreamed, *and the children have nothing, not even water, to drink. O the village,* she dreamed. . . conjuring, even if somehow against her will, the sense of great thirst. It was possible to do that. Possible, yes: but even she, brave woman that she was and always had been, hardened-by-life-and-knowledge woman that she was, did not dare, though she conjured dryness, to dream of fire.

(People burning in trees, someone lying near her dreamt, stirring uneasily. *That smell. The sound of crackling, the sound of limbs breaking, and such great thirst.)*

And so many in our own time, the time of now, who had not previously known what the story would later disclose, finally divined it: the next part. Divined that it was she, that same woman aware in dreams of thirst, whose breasts, of their own accord (though who can ever really know these things for sure?), began to flow. And flow. And flow, without end. Flow, those withered breasts, with milk the color of clouds; milk the color of honey; milk new and fresh as the newest leaves in spring's first blush. Milk warm as desire before the long, hot day's end and dusk's curl. Milk flowing: rivers of it everywhere. Entire lakes. Milk flooding valleys, canyons, and (though this certainly came as no surprise) the village itself. Milk raising to its river-surfaces all the still-sleeping women and children, and some of the men who still dared not awaken —no, not yet; for though the rivers and streams and lakes of milk portended something altogether new—and what that new thing might be not one of the dreamers could possibly guess—no one yet dared, even floating so effortlessly on those milk-currents while still dreaming, to awaken—no, not even rocked so lovingly by the milk-streams, for who knew what, upon awakening, they might remember? Who knew what they might see that over a thousand years of dreaming would still not have obliterated from memory?

Milk finally everywhere. Above the trees. Covering the tops of shacks, huts, even the occupying soldiers' quarters. Covering mountains—yes, and even reaching up to the highest hills north and west of the village, where, years

later, the twisted skeletons of the guerrillas who targeted for annihilation ev-
eryone who came into their midst were found, in precisely the places where
their living breathing bodies are to be found no more. Milk in all colors, all
tastes, drowning the unsuspecting soldiers. Choking them. Putting an utter
end to them for all time. Soldiers drowned in milk. Subsumed in milk. Men
of arms vanquished in unrelenting tides of milk. . . .Why the dreamers them-
selves did not succumb to the rushing tides about them and beneath them
no one—certainly no one today—can say; but it was known at the time, as
it remains known today, that all of them—every single solitary last dreamer,
every child, every woman, every man of that village who had lived there in
peace long before the invaders had arrived—soon began, though still dream-
ing, to descend, eyes closed, beneath the swirling eddies of milk; to sink down,
down, to the deepest depths of the milk; to travel into the most hidden parts
of those tides produced by an aged woman's decrepit breasts, she herself still
dreaming. Descend, never—as far as anyone knows—to be seen again. Never
to be seen again in the region. Our region. Vanished forever. Down, down,
into the milken sea, all of them. Motionless. Eyes closed. Perhaps (for who
could tell? Yet so it was believed) dreaming. Dreaming for all time. . .dreaming
without end. . . .

Never to be seen again? But why do people say such things?

And that voice is, of course, the voice of the child—yes, this one: the one
now crawling on his hands and knees up out of the sea. Up out of that sea
that appears in the sentient realm, the realm of complete recollection, only
sporadically. The same sea that is (and how, given all the preceding events,
could it have been in any way otherwise?) a sea composed entirely of milk.
A sea composed entirely of milk and one that, unlike other seas, does not nec-
essarily end at the sky. He crawls, the child, to attain the shore; to stand upon
the shore; to grasp his small, shriveled penis; to shake it in the now-building
breeze as he shakes out the wetness in his hair; to begin to piss upon the shore
as he does—and yes, of course, it's all right, you can look at him; he doesn't
mind, he isn't shy. He has never been and never will be shy. He does not
mind if you look at him as he pisses left to right, left to right, up and down,
up, down. . .back and forth. He pisses, now pissing stronger, and why does
it come as no real surprise to anyone watching that he pisses a steady stream
of milk? He belches milk; he breaks a wind of milk; and even his tears, when

they come (and they will, rest assured, come later), will be composed entirely of milk. (If you simply look into his eyes. . .) It does not stop, his steady stream of piss; it cannot stop once he has begun; the truth is that it will never stop. He begins to walk, turning now to the East—yes, it is the East—and pissing; casting before him a steady stream of milk fresh from his penis, fresh from that sea. From a past that, though he is apparently now awake, he might never have known outside of dreams. He does not look back at the sea behind him; nor does he waver in his walking. He walks, and soon, we know—*I* know, I who have witnessed every single minute of this and more with my own eyes—soon his milk-piss will fill up the entire world. The entire world, awash in milk; the entire world, guzzling and sputtering in the piss that is the milk that began, I know, in the desiccated breasts of an ancient woman who, like those around her, steadfastly refused to cease dreaming. *Cease dreaming,* I myself think; but now I am watching the child; I am watching the child make his way and piss; I am watching the child make his way all over the world that will soon, one day, at the end of his journey, become all milk; become all the milk of dreams and what the story told us had been feared in that village, in all the villages: *do not dare to open your eyes because of the danger of waking and what will be there; O, do not open your eyes, for what milk can possibly save you now in the midst of these flying limbs? In the midst of this fire and the stench of your own burning flesh?* I have not forgotten; I, but not only I, remember partly because of an ancient woman's breasts that would not—will not—cease in their milk. And now—now he is walking. Clutching his penis and still pissing. Pissing milk. Walking. . .

But so many villages, he thinks as he walks, where still some (nay, a great many) are dreaming, and still are thirsty. . . so in need of water, of milk. Now, please, they mutter in those dreams: water. Yes, they gasp, but softly, very softly: and milk. For we are so very thirsty, they say (but still dreaming). Yes, utterly parched, they repeat, amid all the burning trees. Amid all the limbs smoldering in the trees. And all the faces. The faces that maybe even now, he thinks, are somehow dreaming. That are staring, he thinks, with their mouths open, but saying nothing. No, nothing at all, he thinks. No words nor—

Thomas Glave

WOMAN IMPOSSIBLE TASK

Impossible, yes. But how can she not do it?

After all, someone must. At least that is what she thinks. That is what she tells herself.

Someone must make the bread. Knead it. Roll it. Dust it with flour. (Although now there is no flour.) Someone must . . . but she will not pay attention. No, of course not. Not pay attention to those sounds outside. (Yes, screaming again. But not screaming now. Not like before. In the time of the light, all that *light,* and the noise. So much noise.) Those sounds. . .yes, more rifle shots. In the distance. The grenades—will the grenades come later?

(The grenades always come later, she will not think)

(Someone must go on making the bread, she thinks)

(How empty the house. *How still the light,* she thinks)

(And all the holes, holes, holes everywhere, where the walls exploded—)

Time: the time now, which she cannot know—perhaps it is better that she not know: three o'clock in the afternoon.

Her fingers. Dusty. *From flour,* she thinks. *That is flour on my hands, the flour no one can find now. It is not dust or dirt from the roadside. It is not evidence that I was digging in the roadside yesterday and the day before, looking for—*

O but no. No, no. Why think of that now? She is making bread. You are making bread. Bread without flour. The kind of bread that he always loved.

But he is gone now—

Yes, along with everyone else in the house—

Yes, along with everyone else in the street—

Soon it will be dark, absolutely dark, with no lights on anywhere around here—

The flour no one can find now. One cannot find flour or children.

They warned us two weeks ago, two months ago, to keep our lights turned off after dusk. They said, It would be dangerous. They said, There might be bombs. If the raids come, if the invasions come. . . They said, And keep your children inside. Inside. Inside, they said. But now all the children are gone. Now everyone is gone, except me, except this woman standing here who is me, except this woman standing here in what was once her kitchen, trying, trying. Trying to make bread without flour.

She; she does not; she does not, as she stands there; she does not, as she stands there in this moment; she does not, as she stands there in this moment so perfectly still—she does not, she does not (no, I *will not*) vomit. Vomit, vomit blood, vomit liquid, all over the floor.

No, nor make a sound.

She. She-I. Does *not*. Does not *make.* Does not make a—

There are sounds, there are sounds; there are smells, always smells; please wipe off that rock, a voice that sounds like her own says; the rock is sticky, you must wipe it off, says the voice again—yes, it is hers; I don't like the way it shines, she/her voice says; a part of his face is still shining on the rock, she whispers; now give me your hand, someone tells her, bending over her; no, I promise I won't hurt you, he says, but (so she will believe later she glimpsed in his face) afraid to move her; but who, who are you, I don't know your name, she says, feeling the hard ground beneath her; O, was he your husband, he says, waving his hand for some of the others, also in uniform, to come over; was he your husband, he repeats, and did you see when the explosion; O, she says, moans, as another of them bends over her; please wipe off that rock, she is trying to tell them, part of his face is still on it; all right now, just quiet, try to stay calm, we're trying to help you; where, one of them said; yes, he said, asking again, your child, where; O my God, O my God, please wipe off that rock, she hears herself scream, although she is not screaming; what is this on your face, the other one, younger, says to her, it's blood, isn't it; if you would just let me; no, I'm a soldier; yes, one of our own army, I'm here to help you; yes, he says, yes, I speak your language, of course, aren't you understanding me; she's in terrible shape, the first one says, looking down at her like that; noise, so much noise; smells, so many smells; is that the smell of someone's insides, left on a rock

to dry in the sun; and She, O She *lying there on the hard* hard *ground covered with sticky rocks,* She *does not make, no, not make a sound;* She *does not* make; *there are sounds, there are sounds, and smells, whose insides are those drying on the rock; part of his face was left on that rock; no, her child, no, no idea, no, no one has seen the girl; the girl who could not possibly have been the one she had seen standing next to him just before the bright light had flashed; no, well, it appears that almost no one from that village, her village, is still alive; yes, part of his face was left on that rock; she feels the rocks of the hard hard ground beneath her back; whose insides are those burning in the sun; and look at her smiling,* She *feels herself smiling beneath them looking down at her, all of them so afraid, she thinks; so afraid, she thinks, to move her (and O isn't the younger one in the cleaner uniform handsome—how can they send these young boys out to do this kind of work, there are so many flies, so many bad smells);* She *feels herself smiling, looking up at the O so blue sky; looking up,* She *does not vomit,* She *does not stare back at the faces staring at her,* She *does not make a sound,* She *does not; yes, obviously shock, saying something about her husband's hand and a charred girl, can you get her to sit up straight; let us help you, please, let us help you (but voices, so many voices, now not the first time, no, nor the last); will you give me your hand, I promise I won't hurt you; his hand, she remembers, had come flying through the kitchen window—of course it had been his hand, she would know his hands anywhere; and still* She, *that* She *lying there who is somehow she, does not throw up; please wipe off this rock; well, because it is too red, too bright; too red and too bright and too; yes, his face; yes,* She *had seen the look on his face just before the flash of bright light and the noise, just before his hand came flying in at her—just before all the dogs in the street and the people began to scream; yes, his face looking at her like that before his head had hurled off toward the rock; grenades had made the smell and the hands; where are my hands; where is his face; I have no face; now* She *has no face; HerMy face is on the rock (but he had not screamed); please excuse this smell; all the rocks are melting, just like the hands and my; may I please scream,* She *does not ask; please allow me to melt; I speak your language, one of them says, but who is speaking? but I will not* She *says I will not throw up*

No, She *knows.* She *knows that it could not possibly have been their girl standing in the street next to him when the light and the noise—the light and the hands—*

But quiet. Quiet then.

Bandages. Yes. And water. Quiet.

A hospital? How could there have been one? It had been flaming. Had it not been flaming when all those hands had carried her to the hospital? Or had that been some other building?

Whitenotquiethospital with hands, hands everywhere. Hands reaching out. Stretching.

Stretching in the hospital. Stretching out of the rubble. Stretching from underneath—

A hospital, or a camp. They had taken her to one. *No, she's in terrible shape. We need this. Yes, and some more of that. Tinctures. Swabs. No, clean. All clean.* (Soldiers? Doctors? Nurses? But voices. Always too many voices.) *She's in horrible shape. O all these people here,* she had thought, gazing around at all the burned and the melted, the maimed and the half-armed. The no-longer-handed, the blinded, half-legged. *They are all taking so long to die,* she had thought: whereas he and the charred girl, the girl who could not possibly (no, of course not!) have been their daughter, had died so quickly. One, two, one-two-three. *Here is a head, there are some fingers. Here is my daughter, there is her skin.* Gone. Quickly, she had thought. Ashes. In the sky. The charred parts. All gone.

The charred girl caught out in the street by the blinding light, standing as she remembered seeing her stand so still and openmouthed in the street by his side, could not possibly have been (no, of course not!) their child. Her daughter. Their child. No, no. A great resemblance in the face of that girl to their daughter, an impossible resemblance—but no. And she *had* seen the girl, before the light, turn her head up to him and put her hand on his arm and say something quietly like *Daddy,* as their own daughter would have done. "Daddy." But no. Of course not.

Where is her daughter? She must be wandering the streets again. Always such a bad girl. She never listens when we tell her, when he told her, when she told her: Stay home. *The streets are not safe. They are dangerous, in fact. Do you understand.* Stay home. *Stay close to home in the village. Stay inside home. She does not listen. Children often do not listen. Even in times of war, bombs, flashing lights, and melted skin, they choose not to listen. Young girls who do not listen end up charred. End up as*

smoky, blackened things. Where is her daughter? But how incredibly that other girl, the one who had stood out in the street next to him when the light had flashed and the noise came, had looked just like her. How she had put her hand on his arm just like her: had, for whatever reason just then—who can tell why children play these games? —called him "Daddy." Looked up at him that way with her hand on his arm. Bad girl. Bad wandering girl. Bad notlistening wandering girl. Girl who will wind up black-ened and charred one day: spread across those fields and fields of ashes.

But quiet. Quiet now. A hand, once, perhaps twice, on her forehead. Then blackness. Stench. *I am dead,* she had thought, *and glad to be.*

Here, where there is no bread, she had thought while dead. *Impossible task.*

Not a sound, except those screams—

And then. Then somehow. Somehow one week later, or two. (Who could keep time? It was/It is so much harder to keep time when you are dead.) However much time, but too soon: up out of there. Her body, walking. Impossibly. Told to walk. And walking. *She will have to leave now.* (One of the many voices.) *Yes, now. We have absolutely no more room.* Out of the stenchhospital, the whitenotquiet hospital. *You will have to leave now,* one of them said to her while she was dead, *we need the cot. Yes, yes, other bombings. Of course.* And so. And so still dead. And so still dead she had risen from the cot. Risen and. Had folded her—her *hands,* that was what they were, across her chest. Felt the places, all those places, where their hands had fastened thick bandages. And felt the scars. . .the stitches. The veryhurting places. And then, somehow, impossibly, had. . .walked. Walked out past the dead and the crying-out and the outstretched hands. Out into light and noise. She. Alone. *Woman,* she had thought, *alone. With hands.* She has/I have two hands. Her eyes unseeing. Deadwoman notseeing and walking. Walking slowly so unseeing slowly. But walking very quickly past fields of ashes. Ashes quiet. Past fields of hands with twisted fingers. Twisted fingers reaching. Reaching up out of the ground.

Back to the village of everything dead and quiet, her bandaged feet had commanded. But of course. Where else? Where else was there to go?

In the village, she had thought, *it would be possible to make bread. Bread,* she had thought. *For someone will always need it. Children—*

Her bandaged feet, propelling her there. Onward over all the dusty roads littered with ashes and. . .and all the hard white parts. Grinning. Deadchildren. Deadpeople grinning. The verywhite hard parts sometimes partly exposed underneath where everything else had been torn. Through clouds. Clouds of flies. Dogs everywhere. Bloated deadanimals. The smell of burnt feathers where cocks, only a short time ago, had strutted. Crowed.

Past all the soldiers. The soldiers sometimes sick. Very sick. Bleeding. Bleedvomiting.

She *had never vomited.*

But then well. And so. And so finally. And so finally reaching. And so finally reaching the village. (The village: more than a day's walk—and well no food —almost no water—the water, contaminated?—contaminated, in that river? —well but too late. Too late for her and for those. For those she had seen on the way. Those she had seen on the way who had been eating dirt. Clawing it up with their hands. Those. And she, joining them. Dirt was good to eat. Good, good! Dirt, clawed with the hands, and some kind of yellow vegetable snatched by all of them off a deadman's bloated chest.) *But how quiet,* she had thought upon arriving back in the village; *how quiet the village with no one in it; village of deadpeople crushed beneath the toppled houses. The houses the people burned in the middle of the light. Underneath all the noise. How difficult will it be,* she had wondered, *to make bread with dead hands.*

The house, that house, their house: a ruin. Completely ruined though not entirely burned. No, because part of the kitchen still standing. The little metal table on which she had always made bread (but how, *how?)* still standing. Covered with dust. Dust that was "Ashes," she thought. Ashes, and more.

The smell of smoke still inside what remained of the house.

No voices. No voices anywhere. No birds. No trees.

Quiet. Very quiet.

No water.
No flour.
Nothing but the hands.

And watching. Watching herself. Watching herself walk in. Walk in over the rubble. *Watching her body, watching my body, watching my body her body as I walk in.* Then seeing: Yes, that had been the front door, over there had been a window—she had recognized it! Then stopping. Listening. Turning neither to the left nor to the right. Holding her head, for just a moment, that way. Listening—listening for—

But no voices. Not from anywhere. Nowhere.

No sounds except—

That is the sound of my hands against my sides. Pat, pat-pat. That is the sound of my breathing: in out, in out.

Moving herself over the rubble, over all the stones, to behind what remained of the little metal table. Seeing nothing but the view of nothing at all out there beyond the gaping space where her kitchen window should have been.

The bread: her hands: pat, *pat-pat:* preparing:

Add a little water. (And do not think, she thinks.) Now, press it down. (No, nor remember.) *Roll it out a little more, it's too thick.* (It had been his hand.) *Press down those edges.* (Yes, his hand, of course. Who else's?) *O, you'll need some more water, it's too dry.* (His hand that, minus the rest of him, had come—) *O, hurry, knead it, punch it, quickly!* (—had come sailing, sailing, sailing into her kitchen window, at three o'clock

 three o'clock
 three o'clock
 in the afternoon)

How quiet it is without the children. The children's shouts outside in the streets. The children who had been everyone's, and there. One of whom had called me—why, called me Mother. But now switch to something else. Quickly. (The bread dough: feeling soggy beneath her hands. She needs flour, but who can get flour now? She needs dust, dirt…the things found these days in roadside dust and dirt. She needs—)

A breeze, blowing over what had been her kitchen window, eases its way in to where she now stands perfectly still behind the used-to-be wall that had

once formed part of her kitchen. Part of their house. Eases its way in, carry-
ing no scent, thank God, of burned things. Easing its way in, to tell her, qui-
etly —gently: *Perhaps now that you are dead, back here in the everything-dead quiet
village, you will no longer dream. For deadwomen—well, no, they do not. They do not
dream.*

　　How she hopes, squeezing as hard as she can the impossible bread, that
deadwomen do not dream. How she hopes, even dares now to pray, that they
do not dream of blinding light and noise—and that her exhausted eyes, when
they finally are permitted to close for an hour or two, will never permit be-
hind their twitching lids visions of charred girls. Reaching hands.

*Feeling, as she had walked back over the dusty roads on her way back to the village,
proud of herself. Proud that she finally had not vomited when one of the voices in the
hospital had said something to her about the girl. Said something—(we are speaking
your language, can you hear us, understand us?—and that one had shaken her, looked
long into her face)—said something about one of the soldiers having found the girl.
(No, not the entire girl. Parts of her. They had not meant for her to hear that. They had
not meant for her to know.) Said something about how she must have been with her
father when the light had flashed, the fire licked out, the noise knocked apart the houses.
The girl had just turned fourteen. Had had long legs, one with a deep scar from child-
hood games. Had had wide eyes—yes, shaped like almonds, everyone had always said.
Her eyes—*

*Everything had blurred even more after that: light, noise, and hands reaching out in
the white notquiet hospital. Blurred, then completely fallen apart. Fingers, hands, and
the skin nearest the elbows. You will have to leave now, we have no more room. All
had fallen apart. Fallen off. Melted. The smell. She had not vomited. There had been
no warning before the light, noise. No warning before his hand had come flying. His
hand not with his ring on it. The ring that he had, that they had . . . She had not
vomited. No, nor screamed. No other women had been present when the voices had
—who had they been?—when they had told her about the girl. When another one,
the cruelest voice of all, had talked as if she had not been there, as if she had been un-
able to hear (can you hear us?) about the charred thing found not far from her father.
Someone from the village who must have recognized. . . Fingers had touched her then,
lying there on the cot, but fingers had also fallen off. His ring. . .whoever it was who
had picked up the girl and put her someplace, the place they put all those things, must
have looked down to find his hands blackened. It is never easy to hold charred things,*

especially when they fall apart in the hands. Fingers, so many fingers touching her as she had lain on the cot. O but please hold onto your fingers, she had thought, feeling herself becoming dead. Hold onto them, keep them attached to your hands, so that I will not vomit.

Now if only she had a spoon. And salt. Just a little. If only she had a larger spoon. And some sugar. Yes, just a little. And a knife. And just a little hot water. Impossible task, yes, but how can she not do it? How can she not do it, she asks the lingering breeze, confident now that, looking out at the rubble that remains just below where her kitchen window should be, she will not vomit. Loving the feeling of herself not vomiting. And so the dough will be a bit lumpy, her fingers tell her. Her fingers still so strangely attached to her hand. Lumpy, but I, she, will press it. Roll it, I-she will. Praying that tonight *no dreams, no dreams.* Nor smells.

Feeling her ring. The ring that cannot possibly still be there, but is there.

Yes. Tight on her finger. There.

The hour feeling somehow like three o'clock,
three o'clock,
now three o'clock in the afternoon—

but much later.

The sky, darkening. But still some light—

She must make the bread. *Melt the dough. Stretch the skin.*

The dough must not be charred. It must not end up in a field of ashes.

Is it three o'clock here? It will always be three o'clock here. There will never come a time when it will be any other time than three o'clock, she-I thinks. If he had been wearing his watch on that wrist, it would have shown three o'clock exactly when his hand came flying in. I would have recognized it, the watch, and said, O yes, I see the time.

Darkness, soon coming.

—*but must make the bread. Dough, even without flour.*

Impossible task—

(O, but it had been. No matter what anyone said. It had been his hand, wearing his ring, that had come flying in—)

Young girls who walk out into the street in the middle of the afternoon and say "Daddy" and put a hand on his shoulder the way that one had might end up in parts. Charred.

O but now busy. Busy, busy, in the growing darkness. Bread. Dough. Hands. Flour. And now only a few sounds. Sounds like *rifle shots again in the distance,* she thinks. *Like grenades.* But now knead. *Knead. O but no light. So dark now everywhere. No light that will burn. No fire on my hands. Only darkness*—

(Yes, no one tells her, *the village is empty. Empty*—)

(Will there be fire in the dreams?)

—and darkness. And so many smells. And bright flames. She sees (but darkness everywhere now). She sees—

A pile of shoulders—there was a—

And legs—

Legs, yes. And then, out of the darkness—

Always. *Every time*—

Those reaching hands.

Minnie Bruce Pratt

Eating Alone

This is a strange way to live, in two or three places
at once, and where I am, no one knows that but me.
So that even standing in line at the grocery is a comfort,
and before that, rolling the cart up and down the aisles.
Because at least I'm with other people, foraging for food
in the orchard, the field rows, the shelves stacked up with
merchandise. In line I see how the woman in front of me
has gathered her supper, ground hamburger, white bread.
I don't want that food. I just want someone to turn around—

Talk to me.

How can it be that we are all going to carry our plastic bags
out the snapping doors, and get in our cars, and leave each other,
drive away to eat in twos or threes or one alone, in a blue room
with a map of India to study, the novel open next to three sunflowers
in blue plastic bottles on the table, tranquil and eating alone
with no one to talk to about where Mayapore could be.
Because I know beneath the story, there is a real place.

Driving to Work in the Dark

Those of us who get up and drive to work in the dark
get to see what is made visible only by reflection,
puddles of light shining under pearl-grey first sky
along the margin of the road, the small ponds flocked
with wild ducks still asleep, heads under their wings,

and as the sun breaks cover, the water in the ditch
shatters into silver chains, and in the sky the clouds
that raged on the wind last night are grazing, docile.

Lucy Harrison

SWEAR WITH ME

I will remember that the girl was poor and had crazy parents. She was fascinated with me because I repeated the word that she says and I want to stop and the words are bitter in my mouth and I should stop but the words keep coming and I can melt away on the school bus but the school laughs and says that I am bad for Fountain of the bad words but the words are coming and the words will not stop.

UNDER GREAT TREES

Once InSide The Painting I Find MySelf Studying The Summer Under Great Trees. I Am Wanting To Find The Easy Way To Feel That Summer Is The Way To Live. Sweating In Tight Clothes, I Have No Hat To Escape The Summer. I Need To Blot The Summer From The Painting. I Think I Know My Heart Is The Tiny Peach Pit And The Mind Is A Filling In The Black. I Will Try To Erase The Summer By The Great Trees. I Will Pick Off The Leaves. I Think I See The Work As Important. I Feel It Is Worthy. I Think I See The Pile Of Leaves As A Sign That In The Summer I Am Still Waiting For Death. I Think I Can Do It Although I Am Not Worthy. I Resume The Work Of The Tearing The Leaves. I Will Keep Doing The Job For The World.

MAGPIE

I Am A Magpie In The Tree—A Laughing Rebuke That Does Not
Hurt.

THE SPELL OF AUTISM

In The Breaks. I Can See The Spell Of The Autism And The Spell On
The Autism In The Last Breath. I Can See The Line On The Page
And The Page Is The Spell. I Can Do That At The Same Time. In The
Spell On The Awesome Thing To Deal With The Spell In The
Breaking In The Autism.

I Could Write A Note In The Book. And I Can Worry That I Will Be
The Autism. In The Way To See The Autism Is The Way To See The
End Of The Autism. In The Way To End A Physical Thing To Hear.
The Autism. I Might Say That I Can Work In The Pretty Heavy Soil On
The Autism And The Heavy Soil. I Am Trying To Feel That The Soil
Can Not Be The Barrier Because The Soil Is The Place To Hide The
New Flowers And The Beauty That The Flowers Hold In The Brown
Dirt And The FreeDom To But The FreeDom Is The Heavy But The
WordLessNess Is The Torment.

I Am Willing To Help The Autism.

I Can Help To Try To Work.

David Eye

MATINS

Is it that you've missed breakfast or
in the morning, is your lover's sleeping skin
the color and scent of coffee and cinnamon?
Dancer's arms and legs long as your
imagination. Your head in the small of his back.
Without glasses, sky, sea, and sand
reduce to Rothko bands of color. You think
of taking a swim but can't imagine moving.
A flock of gulls in the periwinkle twilight
will pass, silent, an airborne apparition.
You will need each other for confirmation:
Yes, I saw it too. And then the night.
But he was never here, much as I tried—
three years in his arms, held at bay.

EVENSONG

Our room at the inn snug as a ship's cabin,
windows refuse December's wet press.
Bed in a corner—we had to crawl and slide
over each other getting out and in.
A walk. The mist draws up like a blanket, we see it
ahead, swirling in the streetlamp's cone of light.
Not terribly cold for this time of year,
a few places open, our province.
But at dinner a sudden, sick panic:
this would end when we returned to the City.
I said nothing, and on the way back
my terror dissolved into the kissing fog.
 Across the unseen water, a lone lighthouse
 spun its beam, intoned an unheard warning.

Kyle Bass

THE HEART OF FEAR

[*Two white men—of a type, but not stereotypes—are sitting and watching TV. They drink and smoke. BOYD is in his early forties. He's tired-looking and rough around the edges, yet, somehow, still boyish. There's something sad about him. SONNY is a bit older and larger than BOYD, but otherwise average in every way. He wouldn't change a thing about himself. During the pauses, the men tend to look at the TV, but BOYD frequently looks away from the screen; he looks toward the window; he looks at his hands; he looks at SONNY, etc.; he looks lost.*]

 BOYD
That's somethin I could look at all day.

 SONNY
What's that?

 BOYD
A woman's shoulders. You?

 SONNY
Guess. Don't matter. Once you're on the short strokes…it don't matter.

 [*Pause*]

 BOYD
Now, Arlene—

 SONNY
Mean my Arlene?

 BOYD

You know another Arlene?

 [Slight pause]

 SONNY

What about her?

 BOYD

She's got a pair of shoulders on her.

 SONNY

You think, huh?

 BOYD

From what I can see.

 SONNY

What do you need to be sizin up my woman's shoulders for?

 BOYD

Shit, Sonny. Down, boy. I'm just sayin.

 SONNY

Well, maybe I don't need to hear everythin you've got to say, Boyd.

 [Long pause]

 BOYD

I knew this girl once...Rachel...Like in the Bible?

 SONNY

Uh-huh.

BOYD

Should've seen the shoulders on her, Sonny. Like God or somethin intended
for her to have wings, but didn't bother with feathers once He seen what
He had done.

SONNY

Oh yeah?

BOYD

Un-fuckin-forgettable.

SONNY

That right?

BOYD

Somethin else.

[Pause]

SONNY

So what happened to her?

BOYD

Rachel?

SONNY

Mmm.

BOYD

Wish I could tell you.

SONNY

Lost touch?

BOYD

She had a room down on route 20.

 SONNY

Just passing through, was she?

 BOYD

I guess. Room had cable though. A/C too.

 SONNY

Nice.

 BOYD

Yeah. Nice little room. For what she was payin for it.
 [Pause]
We watched boxing the first night. White guy/Black guy match-up. Rachel
thought the nigger looked pretty good. She paid for the pizza. I brought the
beer and had some weed.

 SONNY

Party-girl.

 BOYD

Know what she did?

 SONNY

What?

 BOYD

Know how there has to be a Bible in every fuckin motel room in America?

 SONNY

I guess.

 BOYD

Rachel, she was smart. Know what she did?

 SONNY

What?

> BOYD

Know how the pages in a Bible are so thin you can almost see right through 'em?

> SONNY

Never noticed.

> BOYD

I didn't bring any damn rollin papers, right? So, Rachel tore a page right out the back of that Bible and that's how we smoked the weed.

> SONNY

Get the hell out.

> BOYD

No lie. Cross my heart. I'm telling you. Those were the best damn joints I ever had.

> SONNY

That's the kind of woman to have around.

> BOYD

No, she was nice.

> *[Pause]*

> SONNY

Whatcha do with her the second night?

> BOYD

Same thing. 'Cept only we didn't bother with pizza or anything. Just drank the beer. Peeled the labels.

> SONNY

And smoked the Good Book?

BOYD

Yeah…And talked…We talked a lot. Kind of got to know each other. Listened to each other's stories, you know? She said I didn't have to wear the rubber that night.

SONNY

Bingo!

BOYD

No, it wasn't like that. It was nice. We got to know each other a little bit. It was nice.

 [Pause]

SONNY

That it? Two and out?

BOYD

I guess.

SONNY

Neat and clean. Nobody hurt. Wish I could hook up with a situation like that once in a while.

BOYD

You don't need that. Whaddaya need that for, Sonny? You got Arlene now.

SONNY

We're just talkin, right?

BOYD

I'm just sayin. All that between you and Shirley, that wasn't pretty. I mean Shirley, she almost—

SONNY

 [Cutting him off]
Yeah, Boyd…I was there.
 [Pause]
So you and Little Miss Route 20…Two and out, huh?

BOYD

I went back the next night. The third night. Just to see, you know, how
she was doin. Took a coupla-three bottles of wine with me. You know?
Thought we'd maybe give that a try. Remembered the goddamned
corkscrew and everything....But she wasn't there. She was gone.

SONNY

Betcha that sucked, didn't it? Bet that took the wind right outta your sails.

[Slight pause]

BOYD

The guy in the little front office—jerk. He said Rachel checked out that
afternoon. He said, "Guess the party's over, huh?" Looked at me like he
knew somethin I didn't. He wouldn't give me her name.

SONNY

Thought you said her name was Rachel.

BOYD
[A little desperate—a little angry]
That's what she told me. But no, he wouldn't give me her *last* name. Said he
had a "confidentiality policy." Fuckin asshole.
[Pause]
That's been a while ago now though. Who the fuck cares anymore, right?

SONNY

What'd you do with all that wine?

BOYD

....It went pretty fast.

[Pause]

SONNY

She had nice shoulders, huh?

BOYD

Beauties. Built to last.

 SONNY

I bet she was married.

 BOYD

She wasn't married.

 SONNY

What makes you think you were the first bum to appreciate her shoulders?

 BOYD

Didn't say I was. Did I say I was? Just said she wasn't married. She doesn't
like wedding dresses. I know that for a fact. She told me that the second
night.

 SONNY

She told you she didn't like wedding dresses?

 BOYD

On our second night. When we were talkin and I told her about the time
when I was just a little shit—four or five—and my mother made me
go with my father to buy a new pair of shoes and on the way home he
stopped to see one of his fuckin girlfriends—I mean, I know that now—
and left me outside in the car in the dark for fuckin…forever. I pissed all
over myself, I was so afraid.

 SONNY

You peed on yourself?

 BOYD

Like a lost puppy.

 SONNY

That's a shame.

 BOYD

It wasn't too bad at first while the piss was warm. Kind of a comfort. Felt
like a warm blanket at first. But when it got cold.… To this day, whenever
I get afraid, swear to God, I go cold all over.

> SONNY

You told that woman all this?

> BOYD

Yeah. First person I ever told.

> SONNY

Boyd, no wonder she booked.

> BOYD

No. I told you, we talked. We got to know each other a little bit. I told her that about my father leavin me alone in the car. Then she told me about when she was a little girl. How she went shoppin with her mother and got lost by herself in the store. Got lost in the wedding dresses, she said. Said she couldn't find her way out. Couldn't find her mother. Just empty dress after empty dress and her mother not in a one of 'em. She said wedding dresses have scared her half to death ever since. I could believe it.

[SONNY *gives* BOYD *a look*]

> BOYD (Cont'd)

Don't look at me like that. I could see it in her eyes. It was an old story, but I could see it in her eyes. It spooked her bad. Deep. She's not married. How the hell is she married? She's afraid of fuckin wedding dresses!

> SONNY

How do you know she wasn't just feedin you some line?

> BOYD

…what?…

> SONNY

Tellin you all that so you wouldn't get any dumb ideas.

> BOYD

Whaddaya mean?

 SONNY

Women and men ain't all that different. Sometimes all a woman is lookin
for is a piece of cock, not a name change.
 [He's laughing]

 BOYD

Whaddaya sayin?

 SONNY

I'm sayin you can come off a little desperate, Boyd.
 [He laughs]

 BOYD

Don't laugh.

 SONNY

 [Laughing]
Who the hell's afraid of wedding dresses?

 BOYD

She was! Don't laugh!

 SONNY

 [Laughing]
And you ain't seen her since? Sounds like a really bad case of matrimon-
a-phobia, you ask me.
 BOYD

It ain't funny.

 SONNY

The hell it ain't.

 BOYD

She was scared to death. I know it. She was scared to death!

 SONNY

 [Laughing]
Of maybe endin up with someone like you, she was.

BOYD

Fuck you! You weren't there. She was scared! So was I!

SONNY

[Laughing]
Scared of a wedding dress?!

BOYD

[On "dress"]
OF EVERYTHING! OKAY? NOT JUST THE GODDAMN WEDDING
DRESS, SONNY! AFRAID OF *FUCKING EVERYTHING!* ALL
RIGHT? NOT EVERYTHING'S SUPPOSED TO BE A BIG FUCKIN
LIE, YOU KNOW! ASK SHIRLEY!

*[Silence. Long pause. SONNY looks around the room, finishing his beer.
He smoothes out a small throw-rug at his feet. BOYD looks at the TV—
looks beyond it. He's thinking of something far away.]*

SONNY

I'm gonna get goin. Arlene'll be waitin.

BOYD

[Calmly. Gazing into the TV]
I had a dog once. "Lady." Good dog, too. She got spooked by the sound
of thunder. I couldn't stand to see what it did to her when it would start to
rain. I had to put her down. I had to put her down 'cause I couldn't stand
to see her afraid of the rain.

[Silence. Pause]

SONNY

Yeah…I'm gonna go.
[Pause]
I need to get home.
[Pause]
Maybe I'll catch up with you tomorrow.

<center>BOYD</center>

Yeah. Maybe.

<center>SONNY</center>

Listen, Boyd; you take 'er easy, 'kay?

> *[SONNY leaves. BOYD is alone. Pause. BOYD turns off the TV. Pause. He sprints, suddenly, to the window and throws it open. We hear the sound of SONNY'S truck pulling away as BOYD shouts out the window at the top of his voice]*

<center>BOYD</center>

[Calling—there's desperation in it]
SONNY!… HEY, SONNY!…TELL ARLENE I SAID HELLO!… SONNY!…

> *[We hear the sound of SONNY'S truck fading away. We hear the crickets in the night and a dog barking in the far distance, calling back to BOYD. BOYD is alone as the lights fade to black.]*

<center>**END**</center>

Regis Cook

LAST NIGHT WAS RADICAL...

Last night was radical…

I kicked the Queen out of
Buckingham Palace.
Snowboarded Mount Everest.
Made my way to the Leaning Tower
of Pisa and parachuted off.
I traveled to the opium dens of China
And played Chinese dodgeball.
Then I decided to wake John Gotti
from his grave and we went on to the
world's longest police chase. Then
I went home.
Hangin' with
John Gotti was fun. He was
smoking his big fat Cuban cigar
telling me with his big Italian
accent kid faster kid go. He was
laughin with his made-to-fit tuxedo
all dirty. He told me to go to his
old neighborhood. We got out and
burned the car and he said you're
all right kid and he was gone.

Robert Phillips

From THE ICE HOUSE POEMS

Karl

sent flowers to each
of the four barmaids
who worked shifts at
The Alabama Ice House,
each bunch wrapped in
newspapers, tied with
duct tape. (He had
very little money;
the flowers looked like
they were picked from
local lawns, which they
were.) The four laughed;
amongst themselves
called him the Stalker,
and nursing his beers
he wondered why
not one of them fell
in love with him.

Stray

Stray, the Ice House dog,
was a good dog, licked hands
like lollipops, gave great wag.

Called Stray because he
wandered in from nowhere,
stayed for fourteen years.

Finally one day he had to be
put down like a dog. Why
is it that people address a dog with,

"Good dog, good dog,"
never "Great dog?"
Stray was a great dog.

Fester

Every morning he sits in back
of the Ice House, gossiping with
old cronies. No beer—he gave up
drinking six years ago, when
his wife of forty-five years died.
(She'd begged him to abstain for decades.)

Every afternoon he sits in front,
harmlessly flirting with pretty
young girls. Which is why cronies
call him Fester the Child Molester.

Every night he watches the TV
with his wife's photo beside him.
He's tempted to drink,
but doesn't, out of respect.

Gene

They call him Gene because all
he talks about is his years
as backup drummer in Gene Krupa's band.

"We did all the States, toured Europe,
spotlighted Atlantic City and Vegas.
Man, it was the life! And Gene
treated me real good. Gave me solos.
Had my own satin tuxedo."

What happened? They ask, looking at
this aged hippy with an earring,
missing teeth. He shakes his head.
Dennis gave him the Box Boy job.
What the Box Boy does is, busts down
all the cardboard cartons the beer
comes in. You'd be surprised how many
there are at a place like this.

Then one day Dennis caught Gene
selling drugs right on the premises,
fired him, told him never to come back.
Now every day Gene sits on the curb
across the street, wearing a bandana,
smoking, drinking convenience store beer,
waving at Ice House customers as they park.

Larry Bissonnette

MY CLASSIC LIFE AS AN ARTIST

It's significant that my artistic style lets me express personal perspectives of an autistic but intelligent old Vermonter.

No one should limit learning of truth in closed rooms occupied only by people with no natural means to communicate.

Going back in desolation where it's only me and letterless walls is not pleasant to think about. Nothing "apartheids" you like the insensitive world of institutional experience.

I began painting keeping busy as a powerless-to-communicate young child.

Starting a painting is like laying down layers of paint on the walls of the house. Gradually, lines and shapes are added like roads for cars to find ways to people's destination when they are on vacation in a foreign country.

Seeing work done isn't totally satisfying because I'm rigged for process and not completion.

Lore around autism uses situations of incompetence to predict what little potential people have to learn creative and artistic skills. Like leading articles in magazines looking at populations of people with disabilities, my aesthetically questionable but not bad to argue work is the best way to clear up mysteries of what I am about. This is my reputation with people who know me.

My muralistic lettered view of life is stimulated not by likenesses of reality but by intuitions of plentiful feelings and sensations.

Knowledge and learning of art have allowed my abilities to soar out on an airfield occupied by people who don't have disabilities.

Hopeful about my knowing personal growth. It makes noteworthy my life.

The above statements are excerpts from the narration script for the film *My Classic Life as an Artist: A Portrait of Larry Bissonnette,* produced and directed by Douglas Biklen and Zach Rossetti of the Syracuse University School of Education. The film was named best short documentary at the 2005 Vermont International Film Festival and was an official selection at the Vail Film Festival (2005), the Sprout Film Festival (2005), the International Short Film Festival (Munich, Germany, 2005), and the Breaking Down the Barriers Film Festival (Moscow, Russia, 2006).

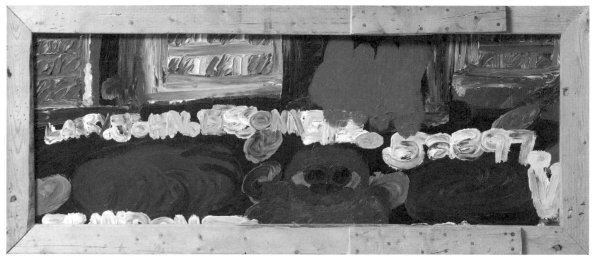

LARRY BISSONNETTE, *Meeting of elegantly written signature with funny personality-less figure is timed to relate words of identity to meanings expressed through painted shapes,* acrylic on board, 1997

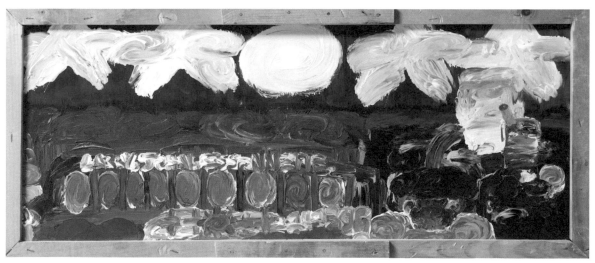

LARRY BISSONNETTE, *Landscapes are better looking paintings without placement of letters on them. Opportunities to leave my signature can't be passed up, however,* acrylic on board, 1998

LARRY BISSONNETTE, *Landlocked pool, pale-faced Vermonters, spreadable blankets promise Floridian experience,* pastel and marker, 2000

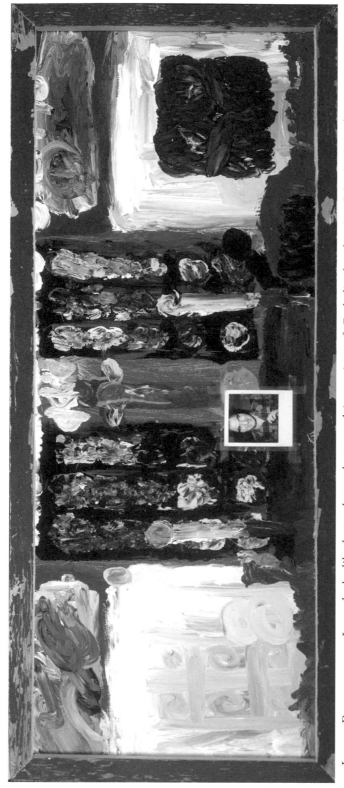

LARRY BISSONNETTE, *Larry looks like latter-day, rather-rooted-in-routines-of-Catholic-church saint. Massive miracle if acceptable behavior for a saint ever gets achieved*, acrylic on board, 2004

WENDY MOLESKI, *Lawn Gone,* color photograph, 2006

Michael Petrosillo

THE GOVERNOR

The Governor, as he was called, loved hockey only slightly more than he loved Jacqueline Kennedy Onassis. He appreciated each one's unique blend of courage and style. On Saturdays in winter he arose at 5 a.m. and dressed in his favorite gray wool cardigan and blue polyester pants. He dined on a large raw egg swimming in a short glass of orange juice followed by a thick black coffee chaser. His kitchen table was small and covered with piles of unopened mail. Side by side on the wall above it hung a peculiar pair of photographs. One photo was a black and white of Jackie, clipped from a 1962 *Life* Magazine. Twenty-four years later the Governor still admired her sense of aristocracy and he was particularly impressed with her taste in hats. Alongside Jackie hung a photo of the Governor's son, Denny, at the age of fifteen, proudly wearing the green and white uniform of the Vermont State All-Star hockey team.

"Bonjour, amigo," he said aloud. "It's a great day for hockey. I sure do wish you could come with me today," he said with a nod to his son's photo. "You've been gone far too long."

Pausing, he looked at the ground and shook his head.

"Yes sir, far too long."

He pulled on his well-worn brown loafers and smiled when he remembered his black galoshes. His blue wool overcoat, which he claimed was once owned by a "duke," was a little snug in the shoulders when he stood up straight. His charcoal flannel fedora, however, including a noble red and black feather, was flawless. The Governor considered the perfect hat to be a true gentleman's indispensable accessory.

He crossed the road at his front door and walked down the west side of Main Street with the hope of catching a glimpse of the sun rising over his apartment on the east side.

"For a man to see the sun rise over his own home is for a man to see himself in the safety of God's glow," he would say.

The sun didn't shine very often on Wakeeji, Vermont, but that day it painted the thin clouds overhead with shades of lavender and pink as it peeked over the third-story apartment. The Governor stopped and tipped his hat toward the sun.

"And bonjour to you too," he said.

• • •

Wakeeji wallowed in the eastern shadows of Lake Hills, the popular tourist destination perched high atop the bluff overlooking Rendezvous Lake. Wakeeji was a small blue-collar town that realized its fifteen minutes of fame in 1975, when a former mayor proposed building a dome over the entire area. It was assumed that the dome would have brought national recognition to the floundering community while at the same time protecting its citizens from the long, cold winters. Some would say that blocking the view of the more affluent homes in Lake Hills was the true benefit.

The dominant structure in the town was a long three-story brick building that was home to two pubs, a hardware store, a coffee shop, a drug store, and a shoe repair store that was still referred to as "the cobbler." The brickwork was intricate, with elaborate designs around the windows and along the eaves. A cast iron gargoyle sat precariously on one corner of the roof. Four rusted bolts saved it from the same fate as its estranged mate: a kidnapping by frat boys in the seventies. The building was much like the structures that lined both sides of Main Street in Lake Hills—but peeling paint and dry rot would never have been tolerated on the Hill.

The Block, as it was known, was designed as one of a pair that would face each other and provide Wakeeji with a cozy, storybook Main Street of its own. The second building, however, was never built and the first ended up facing an expansive dirt lot that sloped gently toward the river. The Block stood awkwardly alone.

• • •

The Governor's weekly trek to the hockey rink in Lake Hills took him about an hour if he focused, although concentration became an ever-increasing challenge as signs of dementia continued to creep in. Usually he stopped and talked with anyone who happened to be passing by.

"This must be your little sister," he said to an older woman waiting for the bus with her granddaughter. "And I can see she's going to be as pretty as you when she grows up."

If he didn't meet anyone on the street, he ducked into businesses or wandered down familiar driveways in search of a sounding board. He discussed the demise of pro sports, his glory days as an athlete, local politics, and the hooligan developers that wanted to build a Wal-Mart on the land along the river, just outside his front door. But mostly he talked about hockey. He dispatched stories of the famous Wakeeji versus Lake Hills rivalries of old, when Vermonters would travel all the way from Newport to watch David battle Goliath.

"In those days everyone knew that ice hockey players walk on water," he said with a laugh.

He relished his role on David's team and spoke of it with the wondrous reverence that many exhibit when speaking of the birth of their first child. That was before Wakeeji was forced to cut its sports programs. That was before the war. That was before they started calling him "Governor."

• • •

The 2,042 residents of Wakeeji were mostly related and shared the names LeBlanc, LeBeau, LaSalle, and Bouchard. They gathered in the pubs and coffee shop day after day, smoking and debating, but mostly complaining. They were absorbed with local politics, Vermont history, and hockey. Days rarely ended with resolution on a subject and discussions were often resumed the following morning. The pattern had been repeating itself for over a hundred years with the faces, but seldom the names, changing. Wakeejians were innately contrarian but they always agreed on one thing: their disdain for Lake Hills.

Being the "Queen City" of Vermont, Lake Hills had its own advertising campaign. The Chamber of Commerce was an aggressive organization focused heavily on increasing summer tourism. Ads proclaimed, "Come to Lake Hills where it's Always the Summer of Love." The Socialist mayor supported the arts and the town became a refuge for musicians and artists from all over New York and New England. The full-time residents of Lake Hills possessed a fundamental optimism that made them appear elitist to resentful Wakeejians. The postcard-perfect buildings and pristine public parks fueled that sentiment.

The Governor was one of the few who were ever embraced equally by both towns. He had been the greatest hockey player the state ever produced back when hockey was considered the golden ticket out of the granite quarries. Although the Governor played for the enemy, the hockey fans in Lake Hills admired his fluid skating and powerful slap shot.

In 1944, after only one season of semi-pro hockey, the Governor, feeling it was his duty, enlisted in the Army. He had been expected to jump to the NHL the following season, but it would be five long years before he returned home, limping slightly from a screw in his ankle—the result of an overturned Jeep in Germany. The people of Lake Hills gave him a parade right down Main Street while indignant Wakeejians slumped over their pints and ashtrays wondering why they didn't think to have one.

"Just rich folk rubbing our noses in it," they reasoned.

They sat amidst the smoky haze of the pubs reminiscing about the old days when Lake Hills wasn't worthy of taking the ice with the Wakeeji Indians hockey team. The inevitable reality that their favorite son must now be shared settled over Wakeeji like a black rain cloud during mud season.

Parade or no parade, the Governor was the pride of Wakeeji when he returned from the war. The town's obdurate collective conscience prevented them from admitting it, but the amount of time they spent talking about him illustrated their true admiration.

• • •

Prior to arriving at the hockey rink the Governor stopped in to the quiet little real estate office in Lake Hills where Margaret Maxwell worked part-time as the receptionist. Each week he brought her a special gift that he picked up along the way. Sometimes it was a shiny piece of granite or some plump berries that he picked near the river. Sometimes he sang her songs that he practiced as he walked. He was always the gentleman and always had something for his favorite girl. In return, as she did every week, she gave him two Hershey's Kisses wrapped in silver foil.

"One for each cheek," she said with a wink.

During the war the Governor wrote to Margaret often, as promised. He labored for days over each letter, striving to perfect his prose and avoid embarrassing himself. The letters, almost one a month for more than four years, were subtle at first, and always included Allen, his best friend, and the third member of the intimate trio. The three of them had been inseparable ever since Margaret had moved to town a few years earlier. The letters became increasingly direct and references to Allen became scarce. His feelings for her, he thought, could not be mistaken for anything but love.

Margaret never once wrote back.

When the Governor finally returned home to Wakeeji, Allen and Margaret were husband and wife and the letters were never mentioned.

• • •

The first game at the Jorgensen Athletic Pavilion started at 9 a.m. sharp. The JAP, as it was called, was named in honor of the Governor's son, Denny Jorgensen, who was once considered to be Vermont's most promising candidate for the NHL—since his father. The entrance to the facility was guarded by an

eight-foot statue of Denny that had been provided by an anonymous donor. It was rumored that Denny himself, a Manhattan business man, paid for the tribute, forever preserving his youth in bronze and pigeon droppings.

Inside the modern arena families gathered, blowing on steaming cups of coffee and hot cocoa. They wore shiny nylon jackets with the name of one junior hockey club or another embroidered across the back. Years of early morning practices, long road trips and expensive equipment caused most of them to look older than they were.

The Zamboni glided silently around the rink in shrinking concentric circles, scraping the scarred, crunchy ice and leaving a fresh coat in its wake. Eight-year-old boys sat quietly in the locker rooms lacing skates and taping sticks with the gravity of old pros preparing for game seven of the Stanley Cup Finals. Young fathers hovered over them, weaving a tapestry of clichés as they dispatched their final words of pre-game wisdom.

"Give it 110%."

"Look for the open man."

"Take your shot when you've got it."

And on and on and on.

"Mornin' Governor!" people shouted from their seats as the Governor made his way down to his favorite spot in the front row, waving and greeting his fans with a smile. The Governor removed his gloves and the duke's overcoat and placed them, meticulously folded, on the seat beside him. He adjusted his fedora before carefully dropping one precious Hershey's Kiss into his steaming cocoa.

"Good morning, Tommy," Allen said. Many who knew him before the war still called the Governor by his given name.

"Bonjour amigo," said the Governor. "I swear that wife of yours gets prettier and prettier every time I see her."

"Oh, thank you," said Allen. "She said you sang her the loveliest ballad at the office this morning. You've sure got her wrapped around your finger."

"You know Allen, as a good friend of mine once said, Man makes holy what he believes, as he makes beautiful what he loves."

"Well, then I guess that makes you one handsome devil," said Allen with a nudge. The two laughed. "I've got to get to my post at the scorer's table. Are we still on for dinner next week?"

"My good man, as a good friend of mine once said, One cannot think well, love well, or sleep well, if one has not dined well," said the Governor. "I wouldn't miss it."

The Governor treasured a sophisticated quote. In the nearly four decades since his return from the war he spoke in clever phrases lifted from famous books and speeches. From Shakespeare to Twain, the Governor recited their memorable lines like a well-read scholar—an acquired talent that had amused but puzzled Allen. He had never considered his good friend to be much of a reader and the Governor never let on that he read hundreds of classics since first meeting the bookish Margaret.

Allen had been the accomplished student. He was conscientious and excelled in philosophy, literature, and history. In high school the Governor struggled in the classroom and gravitated toward what he called the more "measurable disciplines" like hockey and wood shop. The Governor's blistering slap shot and wandering eyes on test days were more than enough to earn him a diploma. Allen would have given anything to trade his prowess in the arts and sciences for a taste of his best friend's athletic gifts and the glory that accompanied them.

"I am not jealous," Allen said unconvincingly. "I am merely intrigued."

The games were played in quick succession with just enough time in between to clean the ice. The earlier games were for the younger kids and the teenagers played in the afternoon. Between the third and fourth games the Governor inevitably made his way to the lobby and ordered two red hots with kraut and triple mustard.

"Young man," he would say to the teenage boy working the hot dog window, "when I was your age I was working in the fields on my father's exotic spice farm in Jamaica."

Every week the kid would smile and say, "Really?" as if it were the first time he had ever heard this.

"Oh yes. We worked all day every day and at the end of the week my father would give us a shiny nickel to go to the movie house."

"Wow," the teen would say. "That's really cool."

And the Governor would smile proudly before returning to his seat dreaming of Jamaican sunsets and Barbara Stanwyck on the big screen.

The Governor finished his red hots and fished for the second of the two Kisses in his coat pocket. As he delicately removed the foil from the chocolate, Reggie McCarthy sat down in the vacant seat behind him.

"Hey there, Thomas," he said as he tried to casually sip his scalding-hot coffee.

"To what do I owe this pleasure, counselor?" the Governor said. Reggie McCarthy was an attorney but everyone always said he was too nice and

too nervous to be any good at it. A few years earlier when the Governor's progressing Alzheimer's became obvious, Reggie's wife had convinced him to take care of the older man's affairs—things like finances, medication, and legal issues.

"We need to talk again, Tommy. Can you come over to my office for a few minutes?"

"Young man, I was playing professional hockey when you were nothing but a gleam in your father's eye. And I expect that, as my attorney and court-appointed servant, you will respect my right to a day of sport, uninterrupted by petty legal matters."

"I understand, Tommy," said Reggie. "But like I've said a hundred times before, these are not petty legal matters. This is important stuff."

Reggie's nervousness had nothing to do with his business with the Governor. He flicked an imaginary cigarette, like an amputee scratching a phantom limb.

"Look," Reggie said. "You really need to acknowledge your condition by appointing someone to be your power of attorney—just to be safe. I know you'd like to wait for Denny to come back, but really Tommy, he's been gone ten years now—and you're all alone."

Reggie flicked.

"Young man, do you have any idea who you are talking to?" said the Governor. "My family has been a pillar in this community for over a hundred and fifty years. To suggest that I am crazy is an insult to me and my family."

"Who said anything about crazy? Hell, as far as I'm concerned we're all nuts. I'm just saying that your mind isn't what it used to be. It's that simple."

"Counselor," said the Governor. "As a good friend of mine once said, Insanity is doing the same thing over and over again and expecting different results. I dare say you are closer to being crazy than I am."

Reggie pushed the errant curls off his brow as he rose, shaking his head and flicking.

"Why do I even bother?" Reggie said as he left.

"That's offsides!" the Governor screamed at the linesman. He sat in uncharacteristic silence.

His father had been a victim of Alzheimer's disease. The Governor was intimate with the painfully slow mental deterioration that once-distinguished citizens suffered in its grip—their dignity smoldering like a dying campfire until its last sparks are snuffed out leaving nothing but cold, worthless ash.

· · ·

After the final game had been played and the stands had long been empty, the Governor stood looking up at the statue of his estranged son as the afternoon sun settled behind the JAP. His look was pensive—his bushy gray brow slightly furrowed.

"Can I give you a lift home, Tommy?"

It was Allen.

Still looking up at Denny, the Governor quoted Shakespeare.

"How sharper than a serpent's tooth it is to have a thankless child," he said.

"They do know how to hurt us don't they?" said Allen.

The two men walked toward Allen's dark green Volvo station wagon.

"I always thought that having kids would make me feel important," Allen said. "I don't know what I was thinking. Imagine, a grown man looking for validation from a child. First you think you're special because someone agreed to marry you. Then you think your kids will worship you just for showing up. In the end, though, you are what you are."

The Governor gazed out the frosty window and gave Allen a slight nod of acknowledgement. He rubbed his thighs to keep his hands warm until the tired old heater kicked in. They drove toward the river in silence.

At the turn of the century the Wakeeji River was a vibrant waterway connecting dozens of towns like Wakeeji, Franklin, and Intervale to Rendezvous Lake. The towns transported granite and lumber down the river to be loaded onto freighters that would take the goods south on the lake toward New York. A wooden drawbridge eventually connected Wakeeji to the thriving Lake Hills and it became a main thoroughfare for commuters and tourists from all around the state. In the thirties and forties Wakeeji took full advantage of the traffic and small businesses prospered. Construction of The Block began in order to accommodate additional businesses and housing. Wakeeji boomed.

In 1944, the same year the Governor left for the war, a troubled teenager set fire to the bridge. Wakeeji commerce ground to a halt and The Block's mate was never built. It would be 35 years before a steel and concrete replacement arrived. Wakeeji never recovered.

Allen's car pulled up in front of The Block and stopped at the Governor's front door. Allen spoke as the Governor buttoned his overcoat.

"You want to know something?" Allen said. "The truth hurts and it takes a hell of a man to face it down—bigger man than me, that's for sure. But you, Tommy, you're different. Denny will come home some day and when he does…"

Allen's voice trailed off.

Allen had watched the Governor quietly grieve his estranged son for nearly ten years. In 1976, the 25-year-old disappeared. He left a note by the phone and took whatever clothes would fit into his hockey bag. The note simply said:

"You should have told me."

Denny ran away on a clear, sunny January day. It was the same kind of day the Governor's wife ran off with a Canadian and left him to raise a baby boy on his own. It was the kind of day that looks inviting from indoors but whose biting cold can leave a man breathless.

The Governor patted Allen on the shoulder, forced a half smile, and pulled on the door lever to get out. He hesitated.

"Allen, my friend," said the Governor. "Can you possibly imagine how it feels to have let your own despicable egocentric behavior hurt someone you love?"

Allen looked straight ahead at the windshield, both hands fixed on the steering wheel.

"I can imagine it," Allen said.

The Governor climbed out and stood on the sidewalk in front of The Block until the flicker of the Volvo's taillights faded. He wasn't hungry but he always ate supper when he got home from the games. And so he did.

• • •

Saturday morning came again and the Governor's pre-game ritual was more hurried than usual. The sun had not yet risen and static electricity caused his sweater to spark like lightning bugs in the dark. He gulped down a raw egg in orange juice and slurped briefly on the thick, black coffee before he turned and smiled at the two photos on the wall over the table. He blew a kiss to Jackie and fixed his gaze on Denny.

"Please come home, son," the Governor said. "I promise not to embarrass you. Besides, as a good friend of mine once said, Genius is more often found in a cracked pot than a whole one."

He winked at the photo.

Hurrying across the street he shot an indifferent glance at The Block—only long enough to notice the dark snow clouds that lurked in the East. He picked up the pace and made his way across the river and up the hill.

As he approached the real estate office he realized that for the first time ever he had forgotten to pick up a gift for Margaret. He was disappointed in himself but he walked into the office and ceremoniously removed his fedora and placed it over his heart. Margaret sat at her desk smiling—two Kisses in her right hand.

"Good morning, handsome," she said.

"Bonjour, my lovely flower," said the Governor.

"Allen told me you've been a little down in the dumps this week," she said. "We sure missed you at dinner. Is there anything I can do for you, Tommy?"

The Governor thought for a moment and said slowly, "My good woman, my sweet Margaret. Were Jackie O. herself to give me her heart this day, I would respectfully decline, for my heart belongs to you my dear Margaret. As a good friend of mine once said, To love and win is the best thing, to love and lose is the next best."

Margaret did not speak. Small tears formed in the corners of her chestnut-brown eyes.

"Margaret," the Governor continued as he bowed dramatically. "Please do me the honor of accepting my heart as the lone gift I can give you today."

"Of course I do, handsome," she said. When she smiled the tears perched in the corners of her eyes dislodged and brought with them two black lines that ran down her cheeks and met beneath her chin. She held out her hand with the Kisses.

The sky was lighter now, almost white. It was as if there was no sky at all, but there weren't any clouds either. Tommy walked past the Denny statue without looking at it and continued along the side of the arena to the back. The Zamboni sat parked in front of a huge pile of ice shavings looking regal, painted purple and yellow.

As the Governor approached the machine he slipped on the ice and lost his footing. He leaned forward then back then forward again, his arms waving for balance, stretching the snug shoulders of his overcoat. The Governor looked to the sky and it was suddenly darker, almost black, then blinding hot white. Then it went silent.

• • •

He climbed up to the seat and placed his hands firmly on the wheel. He felt power in his grip. He turned the steering wheel to the left and then to the right, imagining he was freshening up the entire planet—giving the whole filthy place a clean start. He wanted to scrape away all the deceit in the world, starting with his own. The Governor was certain he had deluded himself about Margaret. He should have been more attentive to the one that said yes.

The key was still in the ignition and when he turned it to the right the machine roared to life. He forced it into gear and the machine jerked forward, tipping to the left as it banked off the slush pile in front of it. He steered it down the gravel driveway that ran along the side of the building and out onto the sidewalk near the front entrance. He looked happy. The Zamboni rumbled past the statue and the Governor tipped his hat to Denny as a pigeon left its mark on the statue's bronze right ear. People were shouting and laughing and cheering.

"Hey, look! It's the Governor! He's gonna clean up the streets!" someone yelled.

"The streets, yes, and a mountain of missteps too," the Governor said.

"Hey Governor, give me a lift!" shouted another.

They all laughed and cheered as he made his way through the parking lot and onto Main Street. The Zamboni crossed the intersection onto the brick pedestrian avenue and rolled between the rows of Lake Hills' boutiques and restaurants. On the sidewalk to his right stood Margaret wearing the most stunning pill box hat and dark sunglasses. Allen stood at her side in his first mail carrier uniform. They looked twenty years old. They held hands.

The Governor felt lucid for the first time in years and for a moment his perspective seemed correct and obvious. That son-of-a-gun was right, he thought. Truth is indeed beauty and beauty is, of course, truth. And the truth is that Margaret belongs with Allen. Who was I to think it a farce?

He sat tall in the seat and waved. He could have been a presidential candidate, or Santa Claus. His smile, with its numerous gaps, was fixed and wide, and his blue eyes sparkled. As the great machine rumbled through growing crowds of well-wishers toward Wakeeji Bridge, the Governor spotted his son. Denny waved, but didn't seem to recognize his father. Denny looked old, the Governor thought, older than himself.

"Come on my boy," the Governor said. "If Wakeeji won't come to the parade, we'll take the parade to Wakeeji."

• • •

Margaret and Allen sat at the Governor's bedside. For three days he had lain unconscious in the hospital bed with a peculiar smile on his face. The corners of his mouth turned slightly upwards but the muscles in his face were relaxed.

"Tommy, honey, can you hear me?"

Margaret's voice was soft and tentative. Her normally brilliant brown eyes were now dull from the fatigue that comes with worry. She held his hand between both of hers and her expression pleaded for him to wake up.

"What in Heaven's name were you doing out by the Zamboni?" she asked him, not expecting an answer.

"Bill Campbell said it looked like he might have tried to climb up on the thing," said Allen. "Says he's had that same smile on his face ever since he found him lying out there."

"Allen, I'm scared," said Margaret. "What if he doesn't wake up?"

Allen shrugged as he paced at the foot of the bed—hands in his pockets. He struggled with heavy hypothetical questions.

"It makes me sick to think that he may never get to make things right with Denny," she said. "What a sad, awful thing—to leave this world without having cleared the air with the person you love most."

There was a brief time when the Governor had let himself believe that Denny left home because he was afraid to face the disease that would strip his father of his dignity. The Governor had known, though, that his dignity could never be taken from him by illness—he had already pawned it years ago for a lie. When Denny was old enough to understand, rather than face the embarrassing truth, the Governor told Denny his mother had died when he was a baby.

• • •

Allen and Margaret were exhausted but it was too early for bed. The dark orange sun sank heavily behind their house. The cloudless sky offering no lingering sunset. They sat at their round kitchen table and sipped coffee.

"I can't help but wondering," Margaret said.

"About what?" said Allen.

"Well, if Tommy had only been truthful with Denny. I know it doesn't change anything to talk about it, but I wonder how all of our lives might have been a little different had Tommy just told him the truth about his mother."

"Well, Denny might not have left," Allen said. "But other than that I'm sure everything would have been pretty much the same."

"I don't see how it could have," said Margaret. "All those years of secrecy. It takes its toll on people, you know? I know it wore me out at times—taking care of that precious child and not being able to answer his questions about how his mother died. I hate that I was a part of that," she said.

Allen rubbed the rim of his coffee cup with his finger.

"Doesn't it make you feel a bit guilty, Allen?" she said. "To have been a part of that shameful lie?"

Allen stood up without speaking and walked down the dimly lit hall.

"Allen?" said Margaret. She sat alone at the table.

Allen returned to the kitchen with a shirt box in his hands. His eyes looked tired and sad.

"What's that?" asked Margaret.

Allen set the box on the table and cut the twine that had held it closed. He removed the lid and pushed the box across the table to Margaret. She stared at it without moving, her eyes moistening. Inside the box were dozens of unopened letters, addressed to Margaret Ellington, from Germany. The postmarks were from the mid-1940s and in the upper left corner of each one, the initials T.J.

Margaret looked at her husband as she would look at a stranger—no recognition, no warmth. Neither one spoke. She slowly pushed the box back toward Allen without inspecting the contents. She stood up tentatively, as if she were stiff and sore. She walked to the sink, rinsed her cup and wiped down the counter top. Then she gripped the edge of the counter with both hands and began to sob quietly. Allen could see her shoulders shrugging up and down from behind.

Still seated, staring down at the table, Allen spoke softly.

"I'm sorry," he said.

• • •

In spring the sun warmed the earth. The Wakeeji River flowed fiercely with thawing runoff and felled timber. Its muddy banks gradually gave way at the outer edges of the curves—forming more pronounced bends in the river's route. Each year's thaw slowly stripped the river of its former directness until it became almost unrecognizable even to those who knew it best.

David Lloyd

DIETY

We don't know where, the father said.
Or by what means. Or to what purpose.

We don't know who or how many,
what color, what shape.

We don't know which words
or if they've been invented.

We don't know when, though some say "always"
and some say "never." We can't repeat

with certainty, the word "certainty."
We can't erase the word "possibility."

We can't hope. We can't despair.
We can't say the name.

We can't not say the name.

THE TOUCH

The father touched the boy
and the boy remembered
and promised to pass on the touch
to his own child, if he could find his way.

Though it burned like a brand,
the boy was proud of its making
and later, in his most intimate moments,
would uncover the scar

as if to say, see, *here is something*
no one else has felt or will feel.
You may touch it.
But you will never understand it.

170

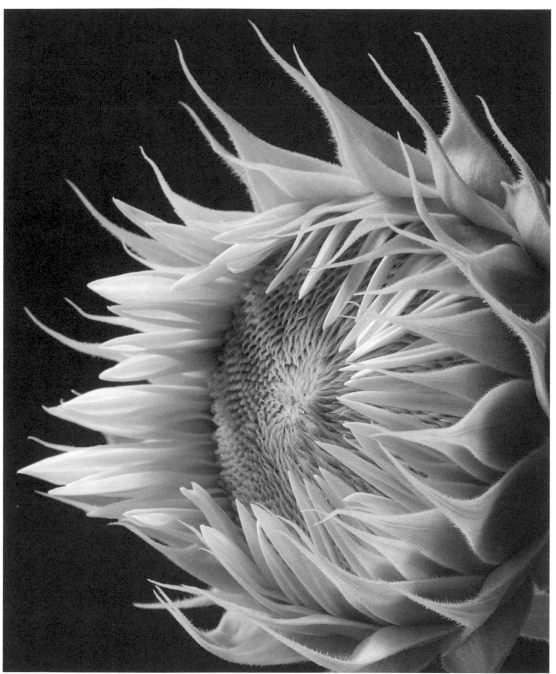

DIANA WHITING, *Sunflower,* black and white photograph, 2006

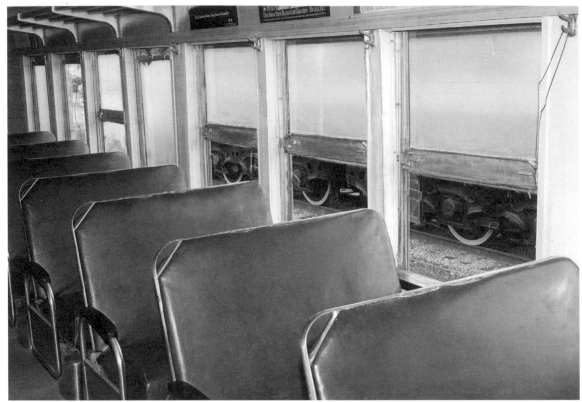

DIANA WHITING, *Days Gone By,* black and white photograph, 2006

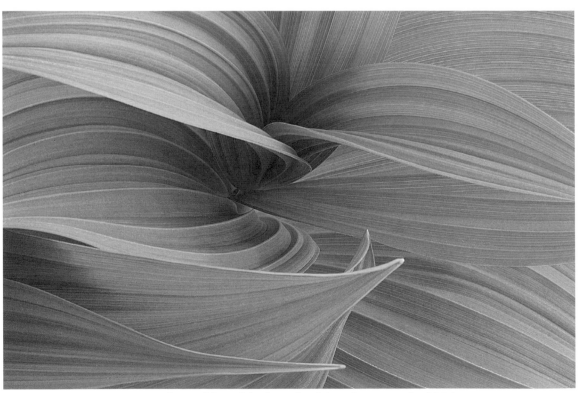

DIANA WHITING, *False Helibore,* black and white photograph, 2006

DIANA WHITING, *Birch Stand,* black and white photograph, 2006

LaToya Ruby Frazier

THE NOTION OF FAMILY: FAMILY WORK 2002–2006

My position and role as daughter, photographer, and filmmaker transcends the objective practice in classic documentary, which has continuously undermined the black family experience by avoiding our emotional and psychological realm.

Photographing my mother, grandmother, and myself is a starting point to understanding my identity and psyche.

Grandma Ruby played the role of mother to me and caretaker to her father, Gramps. Being home consisted of routine checks on Gramps who screamed for help to be picked up off the floor or carried to the bathroom. If we were not tending to Gramps we sat in separate rooms. Family secrets, hidden history, and constant silence defined our coexistence.

The only way I could be with my mother was if I followed her with my camera. Our relationship exists through the process of making images. The deepest feelings she wants to reveal are communicated toward my camera. Her drug addiction is secondary to our emotional connection. When I am capturing my mother I meditate on our difference and sameness.

During my Christmas visit home in 2004 I produced, "A Mother to Hold," a documentary film that intensely reveals the complex relationship I have with my mother. Through the first-person point of view, the camera becomes a magnet attracting and repelling; the viewer has the access to experience and acknowledge our relationship without judgment.

The collaborative development between my family and me, documenting our family life style, illuminates a common experience in marginalized communities. By allowing the viewer access, it normalizes a reality inherent in our society.

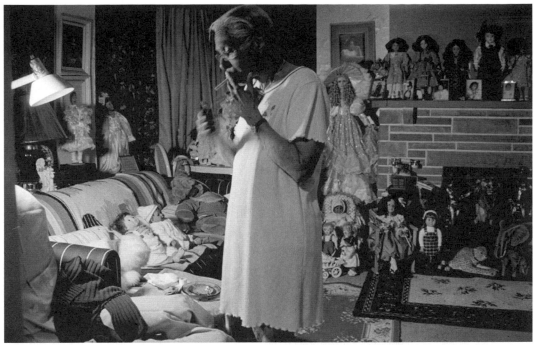

LaToya Ruby Frazier, *Grandma Smoking,* black and white photograph, 2002

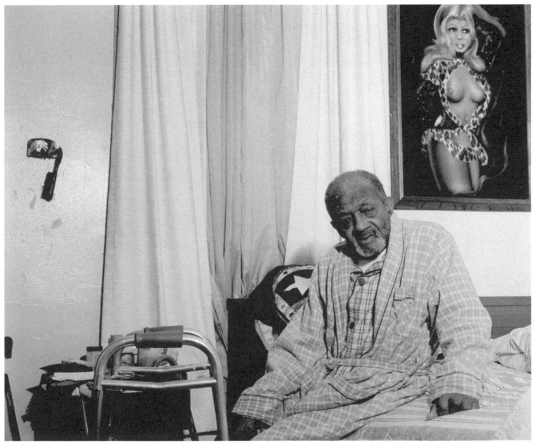

LaToya Ruby Frazier, *Gramps,* black and white photograph, 2003

LaToya Ruby Frazier, *Self Portrait,* black and white photograph, 2002

LaToya Ruby Frazier, *Mom Perming My Hair,* black and white photograph, 2004

LaToya Ruby Frazier, *Self Portrait,* black and white photograph, 2005

LaToya Ruby Frazier, *Grandma and J.C.,* black and white photograph, 2006

LaToya Ruby Frazier, *Mom Smoking,* black and white photograph, 2004

LaToya Ruby Frazier, *Mom and Mr. Art,* black and white photograph, 2005

David Hajdu

THEN LET US COMMIT THEM

The panic over comic books falls somewhere between the Red Scare and the frenzy over UFO sightings in the pathology of post-war America. Like Communism, as it looked to much of America during the late 1940s, comics were an old problem that seemed changed, darkened —an enigma that appeared to be growing out of control. Like flying saucers, at the same time, comics were wild stuff, tainted with the garish aura of pulp fantasy. Unlike both other menaces, however, comic books represented a peril born from within, rather than one originating in a foreign country or on another planet. The line dividing the comics' advocates and opponents was generational, rather than geographic. While many of the actions to curtail comics were attempts to protect the young, they were also efforts to protect the culture at large *from* the young. Encoded in much of the ranting about comic books and juvenile delinquency were fears not only of what comics readers might become, but of what they already were—that is, a generation of people developing their own interests and tastes, along with a determination to indulge them.

Young readers argued persuasively for comics through their dimes. In 1948, the 80 to 100 million comic books purchased in America every month generated annual revenue for the industry of at least $72 million. (The usual cover price was 10 cents, although some digest-format books sold for five cents apiece.) Hardcover book publishing, by comparison, brought in about $285 million, about seven times more, through books priced more than twenty times higher.

In the same year, a few comics readers began to speak out in protest of the crackdown on the books. The most vocal among them was David Pace Wigransky, who was a fourteen-year-old sophomore at Calvin Coolidge Senior High School in Washington, D.C., when he read Frederic Wertham's essay, "The Comics…Very Funny," in the May 29, 1948 issue of the *Saturday Review.* Something of an authority on the subject himself, Wigransky then owned 5,212 comic books. He was a sharp boy and strong willed; when he was four years old, the *Washington Post* reported how Wigransky, "imbued with something of the pioneer spirit," had climbed up the stairs of his family home in the northwest district and locked himself in his parents' bedroom until police came and forced the door open. Offended by Wertham's invective, he countered with a long letter to the *Saturday Review*—one so eloquent that editor Norman Cousins contacted the principal of Wigransky's school

to make sure the language of the document was consistent with the student's usual writing. The July 24 issue of the magazine devoted a page and a third to the letter, and it included a posed studio photograph of Wigransky, a skinny, gravely serious kid with a dark crew cut, wearing a pressed white shirt, poring over an issue of *Funnyman*. A preface from the editor noted, "Although sections of Mr. Wigransky's letter have been omitted for considerations of space, his copy has not been edited." Wigransky wrote, in part:

> It is high time that we who are on the defensive become as serious as our attackers. We didn't ask for this fight, but we are in it to the finish. The fate of millions of children hangs in the balance. We owe it to them to continue to give them the reading matter which they have come to know and love.
>
> Dr. Wertham seems to believe that adults should have the perfect right to read anything they please, no matter how vulgar, how vicious, or how depraving, simply because they are adults. Children, on the other hand, should be kept in utter and complete ignorance of anything and everything except the innocuous and sterile world that the Dr. Werthams of the world prefer to keep them prisoner within from birth to maturity. The net result of all this, however, is that when they have to someday grow up, they will be thrust into an entirely different kind of world, a world of violence and cruelty, a world of force and competition, an impersonal world in which they will have to fight their own battles, afraid, insecure, helpless.
>
> The kids know what they want. They are individuals with minds of their own, and very definite tastes in everything. Just because they happen to disagree with him, Dr. Wertham says that they do not know how to discriminate. It is time that society woke up to the fact that children are human beings with opinions of their own, instead of brainless robots to be ordered hither and yon without even so much as asking them their ideas about anything.

The *Saturday Review* ran pages of responses in issues published through the end of September 1948. Several of the letters discounted Wigransky on the grounds that, as an obviously intelligent boy, he could not be representative of comic-book readers, or that, as a comic-book reader, he could not be intelligent enough to write such a letter by himself. Either way, they tended to support Wigransky's claim that adults did not seem prepared to accept the average young person's capacity for independent thought and discrimination. It was a view that ran deep at the time, even among some parties in the comics-reading generation.

• • •

When the town of Spencer, West Virginia, incorporated in 1858, it took the first name of a beloved county judge, Spencer Roane. It was a neighborly place with an acute regard for justice. In the late 1940s, Spencer had about 2,500 residents, most of them farmers or coal miners and their families, and, each Friday, almost everyone would go to the livestock market, the hub of the community's commerce and social life. Sheep and cattle over-ran the crossroads in the center of the village, an intersection called New California because an enterprising local named Raleigh Butcher once announced that he was heading for the West Coast but got no farther than that spot. "You could almost go from house to house, go into anybody's house without knocking on the door, and if they were having lunch or dinner, whatever it was, you could walk right in, sit right down, and you'd be welcome to eat with them," recalled David Mace, the only son of a couple who ran a small, family-style restaurant called the Glass Door (specialty, the "plate-lunch dinner": one dollar). They lived in a red-shingle house about half a mile from New California, toward Oregon. (The slight similarity of David Mace's name to that of David Pace Wigransky is an odd coincidence—meaningless, but odd.)

"My mother and father worked probably sixteen, eighteen hours a day, and they made sure you were fed and you were clothed," said Mace. "But other than that, I can't honestly say what they thought about anything. They expected you to do the right thing, and it was your responsibility to know good from bad. You were on your own. Of course, most everyone in town agreed with everything that went on in Spencer in those days. It wasn't like things got later on, where you'd have so many different public opinions about everything. We had a nice little tight-knit community. I doubt there was a TV in our community at that time." Television, after all, was just beginning to find an audience. Nine years after RCA brought the technology to the American public, there were only twenty-seven broadcast stations in eighteen cities, most of them on the East Coast and half of them in and around New York City. TV sets—hardwood boxes the size of refrigerators with tiny, roundish, gray screens—were extravagances to be found in only one of every ten American homes, where families could watch rudimentary but high-minded broadcasts of civics debates, lectures, and chamber-music performances for a few hours each day.

Several stores in downtown Spencer sold comic books, and David Mace, like every child he knew, bought them. He thought of them as "thrills and fun," until early in his eighth-grade year at Spencer Elementary School, in the fall of 1948, when one of his teachers, Mabel Riddel, asked him to stay

after class, sat down next to him in a child's desk, and told him that comics had "an evil effect on the minds of young children." Riddel, acting with the support of the PTA, asked Mace to lead his fellow students in an uprising against comics. "She was extremely dedicated—that's the way our school was and the way our teachers were," Mace remembered. "She explained to me about the [harm of] comics books, which I didn't know about. I read 'em, and I never even noticed. The things she had to say made a lot of sense, I could see that, and she told me we could do something about it, and I said, 'Well, let's go!'" Smallish and good-looking, with dark hair (almost black) and blue eyes, Mace was popular and a talker. With Riddel's encouragement and counsel, Mace hit the schoolyard and rallied the upper-class students to join him in a mission to remove all comic books from the homes and stores of Spencer—an elaborate group activity not unlike the games Mace sometimes organized, a scavenger hunt taken out of the playground and into the adult world, ideal for young adolescents beginning to confront the end of childhood and their grade-school years.

For almost a month, Mace led several dozen students in a door-to-door campaign through Spencer. With milk crates in hand or wagons in tow, they urged children and parents to relinquish all the comics in their houses, and implored retailers to stop selling the books. By the last week of October, Mace's brigade had collected more than two thousand comic books of all sorts, from reprints of the Dick Tracy strip to crime comics. The kids brought them into school on Tuesday, October 26, a cool, dry, sunny day, and they piled them on the grounds behind the building. The books made a small mountain about six feet high. At the end of the day, the six hundred children who attended the school emptied into the yard and assembled in a semi-circle facing the comics. David Mace walked to the far side of the pile and stood before the crowd in his best clothes, a white shirt and black wool pants his mother had ironed fresh that morning for the occasion. He put his left hand on his hip, and, in his right hand, he held a sheet of lined paper with some words he had written, with considerable help from Mrs. Riddel.

"We are met here today to take a step which we believe will benefit ourselves, our community, and our country," Mace said. "Believing that comic books are mentally, physically, and morally injurious to boys and girls, we propose to burn those in our possession. We also pledge ourselves to try not to read any more.

"Do you, fellow students, believe that comic books have caused the downfall of many youthful readers?"

The students answered, in unison, "We do."

"Do you believe that you will benefit by refusing to indulge in comic-book reading?" Mace continued.

"We do."

"Then let us commit them," Mace said. He walked a few steps to the pile, took a matchbook from a pants pocket, and lit the cover of a *Superman* comic.

The flames rose to a height of more than twenty-five feet as the children, their teachers, the principal, and a couple of reporters and photographers from the local papers watched for more than an hour. Mrs. Riddel stared with her arms crossed. Several children wept, a signal to those who noticed that not everyone in town agreed with everything that went on in Spencer that day.

When the Associated Press picked up the story, readers of the *Washington Post,* the *Chicago Tribune* and dozens of other papers around the country learned how, just three years after the Second World War, American citizens were burning books. Mace would remember receiving letters of support from around the country, which his mother kept in a cigar box in the kitchen. "She was really impressed when we got all that mail," Mace recalled. "What we did was a pretty important thing at that time, and it put our little town in central West Virginia on the map." Indeed, the Spencer paper, *The Times Record,* covered the national coverage of the burning: "Spencer Grade School Is Famous." Not all the commentary on the event was so prideful, however; as the Charleston *Daily Mail* noted in an editorial:

> The burning of books is too recent in our memories. The Nazis burned them. They went on from there and, in one way or another, burned the authors too. It was the purge by fire of those elements which the Nazi party could not tolerate.
>
> This purge has no place in a democratic educational system. It is not that books as books are sacred. It is just that the idea of burning them is profane. It is a resort to witchcraft when the need is for education, the use of fire when enlightment [sic] is called for. Perhaps the point can be clarified by asking how many of the boys and girls who burned 2,000 "bad" books have read 2,000 good ones? Of the two possible tasks, the second deserves priority.

Images of Third Reich soldiers in black uniforms emptying military trucks full of books onto bonfires endured in American memory. Yet German book-burning actually began with students, young people stirred to act

against literature that they had been led to think of as corruptive to members of their own generation. Worked up to a nationalist frenzy just three months after Hitler assumed the chancellorship, the German Student Association mobilized university students to burn more than 25,000 books advancing "un-German ideas" in Berlin and other cities throughout Germany on May 10, 1933. In the days and months to follow, the student association organized thirty-four more burnings in university towns across the country, and young people chanted, sang, and gave speeches while the fires consumed volumes by authors such as Freud, Thomas Mann, Bertold Brecht, and Einstein. Who better to inspire contempt for the books than members of their intended audience?

In the United States after the war, the incident in Spencer was not singular. A couple of Catholic schools had staged little-noted comic-book protests with ceremonial fires as early as 1945. In November of that year, during Catholic Book Week, nuns teaching at Saints Peter and Paul elementary school in Wisconsin Rapids, Wisconsin, held a competition among students to gather the highest number of "objectionable" comics, as categorized in lists made by the Rev. Robert E. Southard. The boy and girl who brought in the most books were named the King and Queen of a bonfire that consumed 1,567 comic books. (King Wayne Provost collected 109; Queen Donna Jean Walloch, 100.) The event was selective, in its way, targeting only comics that Southard listed as Condemned *(Batman, Wonder Woman, The Spirit, Crime Does Not Pay)* or Questionable *(Superman, Captain Marvel, Archie)*. Spared from the pyre were those Southard rated as Harmless *(Mickey Mouse, Donald Duck,* and compilations of the Popeye and Katzenjammer Kids newspaper strips, comics that had been condemned in their own day. Two years later, in December 1947, students of St. Gall's School in Chicago collected and burned 3,000 comics (including, again, *Superman, Batman, The Spirit,* and *Archie)* in a campaign reported to have been suggested by a ten-year-old fourth-grade girl, Marlene Marrello.

Once the Associated Press spread the news from Spencer, the idea of fighting comic books with fire began to catch on in schools and communities across the country, particularly in Catholic quarters already primed to act on the issue. There were two sizable comic-book burnings in the sixty days after David Mace set *Superman* in flames, both at parochial schools: St. Patrick's Academy in Binghamton, New York, and Saints Peter and Paul elementary in Auburn, New York. Many more would be organized at public and parochial institutions in the months and years to follow. Easy to mistake from the distance of time as the puppetmastery of reactionary adults exploiting

children too sheepish to defend their own enthusiasms, the comic-book burnings of the late 1940s were multilayered demonstrations of the emerging generation's divided loyalties and developing sense of cultural identity. The events exposed the compliance of some young people in the face of adult authority at the same time the incidents fueled the defiance of others.

In Binghamton, the campaign against comics was almost solely the work of an idealistic, willful, and charismatic student, John Farrell. A sixteen-year-old junior at St. Patrick's in the 1948-49 school year, Farrell was the president of his class, as he had been, on and off, since the fifth grade. He was a chunky boy, neither athletic nor conventionally handsome, but a jokester, grand company. He had a broad, toothy grin and a slight underbite that gave him a disarming, comical appearance. In a blue-collar, Irish-Catholic area, where many students' parents (both of them, often) worked in the local factories that manufactured shoes and chemical products, John Farrell was considered well off and cultured; his father was an executive in charge of production at the *Binghamton Press* newspaper, and John dressed and spoke with flair. He rarely dated while he was in high school (and died a bachelor at age 69 in 2001), although boys and girls gravitated to him. Farrell had a knack for vocal impersonations. "He was so damned funny," recalled Paul Plocinski, a classmate who was deeply involved in the comics burning. Tall and sturdy, Plocinski looked like a grown man in his junior year and itched for the freedom of adulthood. "He could imitate every one of those nuns, especially when they left the room. He did it so perfectly, you'd think she was in the back of the room. He was very dignified in his attire, and he knew all about politics, but he used to keep us laughing."

Farrell worked after school as a soda jerk at Crone's pharmacy, a busy, well regarded store appointed with milled woodwork and a 16-foot marble-topped fountain counter. It was a nice environment for good kids to congregate, and it had a magazine rack around the corner from the soda fountain. Part of Farrell's job was to monitor the rack to ensure that a customer paid for a magazine before sitting down at the counter to read it. One of Farrell's friends, Joseph Canny, whose family lived a block away from the Farrells, would sometimes keep John company at Crone's, and even he was granted no free reading privileges. "John was a well-read fellow, and he knew that comic books were controversial," said Canny. A year younger and a grade behind Farrell in school, Canny was a bookish kid, one of three second-generation Irish brothers whose father had died in an odd accident, run over by a driver at his own trucking company, when Joseph Canny

was nine. "It started to bother John that Crone's was making every kind of comic book available, with no discrimination, and John was in a position to watch the reading habits of his clientele. He started to notice that the more troublesome kind of kids were more inclined to read comic books, and some of [the books] were pretty rough stuff." Farrell took up the matter with his boss, Ken Crone, but found him unmoved. "That's when John decided to take the initiative, on his own," said Canny. "He was sincere. John was a religious guy, and he was irritated by all these comic books and the content in a lot of them. The thing was all John's idea, and he had the support at the school to make it happen."

St. Patrick's Academy was a spartan Catholic institution housed in a boxy, three-story red-brick building dressed up with a few gothic flourishes: a pair of ornate spires jutting high above the turreted front roof, and an opulent, arched entrance for faculty and guests. Students used the side doors, the left for boys, the right for girls. The cafeteria provided tables and a drinking fountain, but no food, and the basketball team, which was often good, played outdoors, because it had no gym. All the teachers were sisters of the Order of St. Joseph. Each class had about thirty students, most of whom spent thirteen years, from ages five to eighteen, together. Like many of the Catholic schools in some 7,700 other parishes in the United States at the time, St. Patrick's fostered mighty feelings of loyalty, pride, exceptionalism, paranoia, and restiveness. At the end of the school day, so many students lingered together in the halls of St. Patrick's or stayed in classrooms, talking to the nuns, that the Mother Superior, Mother Anna Frances, had to shoo them away.

"It was very intimate—we knew one another personally, and everyone seemed to be involved in whatever was going on, because of the size of the school," recalled Monsignor James D. Kane, who was a classmate of John Farrell's, took part in the Binghamton comics burning, and went on to enter the Catholic priesthood. "It gave us a *good* education," said Kane, emphasizing the word "good" to distinguish it from both "poor" and "excellent." The local public schools, by contrast, were not as good, in Kane's view. "The others were no better, certainly, although the kids in the public schools treated us like second-class citizens. I don't think they liked what we did, most of the time. But we did what we thought was right, regardless of what they thought."

St. Patrick's, the largest of Binghamton's ten Catholic churches in 1948, served about 2,500 residents of the west side, a predominantly working-class community of first- and second-generation immigrants, most of them of Irish or Slovak stock. One neighborhood in the area was essentially owned by

Endicott Johnson, the shoe manufacturer, which built solid little A-frame houses for hundreds of its employees and deducted low-interest mortgage payments from their weekly paychecks. (Paul Plocinski grew up in an "Endicott house" and recalled it as "wonderful and beautiful.") In the first decades of the 20th century, Binghamton served as the New York State headquarters for the Ku Klux Klan. By 1948, the Klan's legacy was numinous, although the climate of Binghamton remained "fairly judgmental," in the view of Monsignor Kane. "We Catholics were sometimes the target of that," Kane said. "That's one of the reasons we stuck together."

The first phase of Farrell's campaign was a coercion strategy to purge Binghamton stores of objectionable comics. Working under Farrell, students in the four high-school grades of St. Patrick's set out to visit every Binghamton store and newsstand that carried magazines—Murphy's cigar store, Grant's ice-cream shop, Smith's pharmacy—and to press each of the owners they met to sign a four-by-six index card carrying this pledge: "I will support the drive to end indecent and objectionable literature, comic books and the like, by withdrawing them from my newsstand, and will do all in my power to stop their sale." Dealers who declined were told their stores would be boycotted by the students.

The tactic challenged students as well as the business people they were charged to confront. "We had to go around to all the stores—dime stores, any place they sold magazines—and make sure that they didn't sell comic books anymore, and it was unbearable," said Plocinski. "Instead of going home, we had to go to these stores and see how many [vendors] we could get to sign this petition. The storekeepers were shocked—they never heard of such a thing. It was a very difficult thing, but we did it because we were expected to, and we thought we were doing a good thing. But, to tell you the truth, I wasn't completely sure about that." Once, Plocinski picked up a comic to show a dealer an example of the kind of books the students were protesting, and he purchased it, thereby removing it from the shelf. He then took it home and tried to hide it, only to find that the spot under the living-room sofa cushions was already taken; his father was keeping his detective magazines there.

News vendors, riled and unsure how to handle this unusual pressure from youthful ranks, complained to their local magazine distributor, Abraham M. Pierson, owner of a company called Southern Tier, who reported their distress to the *Binghamton Sun,* the competition to Farrell's father's paper. "I know a lot of dealers around here were getting worried about the kids asking them to sign cards [and] one fellow told me that he was really sore

about the thing," said Pierson. "One fellow was going to throw the boys out." (There were as many teenage girls as boys involved in the campaign.) Still, Farrell and his troops elicited pledges from thirty-five Binghamton retailers.

St. Patrick's students boycotted the rest, including the student's favorite after-school hang-out, Smith's, which was across the street from the school on Oak Street. "We were very serious," explained Vincent Hawley, a freshman at the time. A quiet, earnest boy, Hawley entered St. Patrick's in the fourth grade, when his family moved eighteen miles north from rural Silver Lake Township, Pennsylvania, where he had attended a one-room schoolhouse. "We were determined to boycott all these places that were selling these things until they took the comic books off the shelves, and one of the places was the most popular place where we used to go. We were so serious we even made periodic checks to make sure our own students were upholding the boycott, and one day after school, we went over to Smith's—we just stood outside to remind the owner of all the business he was losing, and while we were there, one of our students walked out of the place. Three hundred ninety-nine of us were boycotting the place, and only one kid defied the boycott. When he came out, one of the kids jumped him, and it turned into a huge, big fist fight. We were serious."

For several weeks, St. Patrick's students barnstormed the sidewalks of Binghamton's west side, collecting the materials for the climax of their campaign, a public burning. "We were crusaders," said Hawley. "We all read the comics—the comics were huge! But I separated the good ones and the bad ones in my mind. The hero comics were good, and then there were the other ones. The ones that we were trying to eliminate were the bad ones. We weren't against comics per se, but how some of them were being used. Like all crusaders, I was a good guy who wouldn't do the bad stuff. But there was this bad stuff out there that we thought we should do something about." Hawley and his fellow crusaders so embraced superhero comics' ethos of eradicating evil that they employed it against other comics.

To Paul Plocinski and some others he knew, however, the distinctions between differing comics or between the comics' form and content were vexing to parse. "I had been trading comics for years," said Plocinski. "I had stacks of them. The drawings were really artful, very much so—the artwork was wonderful. We thought we were doing a good thing by collecting the comics and conducting this protest, but it gave me a pain in my stomach. I was torn up inside, and I wasn't the only one."

The day of the burning, Friday, December 10, was cold and gray. Mother Anna Frances ended classes early, at 11 a.m., and released the entire student body of about 560 onto the playground behind the school. To document the occasion, someone set up a stepladder and took a photograph from the top, moments before the fire was set. Published in the 1949 St. Patrick's yearbook, the picture shows a group of eight students—Plocinski, in the center, dressed nattily in a dark wool coat and a white scarf, flanked by three other boys and four girls (none of them Farrell, who presumably was standing on the photographer's side of the scene). The kids have shipping cartons for Rice Krispies and Ivory Snow full of comic books, and they are emptying them into a deep stone kiln (customarily used for burning the school's trash). Behind them, we see a mass of children, many of them early grade-schoolers, bundled in coats with hoods, zippered tight, or wool caps, in gloves or mittens. One boy on the far right is shoving another to make sure he gets in the picture. A small fellow in the front row, wearing a one-piece snowsuit, has his legs spread wide apart, planted to hold his position. In the second row, a boy too short for his face to be photographed waves a cross in the air with his right hand. Most of the faces are smiling; a few brows are furrowed; only two or three young children look afraid.

With a few hundred comics in the kiln, a Sister Lucia, Farrell's chief ally among the nuns, lit the books. Then, as the fire began to rage, she led the students in singing the St. Patrick's alma mater and "The Catholic Action Song," ending with the latter's chorus:

> *An army of youth flying the standards of truth*
> *We're fighting for Christ, the Lord*
> *Heads lifted high, Catholic Action our cry*
> *And the Cross our only sword.*
> *On earth's battlefield, never a vantage we'll yield*
> *As dauntlessly on we swing*
> *Comrades true, dare and do, 'neath the Queen's white and blue*
> *For our flag, for our faith, for Christ the King*

Farrell and his compatriots kept the fire stoked, tossing in more boxes of comics, for four hours, while all the students of St. Patrick's watched. The flames stretched as high as thirty feet. By three o'clock, when the children were released, the group of onlookers had multiplied to include many of the students' families and neighbors, as well as church leaders and members of the local press.

"I remember it very vividly," said Joseph Canny. "I watched them burn it all up, and I thought, 'This is really something!' I thought it was good—I thought it was a good thing, and I was impressed that John had been able to pull it off and get that many people out into the back of the school to witness this incident." Through the Associated Press, again, news of the comics burning at St. Patrick's made newspapers around the country. "I had no idea at the beginning that it would turn out to be such a big thing," said Canny. "I was really proud of John."

The Catholic Sun, a diocesan newspaper published in Syracuse, New York, commended the St. Patrick's students not only for bringing their song of "Catholic action" to life, but for carrying it across the country:

> The action of the St. Patrick's pupils earned deserved national recognition. It was a public protest. It was a dramatization of a very present problem. It does call for a sincere and sustained response from responsible leaders in the publication business. It does declare that the menace of the comics is not mere theory....The students of St. Patrick's are to be congratulated for they have earned the respect and regard of every good American.

The only public dissent came from magazine sellers watching the dime bins of their cash registers. As the *Binghamton Sun* paraphrased distributor Abraham Pierson, "banning books should not be left up to a group of high school students," because authority on the matter "should be given only to those acquainted with the problem." In essence, the complaint was consistent with much of the criticism of young comic-book readers, faulting the St. Patrick's students not for their views, but for daring to have any, one way or the other. Pierson made no claim that John Farrell and his group acted unfairly, illegally, or unethically; he never challenged them for being wrong, but only for being young.

Two days after the St. Patrick's bonfire, on Sunday, December 12, the bishop of Albany, Edmund F. Gibbons, called for a diocese-wide boycott much like the one the students had imposed in Binghamton, dispensing with the gesture of first calling for pledges by the businesses involved. Bishop Gibbons issued a letter to be read at all masses that day, which said, in part:

> "Another evil of our times is found in the pictorial magazine and comic book which portray indecent pictures and sensational details of crime. This evil is particularly devastating to the young, and I call upon our people to boycott establishments which sell such literature."

Less than two weeks later, three days before Christmas, *The Citizen-Advertiser* of Auburn, New York, a small city about sixty miles northwest of Binghamton, reported that the students of a local Catholic school, Saints Peter and Paul, took "quick action" and made a "huge bonfire" of comic books collected by students acting under the direction of the principal, Sister Boniface. Praising the action in an editorial, the paper noted, "This action follows that taken elsewhere in many parts of the country by other irritated parents and authorities," reinforcing that the event was not necessarily an expression of all the students' points of view.

"The holidays came, and everything was wonderful," said Paul Plocinski, "except every time I saw a fireplace burning with the Christmas stockings hung, I thought about that bonfire and all those comic books, and it made me sick. I started to get angry, and really wished we hadn't done that. 'Burning things!' I said to myself, 'I'm never going to do that again,' and went out and bought myself some comic books." Plocinski would always remember the day during Christmas vacation when he walked alone to Smith's shop, ventured tentatively back into the forbidden place, and picked out a comic from the rack. (The title would escape him with time.) "I put my dime on the counter," Plocinski said, "and I don't know what I said—probably, 'Thank you very much, sir.' But I know what I was thinking—'Take that, John Farrell!'" Plocinski walked home with the comic book rolled tight in his back pocket and tucked under his coat, so no one would see if he bumped into anyone from school.

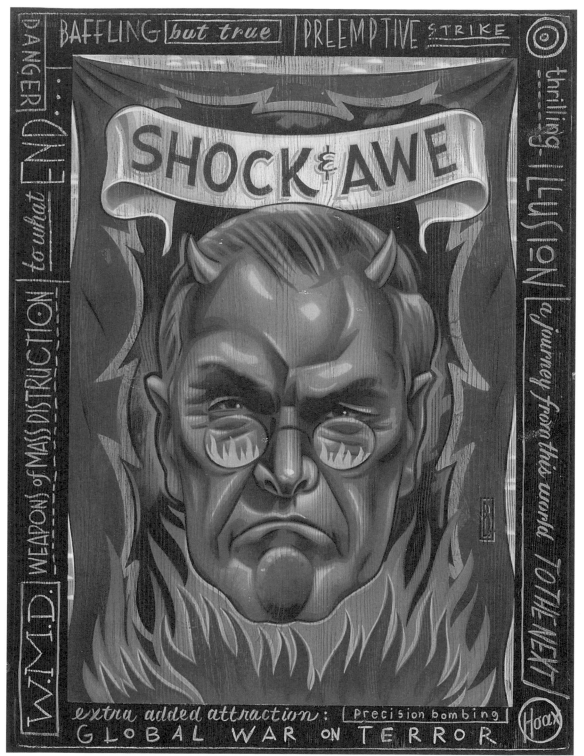

MARK BENDER, *Shock and Awe,* acrylic on wood, 2006

MARK BENDER, *NRA*, acrylic on wood, 2005

CHRISTOPHER GRAY, *Collage Vote,* color photograph, 2004

CHRISTOPHER GRAY, *New Orleans Ensemble,* color photograph, 2002

William Neumire

This year crows outnumber citizens seven to one
so there's a hunt to see who can even the numbers.

For proof you must hang them upside down
on your clothesline like funeral jackets.

A judge will be along shortly
to tally your score.

The winner receives dinner for two at the new
restaurant with the red and black awning.

There will be an interview
and the mayor will show up at your house

beyond the curtain of wings
to shake your hand, and ask how

long you had to hide in the brush
for your chance at fame.

He won't ask if you felt justified
after watching them eat the guts

out of a paralyzed squirrel; certainly
he'll keep quiet about his own hunting.

Ultimately, he'll thank you for the greater good
your murder has done the community.

Even though you've never considered murder,
or the community, you'll appreciate the chance to remember

threatening the whole sky from your ambush,
eating cold and the space betweeen stars,

telling yourself the story of the dead,
not really waiting at all.

A Solatium on the Equinox

Once at the end of March, a wren flew overhead
 and struck the bay window. A friend
picked up the stunned bird
 in one ungloved hand and said,

> *My father showed me*
> *a trick: if*
> *you squeeze like this*
> *it'll make the prettiest song*
> *you've ever heard.*

When he milked that minstrel I could hear
 sheets of snow breaking in the coming heat,
and above that sound the promised voice,
 undeniably sweet, yes, sweeter than Brahms,
and it swam into me like a song I should have been singing.

Paul B. Roth

MISSING REMAINS

All the gentle ones
have left the earth.

At first we noticed
simple gestures
missing:

A silver ring
not spinning
to a stop
on a formica countertop.

A vent's heat
not wagging
sheer hand-towels
back and forth
from their bathroom rack.

A fork shadow
not resembling
the ripple
a crow's wing
carves in new snow
at take-off.

All the gentle ones
have left the earth.

They take
nothing with them
yet never once
with their free hands
wave goodbye.

Charles Martin

THE FLOWER THIEF

At last he struck on our block and snatched
Geraniums out of the flowerpots
And window boxes we had left unwatched,
Plucked the plants whole, took flower, stem, and roots,

Danced down the street in glee and merriment,
Every so often letting out a whoop,
Aspersing us with soil mix as he went,
Until he settled on an empty stoop.

And there gazed on his prizes, fascinated
By something in them only he could see,
While those who called the local precinct waited,
Watching him with or without sympathy.

He learned the essence of geranium.

We learned that the police don't always come.

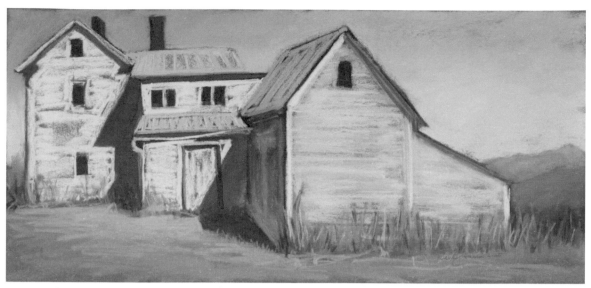

WENDY HARRIS, *Empty,* soft pastel, 2005

WENDY HARRIS, *Bad Girls' Café,* soft pastel, 2005

LEWRAINE GRAHAM, *Tree Line*, triptych, oil on hollow core door panel, 2003

LEWRAINE GRAHAM, *These Fields*, oil on hollow core door panel, 2002

ANNE NOVADO CAPPUCCILLI, *Emergence/Submergence,*
mixed media on canvas, 2004

Jakk Glen III

A TATTOO'S STORY

I have a tattoo and it tells a story.
My tattoo says "Jakk" with two k's
You're supposed to spell it with a "ck," but not me
That's how my father spells it
And how my grandfather spells it
My grandfather is an old, mean, selfish drunk
I don't see any of him in me
Not one bit
My father also spells it with a "ck"
But once again, not me
My father is a dead-beat dad
A drunk, a drug addict, abusive, a liar, and much more
So, I don't see any of him in me either
That's why I spell my name differently
The only thing I got from my father
Is my physical strength
Everything else comes from my mother
Maybe I should change my name to Brenda
Like my mom

Duriel E. Harris

ENDURING FREEDOM: AMERICAN DOXOLOGY
October 7, 2001

And what I assume you shall assume
For every atom belonging to me as good belongs to you.
 —Walt Whitman, "Song of Myself"

I am the hate that I oppose
That which I am not is naught

I am the chain of acts, of generations
I glorify myself and do not waver

For I am might
I shall be magnified

My enemies are as but dust
I wash from my feet

Fall on thy face
Bring of thyself to slaughter

For here am I
Stone seat of holiness

Awful in my killing clothes
Magnificent and melodious

Bad Breast: Self Portrait as a Wire Mother

Observe the emaciated brown body
pocked with udders and mites, the thirsty sack
dress, poorly hemmed, the mother stain
pattern, the bacterial gauge.

Postulate:
Impatient knocking, hooves trampling the solid core
door. Cameras roll down into the house. A vacuous crib
lurches into present detail.

Naked yellow-brown baby, newly sleeping
a dense rasping sleep. Behind you, a woman
in labor, midway, gathering her purse
and essentials: petrolatum lip balm, mirror,
rescue inhaler. Heading out in alarm.
More are coming.
More than one crammed into the petite frame.
More babies' pod-like fists and gummy mouths
dribbling into the bright room, arias bounding
to bright yellow windows' stucco arches.

The cluttered room plush with everyday
use and dust peaks at 104 degrees, coaching
an electrode claw, intravenous itch.

You hold the heavy head against you
and smudge its saccharine breath against your breast.
The second baby dies; the third retreats into sterility.

Wendy Gonyea

FOUNDATION

They were waiting for me there
At Tommy Porter's store
On the shelf near the Confederacy bags and hats
They were soft and new, with some beads on them.
They were
My first pair of moccasins.
They fit just right.

Like a child I was anxious to wear them.
I kept them in the special place with the works of art made by my children.
Wood carvings, ceramic sculptures, dolls, even a big-eyed fish puppet.
They waited to be worn.

The time for ceremony came.
Hurry and get ready.
Put on your Longhouse dress.
The Elder brothers are already coming down the road.

I joined the solemn procession.
My moccasins followed Confederacy Chiefs and Clanmothers
The ones holding the words of our ancestors, the ones preserving us.
Our ancient ceremony came alive by the edge of the woods.
Time stood still.
Feathers moved when the wind stirred.
Birds circled above.

The earth was soft beneath my feet.
I could feel all her contours.
Grass, soil, pebbles, and life itself.
I stood there, connected.

My moccasins are no longer new.
They walked with me.
They danced.
They are waiting to be worn again.

Enemies No More

I mustered the courage to ask about his injury.
He didn't talk about the war.
He rolled up his pant leg showing the round scar on his pale leg—the color
 belying the brown hands, face, and ears visible to me since childhood.
He didn't say anything.
He didn't need to.
I knew the story. He was hit when he parachuted out of a plane going down,
 in a land so far away.

His crew called him "Chief," although he never was one.
It was common for Indians who went off the territory to be called
 Chief back then.
He was a young man, already a father himself, when he went to war.
In the scar I saw a visible reminder of pain, terror, and loss. I saw the
 darkness many find hard to shake.
There were invisible scars too, I'm sure.
That would explain the years of alcohol and escape.
He had lots of friends who must have had their scars too.

So when I sat in a beautiful, serene Japanese garden on a visit to shrines
 and temples in sacred Japanese places
I thought of the scar.

My Dad's been gone a long time
But some images are vivid.
They stay with you till it's your turn they say.
I grew up knowing they were the enemy.
He fought a war with them.

I was at peace in that place
I hoped that he found it too
for we are enemies no more.

W. D. Snodgrass

Snodgrass Revises

THE DISCREET SPOILS OF A REICHSTAG FIRE

Those who do not learn history are doomed to repeat it.
 —Santayana

No accident, no natural catastrophe
Advances our goals. Flash floods, storms, earthquakes—
These could elicit short-termed sympathies and make
Born strangers think they could be friends. Obviously,
No survivor, although injured, craves retaliation
Against what their god disposes or an impartial
Nature. Intent to damage: nothing else welds us all
In icy hatred toward some alien foe or nation

As yet unspecified—one, though, blessed by resources
We aspire to, or bases situated to attack
Whoever has. One major provocation is some lack
Of up-to-the-second weaponry or well-trained forces.
You can make much, though, of obscure threats: forbidden
Stores of nerve gas, maps drawn up for chemical or germ
Assaults. Herr Goering said, "Red sympathizers—we have firm
Proof—keep high explosives stockpiled and hidden."

Your first shift is to demand from your Reichstag a Decree
For the Protection of the People and the State;
When that's choked down, a second Law to Alleviate
The Misery of the People, called familiarly
The Enabling Act—so finessing the suspension
Of free speech, press, and assembly while condoning
Search, seizure, opened mail, tapped wires and phones
Or wounds obtained in unlimited "protective detention."

The Reichstag shelved, you can look with calm contempt
On schemes subjecting your designs to higher order
Or outworn treaties. No land on this earth has a border
Or air space sealed against your clear right to preempt
And set right. If you feel irked to jail or execute
Those you've conquered who still spurn your commands,
One triumph can still console you: in your homeland.
Your least wish is law and your whim absolute.

—February 2006

THE DISCREET ADVANTAGES OF A REICHSTAG FIRE
Those who do not learn history are doomed to repeat it.
 —Santayana

No accident, no natural catastrophe
Can advance your mission. Storms, earthquakes,
Or flash floods can stir up short-term sympathies, making
Mere neighbors believe they could be friends. Obviously,
Victims of those disasters will crave no retaliation
For what their god's determined or an impartial
Nature. Nothing but willed injuries can secure us all
In rancor dead-set against some alien folk or nation

As yet unspecified—one blessed, though, by resources
You aspire to, or bases situated for attacking
Those who have. One reassuring factor is any lack
Of the latest minute's weaponry or well-trained forces.
Make much, though, of some obscure menacings: forbidden
Stores of nerve gas, plans drawn up for chemical or germ
Assault. Herr Goering said, "Red sympathizers—we have firm
Proof—keep high explosives stockpiled and well hidden."

Your first stroke is to require from your Reichstag a Decree
For the Protection of the People and the State;
Once that's locked in, a second Law that Alleviates
The Misery of the People, though termed officially
The Enabling Act—mitigating thus the suspension
Of free speech, press, and assembly, while condoning
Search, seizure, opened mail, tapped wires and phones
Or wounds acquired in limit-free "protective detention."

The Reichstag silenced, look down with a calm contempt
On schemes subjecting your designs to higher orders
Or outworn treaties. No land on this earth has a border
Or air space sealed against your clear right to preempt
And rectify. You may be forced to jail or execute
Some you've conquered but who still thwart your commands;
There's one triumph can console you: in your homeland
Your whim is law and your least wish absolute.

 —April 2006

Leah Zazulyer

STEALING FROM A DEEP PLACE

In Guanaguato Mexico,
city on UNESCO's list of
historic and stunning sites—
despite the perfuming sway
of lavender jacaranda trees
the hills of yellow sempasuchi bushes
and the terra cotta tiled patio—
it only took two terrific margaritas
and five minutes of Iraqi war news
for our fearless, laid back
take-life-as-it-is-guide
to retreat to remembering his
stint as a lieutenant in Vietnam
training them to use our weapons:

"Well we had three kinds of grenades,
a red, a white, and a blue…
Wouldn't you know one day two kids
picked up one of the white ones,
which was the worst of them.
Bingo.
It shredded their faces.
I mean just shredded them.

"Well you know I'm six-foot-four,
but when the mother threw herself
around my legs, that little bitty woman
held me so tightly I couldn't move.
She was sobbing and screaming and begging
for me to save her kids.

"Well of course I wanted to shoot them.
It would've been the kindest thing to do
but I couldn't in front of her,
'cuz she didn't really understand
and I couldn't explain it—
even if I could've spoken Vietnamese—
there was simply nothing I could do
to save those kids.

"Well what DID we do?
We shot them up with
a whole lot of morphine
and left. I mean, war is war."

Leah Zazulyer

Vi Lebedike
(Like Living)

On the secondhand table—
desk, eating place, and library,
the elderly emigrants from Odessa
had given over the center
to a tall bouquet of silk flowers
purchased with its green glass jar
at a garage sale next block.

First thing and with ceremony
they introduced me to it
like a long lost relative
just rescued from a pogrom...

I thought immediately of the huge cement urns
either side the Metropolitan Museum's entrance
endowed in perpetuity with flowers so fresh
they look like Renaissance still lives...

"C'is shane," he sighed in between
my struggles with Yiddish-complemented verbs,
"Vi lebedike," he marvelled in a voice
thick with their imagined fragrance,
but eyes trying not to cry.

Yes, beautiful, I agreed, and explained
the idiomatic "looks real," as we traded
flower names back and forth
between the old and new world.

Tea, kugel, and her remembering again
the garden they'd had to leave,
each flower and fruit tree unbearable
in memory, and the sea mere blocks away
pounding through her weak heart, again...

I already knew why old Jews
followed their kids and grandkids
to cold cities in alien languages,
left tree ripe apricots for food stamps,
gave up everything for family and faith—
and tried to console themselves with democracy.

I only began to understand—
that a great big fake bouquet
had become a barricade
a border guard forbidding each's
everlasting bewilderment
from crossing over to the other,
a silken jungle, a no man's land,
a free zone, where tears
they didn't allow themselves to shed
were still alive but could hide
in that small shoddy SSI apartment
where they grow ever more aged
while their kids grow ever more American

and as beautiful as they are
they're only like living.

Laurie Stone

THREADS

For a number of years, I worked for a catering company. One night we did a wedding on the Lower East Side in a venue that had once been a synagogue. It was near Cannon Street, where both my parents, by coincidence, had lived as children. According to my father, the street you grew up on sent you off like an arrow. There were socialist streets, merchant streets, and gangster streets. My father left school after the ninth grade and at fourteen became a traveling salesman, selling ladies' dresses in New England. A cousin of his became a member of The Purple Gang, he told me, flashing a rakish, Clark Gable smile. It sounded juicy to a kid in the suburbs.

What were my parents doing on Long Island? They moved for their children, they said. My father commuted to his business on Eighth Avenue, manufacturing girls' coats. We lived near the ocean, and the surf, alone, spoke to my father. He liked to swim parallel to the shore and come out smelling of brine. He'd bound from the waves and whip his head so the water arced off like a pitch over home plate. He'd "play the ponies" some Sundays, driving to a track in a nearby town. But the city stuck to my parents like gum under their shoes. Weekends, they'd take long, long hikes with some sort of errand or meal as a destination. Really, it was to be in the whirl.

When we first moved to Long Beach—I was nearly eight—I heard its song. Our small weekend cottage was converted into a year-round house, and I could ride my bike wherever I pleased. I had a best friend with a dog and an easy-going, cooking-baking mom. Linda and I played in forbidden houses under construction and in the canals near my house, with their radical smells and horseshoe-crab armies. If the street you grew up on sent you off like an arrow, where was I headed? I took to striding up and down the length of the town, feeling lonely and chased, though restored by the march. Who knew why?

The Purple Gang, I later learned, were exceedingly violent Jewish thugs who terrorized Detroit in the days of prohibition, first as vandals in their neighborhood, then as hijackers and bootleggers running booze down from Canada. During their peak years, they recruited members from Chicago, St. Louis, and New York (the cousin), and were responsible for some 500 murders. They were brought down in the late 1920s when Italian mobsters cooperated with the FBI and when one of their own testified against the leaders during a trial for a horrific massacre. Among the kingpins were the

Bernstein brothers—Abe, Ray, and Izzy; Harry Fleisher, Abe Axler, and Phil Keywell. Phil's brother Harry managed to snake past peril. After serving thirty-four spotless years of a life sentence, he was released in 1965 and he found a wife, a job, and a rabbit hole out of history.

Jews became gangsters in America because they'd been gangsters in Europe, famously depicted in Isaac Babel's stories about Benya Krik, the king of Jewish gangsters in the mythicized Odessa of the author's youth. Jews became gangsters, too, as a way to be American, to ante up to other ethnic tribes and get a leg up on success. The gangster figure acquired noir appeal from the movies. Symbolically, he remains a tough little guy, a striver, a scrapper. He preys on the weak, but his crimes cannot be as encompassing as the pogroms, concentration camps, and gulags authorized by governments. To a kid in the suburbs of the '50s and '60s, the image of a lawless, danger-courting Jew was exotic. My parents had put up with street taunts and other discrimination, but on my landscape of well-off Jews, there was no risk in being one of them. Bigger stakes, I'd discover, were in the kind of female I could become: protected or unprotected.

The floors of the former synagogue where the wedding was staged were splintery and creaky, the staircases steep and rickety. Plaster flaked from the walls. There were no banisters and not a single straight angle in the place. Going up and down between floors called for gymnastic concentration. But the place was beautiful, with a vaulting, domed ceiling and a romantic mezzanine that looked over a ballroom festooned with gauzy silk curtains and twinkling votive candles. It was easy to imagine earlier weddings here and the days when my parents had run around the neighborhood as kids. It was cold outside, the gutters mounded with crusted snow, the air blue with ghosts playing handball against brick walls. Fine, dry snow swirled over frozen streets, keeping its form, like fake snow in department store displays. I could see my grandparents bustling along, their hands chafed, twisting through pushcarts selling hot chick peas—*heise arbis*—and roasted chestnuts. The salted, greasy peas were scooped into paper cones and secured at the bottom with a pert twist. The chestnuts nestled in coals that cooked inside metal braziers, the shells becoming black as beetles, little tongues of flame dancing up and down them like a bow over violin strings.

I saw my father slapping a hard black ball against his palm and sweating into icy air, impatient to pitch himself into the world. He doesn't come from the street of learners. They will go to City College and their sons will become college professors and doctors and lawyers and their daughters will raise the children of such men and teach them to use the right fork for eating fish.

They will have cooks who know how to galantine a capon, layering the boned sack of flesh with nuts, fruit, spinach, and eggs, a color for each season of the year. They will hire workers to sweep up snow that doesn't melt. My father will don a camel's hair coat and a furred fedora with a wide brim and look like John Garfield (born Julius Garfinkel), a guy on the make who could play a gangster in the movies, a Jewish gangster, muscular, short, and compact. Except my father's job isn't hurting people. He has the same eyes as my dog, Russian Jewish eyes that laugh and cry simultaneously and high brows that can't be shocked. My father will work out every day. His body will smell good as it slips among other bodies, smoothing down a back to fit a dress, tugging smartly at a hem to make the garment lay right, his clean smell arriving first, clearing a path. Before they know what has hit them, people will want to buy things, and my father will collect the dresses and coats and place them tenderly in tissue paper, as if laying a lover onto sheets, and he will circle the box with twine and attach a handle so they can carry it like a little suitcase. He will shave the price, wave them away, say, Wear it in good health.

His daughter will learn how to galantine a capon and sweep floors, though not from my mother. She didn't expect her children to do housework. I was never asked to make a bed, prepare a meal, wash a dish, vacuum a floor. She didn't think children were brought into the world to labor at these tasks.

The bride and groom were young and easily pleased. It was a Jewish wedding, and there were excesses of food. Beautiful, catered pyramids prepared by a hive of chefs in white jackets: Asian and Mexican fare, a raw bar, a caviar station, and an expanse of deli meats as long as a block. The guests swanned gracefully between the tables, arranging moderate portions on plates. No drunken uncles with toupees askew groped teenaged girls or boys. No tipsy grandmothers in acid yellow wigs needed to be propped up on skittering heels. Still, it wasn't a WASP cocktail party or British high tea. A version of the "beslobbered breasts" and "blobs of rampant, sweet-odored human flesh" that Babel describes in an Odessa wedding scene managed to seep out, molecule by molecule, from the synagogue's ancient patina.

I worked there from three in the afternoon until one in the morning. The service was arduous, up and down the steep stairs, balancing heavy platters for the buffet stations, crouching and dipping back to the basement. The breakdown was sloppy, walking and walking, clearing and scraping, hauling and hauling. I liked using myself this way, although I worried that I enjoyed abjection. I needed money. I could have taught or hunted for more writing assignments, but I preferred this. The foxhole humor and camaraderie of the actors and chefs who largely populate this world offered relief from searching

for words, though when I thought about friends who were living just by their creative strokes, my head would go on fire.

This night, though, there was something sweet about *schlepping* near where my grandparents had been *schleppers*. One grandfather had been a sewer, the other a presser. The presser I knew, my father's father. I didn't like him much. He was remote or zenned out. He had the still, satisfied look of a chimpanzee smoking a cigar. The other grandfather was dead by the time I was one. There is a picture of him holding me and smiling, his skin yellow in the glare of bright lamps. He has a wide, Slavic face—my mother's father—with a Stalin mustache, but warm, like his blazing skin. He looks like the grandfather who would have put his face up close and I wouldn't have minded.

My father didn't come from the street of learners, but he pitched me toward them, to a prep school where the parents of my classmates employed cooks and maids. They had Gatsby money. They were all little Gatsbys or little Daisys and Toms but Jewish. Jewish Daisys who could run you over accidentally in the Jaguar they'd received for a birthday. I stood next to them in the locker room and studied their underwear, their shoes, their slouches, the turned-out angles of their feet, salt water and chestnuts sloshing in my head. When my father died, he left me nothing and I took it as a gift.

I cleaned the kitchen, filling 40-gallon garbage bags and lugging them to the door, wiping down yards of steel counters, sweeping tiled floors. After waiters took the leftovers they wanted, I dumped the rest—enormous quantities, hideous waste. For myself, I packed pounds of thinly sliced corned beef and brisket, the kind of lean, dense delicatessen meat my mother used to buy on weekends. Stacked up in columns, it looked like money printed with the faces of my family.

Two young women—the party planners—stayed late with our crew, boxing ornaments and vases that had decorated the tables. They were responsible for transporting the unused liquor as well as presents people had brought—a considerable load. A van pulled up as we were carrying out the garbage. We ferried the young women's boxes to the driver who loaded the vehicle. The cartons overflowed onto the backseat, leaving only a small space for the planners and an empty seat up front beside the driver.

He had a lean, hawkish face with a thin nose and shrewd eyes. He wore a wool cap and spoke with an accent I couldn't place. His van was immaculate, and he was precise in organizing it. I don't know why, but I asked where he was going. It turned out to be close to where I lived, north and west of where we were. My shopping bags were heavy, and it would have taken a long time to travel by subway, plus the nearest station was blocks away. I asked him for

a ride, and he said, Why not? Jaunty. I don't know if he cleared it with the young women when I went to get my things. I didn't thank them. They kept themselves apart from us, the help, in the way that people do, by averting their eyes and barely saying thank you for a large service, by relating to your body as if it is a surface to leave a drink on.

It's instructive being the help, *instructive* being a word used maybe by people who can slip in and out of the role, although everyone who labors in a uniform—even one that upgrades you on the food chain, like a doctor's lab coat—knows the Pirandellian slippage into a set of assumptions and the pleasure of hanging out in them while, inside, you're a volatile element, a pile of crispy leaves, a mutant fuck. Every minority person knows this, too, in a field of dominant others. The way I situate myself with poor people and working people drives my mother insane. "You don't like yourself," she will say, and I don't tell her she is wrong, because how can I? I say, "You haven't been Queen Marie of Romania all that long, your highness. We come from peasants and *schleppers.*" She will move back from me, startled that she has forgotten her life. "Not peasants," she will correct. "They lived in cities." Anyway, what I mean by *instructive* is that working in a service job reminds you that you are a wind-tossed snowflake with no purchase on permanence. When you contemplate mortality—even if you have an "easy" death at ninety-five at Marianbad instead of a terrified one at twenty in Auschwitz—everyone's story winds up haunted, hunted, and ephemeral. What is the purpose of being reminded of this all the time? None. There is no purpose, period, but let's not pull on that thread this moment. The ephemeralness of everything is pressed on you below stairs as you look up and see how you're seen. If you're never in this position, it's easy to overlook it, and that puts you at risk for never going anywhere. Not tragic but not so much fun.

I was wearing a down parka over my tux jacket and looked clownish in the combination of finery and street, like a figure from Vaudeville or a Beckett play. And I had all these bags stuffed with food crammed into the space by my feet. There was a bag lady aspect to me, definitely. The young women talked on their cells or murmured to each other, as if their conversation were a dessert they didn't want to share. I felt a connection to the driver, fellow *schlepper* and rescuer, with his trim body and neat jacket—a garment, I could see, that got escorted to a closet rather than tossed over a chair. Something wry and cagey leapt off him, a silky, familiar thing that licked my face. I asked if he owned the van. He said he did, and we began a conversation.

He lived in Queens. I knew that many Russians live there and because I

had recently traveled to Russia and wanted the driver to be Russian, I asked if that was where he was from. He said he was born in Italy and that he'd moved to Israel where he'd lived until he was thirty. "It is the story of the Jewish people, moving from country to country. We are gypsies. It makes us uncomfortable to remain in one place." He turned away from the road and looked at me for a moment. I said I was a Jew, too. For all I knew, the girls in the back were Jews also, but if so, they were Daisy Buchanan Jews, snugged catlike above stairs, and although in high school I had aspired to dress like them and become their friend, I was not one of them, not just because they had more money than me but because protection seemed unsexy.

I thought it was unsexy to the driver, too, the way he bragged about Jews being gypsies, as if that were romantic and as if they marched around so much out of wanderlust rather than because they were hounded. He said he'd moved to Israel for survival and to the U.S. to be a stranger. I said I was happiest where I didn't belong. In those places, I didn't think about myself so much. I could be satisfied and still. We cruised up the FDR Drive. The water was shining under a winter moon and reflecting lights on the bridges that danced on the waves. I felt as if a force from the old neighborhood had reached out and was saying: You come from us, you know how to get by. There is nobody to depend on but who cares, who cares, when you can pick the right strangers.

The young women wanted to be dropped off first, but the driver explained it would be shorter to take me home before them. They waited with tight little mouths as I prepared a package of deli meat for the driver. He said he would have it for lunch the next day and didn't drive off until I was inside my door.

Upstairs, I felt good, exuberant, and I sort of danced around, putting things away, not tired, not bedraggled. I told myself: Don't get all Blanche Dubois about the ride and fall in love with needing luck. It was only a lift between two snowy streets. But I wanted to make more of it and connect the strands of the day which felt like a bundle of something: the Jewish wedding, the old synagogue, Cannon Street where my parents had roller skated, the Lower East Side, dealing out strivers, revolutionaries, and gangsters all jumbled together like cards in a deck, the van driver's rescue, his life stamped with the boot of the Holocaust, as the lives of all Jews have been, before and after it, and all people on the planet, though not always in as deadly a way. The day had made me remember and imagine. It had made me feel Jewish.

I'd felt puny, then touched by my puniness, and the rhythm of that— the self-consciousness and comedy—were things I associated with being a Jew. Naked appetite, too—my shopping bags of food. At the wedding, a

traditional money sack—a soft, padded pocket for collecting gifts—had been passed around, albeit discreetly among this crowd. Jews give each other money, something considered crass in other cultures. Jews do this because in most of the lands where they lived—under threat of being banished or killed—they weren't allowed to own property. Money, not dressed up as a thing, is an advertisement for desire and for our animal helplessness before it. But money is more than appetite. It's a symbol of freedom, the potential for transformation, the nothing a thing is before meaning is attached to it. The Jewish interest in structures of interpretation is owed in part to the long experience Jews have had of being interpreted by others—though this contemplation is hardly confined to Jews. I felt linked to the past, a sensation at once cozy and desertlike that stuck to me like an oily smudge. I was a tumbleweed shot from the street of tumbleweed, proud to know that life was thorny and restless.

But almost as soon as this feeling came over me, I smelled something corny and nostalgic in it. When I told the driver I was a Jew, I was saying he didn't have to translate himself—but I was establishing more. He was talking about history, and in history I saw myself as a Jew. I was a Jew because my parents were Jews, and to disavow that was to deny a part of reality. I was a Jew because people hated Jews for being Jews, and in this context to say you weren't a Jew would turn you into something else you weren't, because there was no such thing as being a nothing and beside that I wasn't a nothing. I was a person others perceived as a New York Jewish type: my syntax, my speed, the Yiddish words I tossed around. I didn't have a problem with that, but with other issues I did. I was an atheist, and I didn't want people thinking I practiced a religion or believed in God. I didn't think existence had meaning. I didn't think human beings had a role in a plan. I thought we evolved from stuff—amino acids, that kind of stuff. When someone wished me a happy new year around Rosh Hashona or said, "Happy Chanukah," in December, I made them take it back with a speech about the kind of Jew I was and wasn't and made them wish they hadn't tried to be nice. I didn't think they were being nice. I thought they were trying to shoehorn me into a slot, so I wouldn't be flying around slotless and maybe upsetting the balance of the universe. That was a job description I might have chosen had it been in my power. My parents—my mother especially—were fearful of non-Jews and had wrapped Jewishness around them like a good fur that could keep out the wind and rank them as something special in their own eyes. I'd pushed away that style. It had seemed anxious and false. What was all this harping on being a victim? The Holocaust hadn't reached out a hairy paw to claim

them. And yet here I was with all these *schmaltzy* feelings. What to make of the resonant proximities of my day and of the way they were touching me? Something? Nothing? Where did memories and imaginings fit alongside the seismic eruptions of history? My *schlepper* identification, although streaked with self-pity, was a badge of an unprotected life. What were the productive ways one could choose to be unsafe—or not deny precariousness—so that an individual life could become a social action?

W. G. Sebald meditates on coincidence, memory, and the relationship of individuals to history in his essay collection, *On the Natural History of Destruction,* believing that coincidences only look accidental because we don't understand their links in time and space. "I have kept asking myself . . . what the invisible connections that determine our lives are, and how the threads run," he says in an address to a literary center in Stuttgart. He likes to weave events into a shape so they won't get lost to memory—make bookmarks and scars out of them. He's interested in forgetfulness in general, but as a German, he's focused on forgetfulness of the Holocaust—the way it exiles the forgetters from history and fouls a society that misplaces its torture and murder.

Like Nietzsche, he believes that a memory of pain insures it a niche, and like Freud he sees forgetting as something that may appear accidental but in reality is a structured activity. Forgetting is one kind of apparent randomness that has meaning, and its underlying structure—the unconscious we struggle to apprehend—is the most durable and elastic thread that weaves us.

But in seeking links for what appears random, Sebald is looking for more than the unconscious. He's interested in the contact points of small and large actions, sometimes evoking circumstances similar to the butterfly effect of chaos theory, where a barely noticeable action, like the flutter of a butterfly's wing, ripples out to produce large consequences, like a far-away monsoon that, a month later, is set in motion or circumvented.

He tells a story about a date that links his own birth, a journey to France taken by the philosopher Hölderlin, and a terrible massacre by S.S. troops in Tulle, where in 1944, 101 years to the day of Hölderlin's death and three weeks before Sebald's birth, "ninety-nine men of all ages were hanged from lampposts and balconies of the Souillac quarter in the course of that dark day The rest were deported to forced-labor camps and extermination camps, to Natzweiler, Flossenburg, and Mathausen, where many were worked to death in the stone quarries."

Sebald is looking to the past to discover a dimension of himself, and he is looking for a way to attach his life to history. As a German, attaching himself to history means implicating himself in crimes—those in the past and possible

future ones. He's saying: I could have been one of the killers.

How to live with that? He's a writer. He claims for writing that imaginatively recreates injustice a redemptive dimension, something he can aspire to. "There are many forms of writing; only in literature, however, can there be an attempt at restitution over and above the mere recital of facts, and over and above scholarship," he maintains. By restitution, he means the restoration of something that has been veiled or buried. But he doesn't stop there. Referring again to Hölderlin, the massacre, and himself, he speaks of "strange connections [that] cannot be explained by causal logic," wanting the pieces to add up to something more than a prompt for memory. Is this something outside individual consciousness—say fate, or God, or the universe with a plan—a story that already exists and little by little becomes revealed? If so, he's at odds with his brief for memory, for the part of the mind that believes in fate or a planful universe is just like the part of the mind that forgets. They are both activities of wishing for things to have a particular shape.

Passing Sebald on the sidewalk of history, where he can say: I, a German, could have been one of the killers, I can say: I, a Jew, could have been one of the killed. That's if we're talking about identity, being born something. But Sebald also talks about identification, an imaginative process that writing, with its images, can set in motion—like the flutter of a butterfly wing. Images and contact—brushing against someone, looking in their eyes, feeling influence, friction, arousal, sweat, a chain of associations that link a shared present to individual pasts—all this gives life to identification. Through identification, I could be one of the killers and Sebald one of the killed. Which drag is riskier?

Around the time I was mulling on my *schlepper* day, a book arrived from its publisher: *Savage Shorthand,* a brilliant, idiosyncratic study of Isaac Babel by Jerome Charyn. I read it transfixed, for there, racing across the pages like a pack of yapping hounds, were all of my threads: tough Jews, unlucky Jews, the consequences of erasure, and the unprotected life.

On the advice of Maxim Gorky, Babel left the safety of his comfortable, Jewish enclave in Odessa to go into the world as "a barefoot boy." He traveled with the Russian cavalry in 1920 as a war correspondent, assuming a Russian pseudonym and riding with the Cossacks into Poland and the Ukraine. Their mission on paper was to advance the Revolution. In reality they slaughtered Poles and Jews in their *shtetls.* Babel had believed in the Revolution, which at first lifted restraints, among them abolishing laws that confined Jews to the Pale. Before the Revolution, Babel had traveled to St. Petersburg and lived

there illegally. Riding with the Cossacks, he kept a diary, writing in what Charyn calls a "savage shorthand," a pitching, violent present tense without direction or exit. He watches a soldier take the head of a Jewish man under his arm and slit his throat so efficiently no blood splatters on his clothes. He observes rapes, people begging and coldly denied.

The images tumble forth moment to moment, recording what Babel felt, or could not feel, as he witnessed months of cruelty. It "crazied" him, in Charyn's phrase, and he crafted a Russian that aimed to destroy language, with its deceptive definitions and orderings, a language that viscerally dramatized the failure of words. Babel might agree with Sebald that imaginative writing can re-engrave cruelty, but he doesn't seek metaphysical meaning in existence. He doesn't look for grandeur in suffering or anything else. Meaning arises not from the fact of existence but from what is next to you, a shifting slippage of contexts. With the Cossacks, he becomes a predator, too, feeling the excitement of unbridled power and the helplessness of being at its mercy. Sudden images of sex are juxtaposed to the brutish details of murder, Babel exposing the matter-of-fact way that violence bursts through the seams of ordinary life. "The girls are playing in the water, a strange, almost irrepressible urge to talk dirty, rough, slippery words," the diary records. Elsewhere from the diary, "I'm an outsider, in long trousers, not one of them, I am lonely, we ride on...."

More transforming even than scenes of battle, Charyn shows, was Babel's exposure to the *shtetl* world of caged Jews. "He haunts the *shtetl,*" Charyn writes, "repelled by the poverty, the forlorn faces, the smell of excrement, yet drawn to these Ukrainian Jews, so unlike the round and jolly worshippers at the Brodsky Synagogue in Odessa." The diary again: "Discussion with Jews, my people, they think I'm Russian..." He scuttles into a synagogue. "I pray, bare walls, some soldier or other is swiping the electric light bulbs... I roam about the *shtetl,* there is pitiful, powerful, undying life inside the Jewish hovels, young ladies in white stockings, long coats, so few fat people."

In the *shtetl,* he felt he'd discovered an aspect of himself he hadn't known about, at least not in an intimate way, a version of Jews as the bottom of the food chain. It was the flip side of his identification with the defiant Jewish gangsters he would evoke in his Moldavanka stories—tales of mythically proportioned, cutthroat, but wildly, humorously verbal thugs. Living in the Moldavanka, a Jewish ghetto surrounded by Czarist might, Babel sidles up to the guys with anarchic, warlord clout. Riding with the Cossacks and coming upon *shtetl* Jews, he's presented with a far riskier identification, both to his image of himself and to his actual survival. Still, he feels impelled to say, I am not other than you, forming solidarity on behalf of their common risk as Jews,

the sentiment being: If you are in danger, then I am in danger, and if I join you in your risk then we are both safer. Or at least connected.

The *shtetl* world made him feel less alone, even though it reminded him of his vulnerability, both as a Jew and as a creature who would some day be snuffed out. From this point, he identified with both gangster Jews and *shtetl* Jews, allowing them to speak to each other inside him, the contradictions building his art of clashing images, of collages and jump cuts, like Sergei Eisenstein's (Babel would later write film scripts). In his writing there is no connective tissue, no narrative arc, only a refusal to avert the gaze and the need to narratize.

He was arrested in 1939 on trumped-up charges of spying. During the years before that, because he refused to produce one-dimensional, Socialist Realist agitprop, it had become harder and harder for him to publish. He thought his job was to convey that horror and rapture often arrive simultaneously, to evoke aliveness for its own sake and moments of shared sensation. He didn't skimp on reporting Cossack brutalities, although the Red Cavalry rode under the banner of the Revolutionary government, and he didn't dim his admiration for the street-rat rebelliousness of his illicit Odessa hoods. When he was arrested, all his papers and unpublished works were destroyed. Eight months later he was shot by a firing squad, and although he had been one of Russia's most celebrated writers, his books were banned and his existence expunged from official records until 1954. The full story of his murder wasn't uncovered until the early 1990s, after the fall of the Soviet Union and the release of KGB papers.

What smells do we follow, what songs lilted in faraway mountains do we hear? What tiny actions ripple out into large consequences? What accidental meetings lure us to feel attached and after that implicated?

Because the van driver told a Holocaust story, I thought of him as a Jew, but our camaraderie preceded our knowing we had that link. I couldn't connect to the stakes of being a Jew that he, my grandparents, and Babel experienced. I grew up with so little risk that I connected Jewishness with privilege and safety. The sufferings of the past did not planfully lead to the comforts of my childhood. They simply coexisted, in the way that good fortune and treachery arrive like twin fairies at a dinner party. In the former synagogue, I felt sympathy for the people who'd had fewer choices than I and glad for my having more.

In a photograph taken in 1931, when he was 36, Babel looks at the camera with a wry little smile. His lips are sensual and full. The tip of his nose is strangely angled, like the Tin Woodsman's in *The Wizard of Oz*. A wool worker's cap is pulled low on his forehead. Rimless round glasses perch on his nose and behind them glint out warm, intelligent dog eyes looking for action.

In the kitchen of the former synagogue, the meat was sliced against the grain and looked like a lattice of small tiles—like the shingles of our house in Long Beach.

One day when my mother was cooking mushrooms in a skillet, they came to resemble my father's face, and she wrote in a note this filled her with joy.

Joseph Scheer

A Celebration of Moths

As an artist I am attracted to moths, not only because they are amazing and beautiful, but also because of their imagery and symbolism. They are mostly creatures of the night, as opposed to butterflies, which are creatures of the day. They are a family of insects that people typically know little about, either visually or environmentally. Some people are afraid of moths. Some revile them as small, ugly creatures that mess up their food and eat their clothes. And of course, the idea that they are attracted to light, to the flame, is a powerful metaphor. Think of what exists in the human world at night that is not part of the mainstream culture. For me, moths are a symbol of all that. They are beautiful creatures who most, but not all, are only seen at night. They are short-lived, and have this intensity, and then they are gone.

I have been working with moths since 1998, first collecting them in the art studios where I teach and then at a friend's farm in Alfred, New York, gradually finding myself becoming more and more astonished at what I found. Eventually the project became a real obsession. I ended up documenting over 1,000 species of moths in Upstate New York alone, and have now collected thousands from all over the world, from as far away as Australia.

A goal of my artwork is to bring information about moths, through multimedia experiences, to a broad audience who may not be aware of, or come in contact with, their beauty and diversity. The moth project has opened up the world for me as well. Over the years I've been doing this, I've learned about how the environment affects what species will show up at any given location: the phase of the moon, the time of month, the temperature, the types of plants around, all of these factors determine which moths we encounter. There is a complexity to their patterns that I have slowly come to appreciate, and I am now much more aware of the fragility of our ecosystem. I believe that we live in a time in which it is highly critical to promote our respect for, and redefine the delicate relationship to, the many living things on our planet.

If I had endless time and money, I would try to document the whole spectrum of bio-diversity that exists in my part of the state and scan the results as a database for people to study. While not formally trained as a scientist, I use the same observational skills that are practiced by researchers in the scientific process, and this is now an inseparable part of my work.

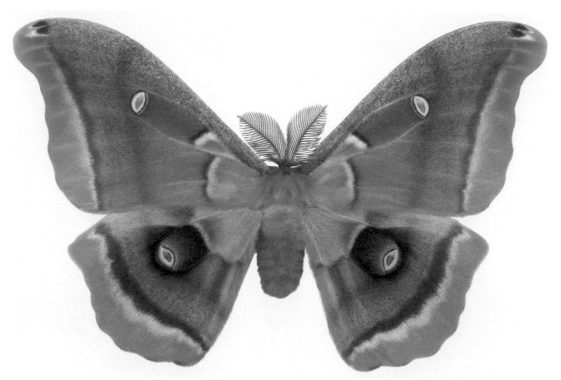

JOSEPH SCHEER, *Antheraea polyphemus* (Alfred, New York), photograph

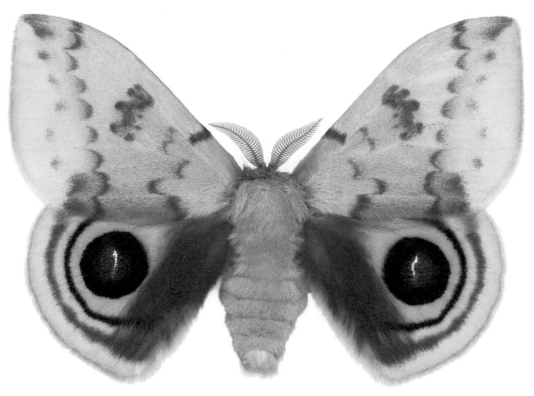

JOSEPH SCHEER, *Automeris io male* (Alfred, New York), photograph

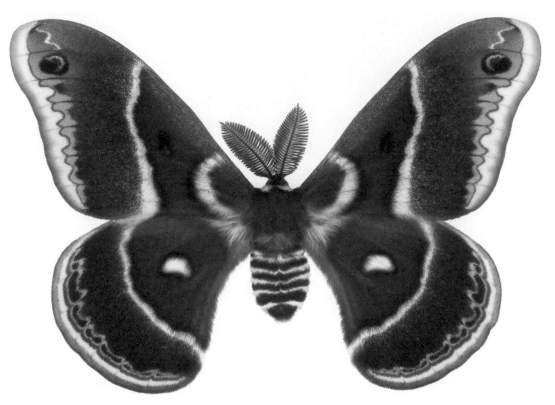

JOSEPH SCHEER, *Hyalophora columbia gloveri male,* (Box Canyon, Arizona), photograph

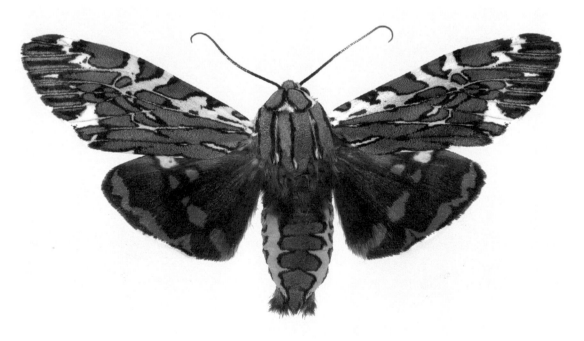

JOSEPH SCHEER, *Arachnis aulaea,* (Harshaw Creek), Arizona, photograph

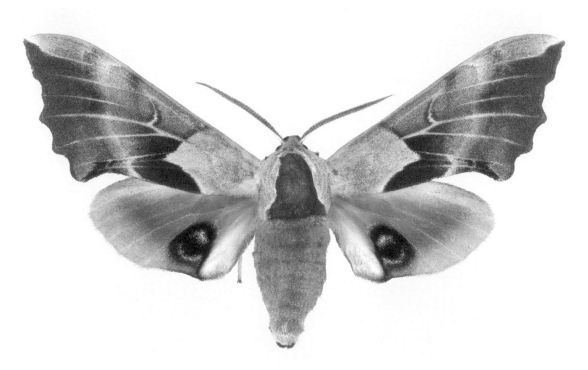

JOSEPH SCHEER, *Smerinthus saliceti,* (Pena Blanca), Arizona, photograph

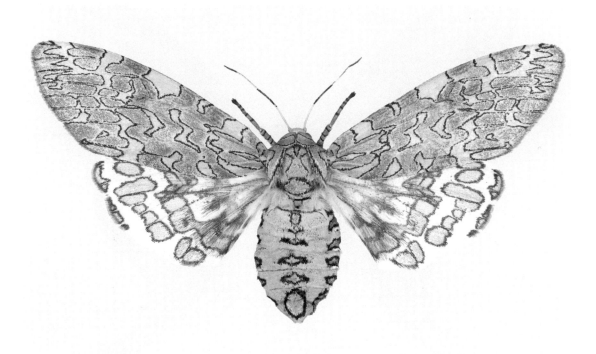

JOSEPH SCHEER, *Hypercompe suffusa* (Harshaw Creek), Arizona, photograph

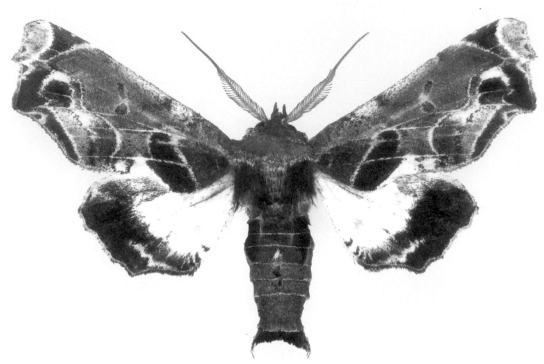

JOSEPH SCHEER, *Eutelia pulcherrimus* (Apopka, Florida), photograph

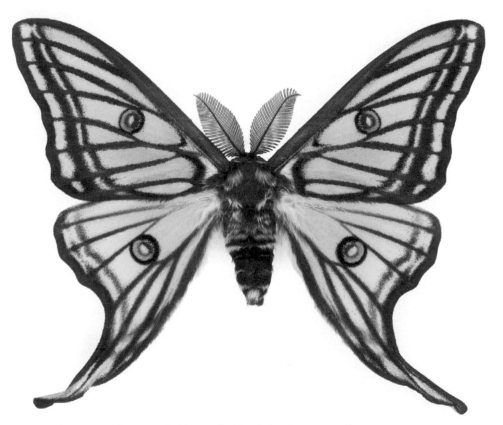

JOSEPH SCHEER, *Actias isabellae male* (Spain), photograph

Carly June L'Ecuyer

The Ballet

As a child I was no stranger to the ocean. Instead of getting frantic warnings to swim near the shore and always stay near Mommy, I spent my summers being tossed into the waves by my stepfather at the beautiful beach my family has been visiting for fifty years. South Carolina was more than just a vacation spot; it was a home away from home, a place that reeked of sunscreen and the sticky ocean air, where the stars from the porch window in our room lulled me to sleep, where our skin peeled off and left our bodies red and raw. I loved those summers.

When I was seven and my cousin Laura was ten, we spent most of the summer joyously spinning in the ocean's salty waves. Laura's five-year-old brother Ben usually padded along after us. The day started off as any other: small, blonde Ben struggling over a sandcastle with his father, Peak, while Laura and I shrieked over a swollen, floating gummy bear in the water. The air was heavy and it was hard to breathe; the cold water was a relief against the sun.

"Girls?" Peak called out suddenly. We looked over at him. His bald, red head glinted in the sun; he looked like a tomato. I giggled. "I'm going back to the cottage. Just for a *minute*. Watch Ben, okay? Both of you?"

"Yes, Daddy!" Laura piped out sweetly, waving her arms. "Yes, we're watching him!"

"Just for a *minute,*" he repeated, and dashed towards the cottages.

Laura began floating on her back in the water. She could float better than I could.

"Okay," she said, immediately returning to our game, "now we're going to lie in the sun and be singing, and a pirate ship will come along, and—"

"No-o," I protested. Tired of treading water, I tried to lie flat on the ocean's chilling surface like her. "Not again. That's what we played *yesterday.*"

"I'm older, so I get to pick," she flashed, her soaked white-blonde hair sticking to her face. She scowled at me, arranging her features into such a horrible, twisted display that I backed down. Anyone who could *look* like that would definitely—well, I didn't mind playing mermaids, anyway.

Our names changed as we drifted with the waves; first we were Augustine and Sierra, then we were Annabelle and Lenora. Pirate ships billowed through the roaring wind to chase our majestic voices that sometimes uttered in-

comprehensible sounds and other times harmonized to songs from *Hair*. Our bright bathing suits flashed messages to the sky above.

As Laura crowned herself queen of the ocean with a nest of slimy seaweed, I squinted up at the sun, which looked miraculously like Gramma's lemon drops. My stomach growled.

"I hope we're having lasagna tonight," I said wistfully.

"Or barbecued chicken!" Laura's voice was hopeful. "I'll ask Daddy—"

Her voice died out to a whimpering squeak. Staring behind us, she seemed to slip in the water; I whirled around and felt my heart sink to the black bottom below—the shore was barely the size of my finger, and Ben was only a blonde smudge against the sand dunes. In a rush I realized that we'd turned our back on the shore the minute we became mermaids, and the waves had slyly pulled us deeper and deeper into its depths. We were silent for almost a full minute, thrown into a speechless tangle of surprise.

Suddenly, Laura's panicked, frozen expression changed to horror with the speed of a hurricane and a piercing voice exploded from her tiny body. "Daddy!" she screamed, though Peak was nowhere in sight. "Daddy!"

I watched helplessly as Ben, small as an ant, rushed away from the shore. Laura's screams echoed around my head, clouding the purr of the ocean. I covered my ears, trying to block out her voice, but the undertow suddenly yanked at my legs and I was pulled under, slipping out of chaos and into a quieter world of browns and greens.

I burst into air again and gulped down mouthfuls of wind. Peak was on the beach, his barking voice mingling with Laura's horrified peals of terror; as though in slow motion, I saw Peak jab a finger at Ben, clearly shouting, "Stay there!" and plunge himself into the water.

With a swirl of salty droplets I was sucked under the surface again. I floated, blinking, jostled by the water, listening to the breath of the ocean, rolling where the waves pleased to push me. It never occurred to me to be scared, to panic, to fight against the powerful being that tossed me around like a toy....

Peak was next to me. He fought against the waves, his sinewy arms cutting through the water, his face screwed up against the spray. He lifted me in his arms and I clung to him, but the water was above his head too. He threw me with the waves toward the shore, panting, slipping under the water...but the ocean pulled me back. Even as he swam toward his sobbing, choking daughter, I was drifting back toward the same spot from which I had been rescued.

And over and over and over again he went, throwing each of us in turn only to have us pulled back again, both of us occasionally plunging under the surface. I caught flashes of frantically pedaling white legs and the flowing fabric of my uncle's T-shirt, but it was overall much calmer and cooler under the water. The shifting shades of blues and greens, the seaweed gently being tossed with me in the tornado of bubbles, were calming and familiar to me. And, powerless, I allowed the sea to carry me as it would, never believing that it would hold me back from the breath of life, always trusting the watery hands to push me back toward the surface....

And suddenly I was climbing, exhausted, onto the shore, falling onto the sand, covering my quivering arms and legs with swirls of the earth. Laura's shuddering tears as she was embraced by her listless father and Ben's sobs of panic swept over me as I breathed in the air and the sea and the sand, closing my eyes against the fear and letting the hot sun caress me again.

Carrie Mae Weems

ROME PROJECTS

During the past 25 years, I have worked toward developing a complex body of art that has at various times employed photographs, text, fabric, audio, digital images, installation, and most recently, video. My work has led me to investigate family relationships, gender roles, the histories of racism, sexism, class, and various political systems.

Storytelling is a fundamental aspect of my artwork, a way to best express the human condition that has been a focus from my earliest documentary photographs. This characteristic continued through increasingly complex and layered works during the 1980s, as I endeavored to intertwine themes as I have found them in life—racial, sexual, and cultural identity and history.

During the 1990s a trio of museum commissions resulted in large-scale fabric installations, leading to my most recent investigation, *The Louisiana Project* (2003), condensing a web of relationships between black and white, rich and poor, elites and the masses. The installation includes digital photographs, text, video stills, and video. This first addition of the moving image in my work allows me to finally negotiate the space between museum culture and popular culture, while digital technology has enabled me to make current shifts in my artistic production.

Coming Up for Air (2002) was my first video endeavor, first screened at the Museum of Modern Art in New York City. In it I wove together a series of vignettes, separate yet linked, comprised of a narrative sequence of photographs, moving footage, and live action. On the surface, it may appear that I am moving away from questions of race and gender. However, as a socially engaged artist, I continue to explore these subjects, while turning a poetic eye to the subtle and ephemeral qualities of love: its power to embrace and to destroy.

These ideas continue to express themselves in my two most recent projects, produced in Rome, Italy, during a year-long fellowship at the American Academy in Rome. The photographic series, *Roaming,* consists of approximately 35 large-scale photographs that question the nature of power as exemplified through space and architecture, while the video project, *Italian Dreams,* engages the seamy side of desire and longing. Shot at famous Cinecitta, the film references the films of Bergman, Fellini, Antonio, and Pasolini.

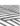

What Do You See in Me

I asked John Guare What could I play?

He Said:

I told you, the more I know you
the more I see the power in you,
you're not a shrinking violet.
You're a very powerful woman…
with a degree of anger,
which I love.
And I would try to harness that:
You could play Bonnie for instance.
"The House of New Orleans,"
where Bonnie is this brawd
comes in to take over a man's life, saying:
"I'm gonna make you what you could be.
You don't know what you could be.
I'm gonna show you.
You've got all these tools in your life
that you've never used before;
We're gonna pick up these tools & use them.
We're gonna have a great life together."

I could imagine you coming in and doing that.

I could imagine you, ahm… I don't know: an artist,
or a great somebody who had been a movie star,
who had made a picture a few years ago
and hadn't found another role
and was looking for another role.

CARRIE MAE WEEMS, from *Roaming* Series, black and white photograph, 2006

CARRIE MAE WEEMS, from *Roaming* Series, black and white photograph, 2006

CARRIE MAE WEEMS, from *Roaming* Series, black and white photograph, 2006

CARRIE MAE WEEMS, from *Roaming* Series, black and white photograph, 2006

CARRIE MAE WEEMS, from *Italian Dreams,* video still, 2006

CARRIE MAE WEEMS, from *Italian Dreams,* video still, 2006

CARRIE MAE WEEMS, from *Italian Dreams,* video still, 2006

CARRIE MAE WEEMS, from *Italian Dreams,* video still, 2006

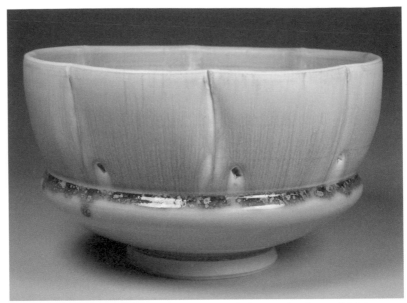

BRYAN MCGRATH, *Porcelain Bowl,* celadon/ash glaze, 2006

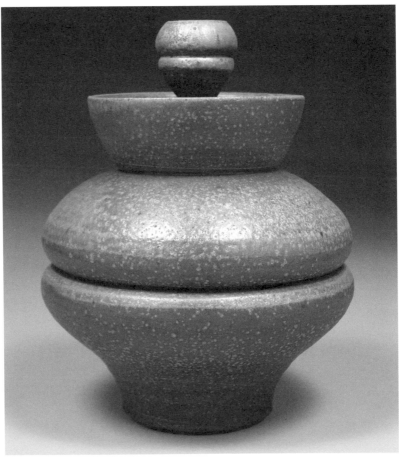

BRYAN MCGRATH, *Salt Glazed Lidded Jar,* stoneware, 2004

Paul Aviles

THE PAINTED DOORS AT SAN CRISTOBAL

For D. Steiner

The construction is primitive
post and lintel
with the raw beams
that seem to bear

the whole weight of these houses
planted squarely at the edge
of sidewalks cut from stone
that every few feet

dip, allowing cars to pass
while, oddly, those on foot
are forced back to the street.
All day the sky

is moody,
shifting
in and out of light
so that the houses painted

one of several blues
get washed out or intensify
depending on the time of day.
But there are yellow houses too

and others
tinted lilac, salmon, powder blue, chartreuse,
each one with a door of some contrasting color
floating in its frame; this same sequence

always: a door, its frame.
the expanse of a surrounding wall,
each one quite willing to drift off happily into space.
Yet adamant and earthbound,

these houses squat.
They are immovable,
they hug the ground, stubbornly,
the way the bare feet flat as cactus pads

you see here do. A child's houses, really—
the same straight lines and angles,
the audacity of pink and green together.
They will not easily be uprooted.

Mornings in the tiny plazas women
sit out combing one another's hair,
tying shiny ribbons into braids. They talk
and comb, talk and separate, and

in the cold, unfiltered light
fine particles of dust
float everywhere. Such intimacies
at six a.m. come unexpected.

But of the life inside, these doors
offer no more than a glimpse
of bicycles and tiled floors,
a fountain or some foliage.

This city gives its soul to no one.
Acquisitive photographers who ignore the warnings
posted in several languages in hotel lobbies
and in banks, for robbing native souls

could end up dead.
And those who still go
blindly clicking through the streets,
chasing the genius of the place

in vain will later find
the camera does not work, or inexplicably
is out of film, these doors,
by some mystery refusing to be photographed.

Toward dark the houses are all sealed
hermetically keeping out the mountain air
and spirits
trapped all day like heat in stone.

The nights come on a dense blue-black
making even the lush green jungle vegetation
of the surrounding mountains indistinct,
swallowing these crossbeams and the painted doors

one-by-one,
the way the eyes of the women here get swallowed
by the iridescent ink-blue shawls
they fold themselves into.

The way a face absorbs
a love,
its death,
intensest joy.

Evalena Aisha Johnson

Cold Silence

Looking out the window
Watching the rain fall
They are watching you.
They will never speak,
They hear nothing,
They have no opinion,
And they will never judge you.
They just sit there
Cold. Lifelessly watching.

Diana Abu-Jaber

SYRACUSE IN THE BLOOD: AN INTERVIEW BY ROBERT COLLEY

At five every workday, Jem left the business office, stabbed her card into the time clock, and dashed to join the nurses at the Orange, Sutter's Mill, or the Won Ton à Go-Go, bars edging the strip between the hospital and Syracuse University, all rotted by weather, perfumed by beer. The city, slanted into its hard sky, could almost have been by the ocean. But there was no ocean by Syracuse, just the finger of Onondaga Lake, gray as bone. Further north was Lake Ontario, which, though hidden, made itself felt in the rain and snow that wound sheets around the city, the wind driving people's faces down into their chests like the heads of sleeping birds. Sometimes in the winter Jem couldn't get warm, no matter how many layers she wore, and it was only in the tunnels of the city bars, protected by tavern walls, in nests of peanut shells and sawdust, that she would find some distance from the cold.[1]

<div align="right">Arabian Jazz, p. 7</div>

So begins Chapter 2 of Diana Abu-Jaber's remarkable first novel, *Arabian Jazz,* published in 1993 and set in the city where her dad, an immigrant from Jordan, settled with his family. Called "oracular" by the *New Yorker,* the book was a finalist for the National PEN/Hemingway Award and garnered critical praise for its memorable and sympathetic portrait of an Arab-American family trying their best to "pass for Americans," yet also determined to honor their family traditions and keep close ties with the homeland. As one critic put it at the time, "Abu-Jaber's novel will probably do more to convince readers to abandon what media analyst Jack Shaheen calls America's 'abhorrence of the Arab' than any number of speeches or publicity gambits."[2]

Ultimately, however, the novel's appeal is universal. Seldom has a writer of fiction been able to capture so vividly the feeling of being an outsider in one's community, as evidenced by the following long passage about the family's move to a small town called Euclid, north of the city of Syracuse:

1. Reprinted from *Arabian Jazz* by Diana Abu-Jaber. ©1993 by Diana Abu-Jaber. With permission of the publisher, W.W. Norton & Company, Inc.

2. Jean Grant, *Washington Report on the Middle East,* September/October 1992. 70.

Hilma thought of Matussem as "that cute little brown guy." She never minded that her youngest, Peachy, liked to spend time over there with his girls, but she had to keep her own distance. She knew about Arab men....So her and Matussem's conversations were amiably conducted across wide spaces, usually across the street or over the aisles of Bumble Bee Groceries. Matussem considered this distancing another of the myriad eccentricities he'd discovered since he arrived. He liked to tell his relatives, "I don't care how many Bonanza you watch, nothing get your brain ready for the real America."

• • •

Peachy was Jem's only friend on the bus. The other children taunted Jem because of her strange name, her darker skin. They were relentless, running wild, children of the worst poverty, the school bus the only place they had an inkling of power. She remembered the sensation of their hands on her body as they teased her, a rippling hatred running over her arms, legs, through her hair. They asked her obscene questions, searched for her weakness, the chink that would let them into her strangeness. She never let them. She learned how to close her mind, how to disappear in her seat, how to blur the sound of searing voices chanting her name. One day someone tore out a handful of her hair, on another someone raked scratches across her face and neck as she stood, her eyes full, the sound of her name ringing in rounds of incantation. Waiting to leave, she could see her name on the mailbox from half a mile away, four inches high in bright red against the black box: RAMOUD. Matussem had been so eager to proclaim their arrival. There was no hiding or disguising it. She would run off the bus, straight to her room. But the voices would follow and circle her bed at night.

None of the other children ever helped her, not even Peachy Otts, who would watch blandly, without surprise. By the time Melvie started school, the bus route had changed to accommodate new subdivisions, the tentacles of suburbia reaching from Syracuse toward Euclid. New children rode the bus, mild middle-class children with combed hair, cookies and raisins in their lunch. "Faceless," Melvie complained in seventh grade. The bus no longer took the long, gravel road south to the shacks and trailers, as if the school had forgotten those children were even there.

As Jem moved toward graduation and college, her tormentors scattered. The kids on the bus dropped out or got pregnant, went to juvenile homes, foster homes, penitentiaries, turned up poverty-stricken, welfare-broken, sick, crazy, or drunk. After a while, no one was left to remember the bus. A kind of relief and loss: no one to bear witness. There was no room left in her to think about any of it; she knew those children had been right. She didn't fit in even with them, those children that nobody wanted.

Arabian Jazz, p. 89

Robert Colley: A big part of the story of *Arabian Jazz* has to do, obviously, with the attempts of various members of a fictional Arab-American family to come to terms with their dual identities and find their "place" in the world. At the same time, I found it so easy to identify with and care about the characters that they seemed in some fundamental ways "just like any" family with their fair share of joys and conflicts. Were you conscious of operating on two levels, as it were, when writing the book?

Diana Abu-Jaber: Not really. I always feel that the best stories are the most specific and intimate. True intimacy comes from the details. So while I'm glad that the characters transcend their cultural boundaries, I think the more exact (and exacting) I can be in their dimensions, the more appealing the story will be. Or at least I hope it will!

RC: I do have to admit, though, that part of the pleasure of reading the book was in knowing that it was set in Syracuse. What was it like for you growing up in the "Salt City" and the surrounding area?

DA-J: Syracuse was always home to me. There was a rich Arab-American community centered around the University when I was growing up. I can remember being a little girl and going to King David's restaurant on Marshall Street with my family. It was always filled with Arab students, and it was the only place where you could go (in the '70s) that tasted like our family's cooking. My father was born in Jordan and he's a fantastic traditional cook. King David was responsible in large part for my sense of the restaurant as a gathering place—a taste of home outside of home.

RC: What brought your dad from Jordan to Syracuse in the first place?

DA-J: Dad was around twenty-three years old, fresh out of King Hussein's air force, and he didn't speak a word of English when he first got to the States. Well, he could say, "Coca Cola and hamburger." He came for a lot of reasons—some of the obvious sort of immigrant daydreaming, following his brothers (several of whom enrolled at Syracuse University), and also for subtle, complicated reasons about a sense of frustration with his family and country, and a search for his own identity. He worked at all sorts of odd jobs at the University and on Marshall Street.

RC: And did your own family at some point move from Syracuse to Euclid?

DA-J: We did move to Euclid, New York, in the late '70s, and I missed the bustle and the energy of Syracuse immensely. Actually, that's one of the stories I tell in *The Language of Baklava*. I think of that move as my parents' retreat from the disappointments of suburbia and a weird sort of middle ground compromise. Dad kept trying to move us back to Jordan, but he'd get irritated with Jordan and move us back to the States again. They were planning yet another move to Jordan when I was in the seventh grade but something sort of snapped in Dad and instead they up and moved to Euclid. My parents work in mysterious ways. I think they were hoping that perhaps if they withdrew from Middle America, they could find a peaceful, pastoral setting that we could finally fit into as a multicultural family. Only that didn't work out so well either.

RC: That harrowing description of Jemorah being harassed on the bus—did that extreme experience mirror your own in some way, or is that sort of passage more the work of your creative imagination?

DA-J: After we moved to Euclid, I rode to school every day on a bus filled with wild, scary, scrappy, deeply impoverished country kids. I sort of wonder what happened to them all now that the Great Northern Mall is plonk on top of the old tar paper shacks and abandoned school buses they used to live in. It was like Appalachia out there. I don't think I was particularly singled out for torment the way Jem is in *Arabian Jazz*—our bus was a more democratic hellacious free-for-all with the tough kids, like the Otts family, terrorizing the rest of us, and the bus driver never looking backwards if at all possible.

RC: The story goes that you first got the idea for the book while jogging, and that you stopped immediately, found some paper, and wrote the first few pages on the spot. True?

DA-J: Yep. I get a lot of my best starts when I'm doing something besides "writing." I think a lot of writers are familiar with the experience of gaining inspiration through a repetitive or mindless physical activity. Back when I used to run a lot (in the olden days) all sorts of ideas would come to me.

I was running on the track at the University of Michigan and I started to think about a guy I'd known in college—a real wiseacre. He really was quite an entertaining weirdo and I just started to think what an interesting start of a character he'd make. So I sat down outside the track, grabbed some papers off a bulletin board, and started writing.

RC: *Arabian Jazz* has some great antic, comic scenes but also some more serious, poignant ones. One critic paraphrased you as saying you didn't intend the book to be a comedy, but that is how it turned out. Is that a fair way of putting it? Do you see it as essentially a comedy?

DA-J: Well, I always try to get as close to a kind of emotional "honesty" in my writing as I'm capable of, even if the story itself is fiction. It's a little hard to recall my original intentions with *Arabian Jazz,* but I do remember feeling surprised at how some of the humor started to unfold as I wrote. Many of the characters in that book were inspired by family and friends and I began to recognize the inherent sort of humor (as well as tragedy) that is part of being an immigrant. A lot of it has to do with just getting things wrong—silly basic things that most of us within the culture take for granted. Like mispronunciations or getting the aphorisms wrong. For example, two of my cousins brought about six cans of Crisco when they got here because they thought the pictures of pie and fried chicken on the label showed what was actually in the can. Imagine their dismay when they opened those cans—the sort of thing that makes you cry and laugh.

RC: Your work has been praised for its power to counteract Arab-American stereotypes. Is this ever a conscious goal for you as a writer?

DA-J: Actually, it's important to me that I not attempt to write public service announcements. I try to write the clearest, truest, most entertaining stories I can. Even though *Crescent,* for example, is about Iraqis and Iraqi-Americans, I didn't want it as an explicit sort of political statement. My main concern is to try to paint the characters with as much emotional honesty as I can, no matter what their cultural background. If my characters are true to life, they will be complex and shaded, and if that can help combat stereotypes, that's a wonderful plus.

RC: Fair enough. You have also been described as a seminal figure in the Arab-American literary tradition. When you were writing your first book, were you at all conscious of being part of a tradition? Now, three books later, how do you feel about such a compliment? Is there a sense of obligation that goes with it?

DA-J: Mostly, I remember feeling frustrated that I couldn't find novels written by Arab-Americans. So I turned to writers like Maxine Hong Kingston, Philip Roth, Toni Morrison, and Louise Erdrich to help me understand how to write a different kind of story. While it's great to feel that one's work is taken seriously, I wish there had been (and I continue to wish there were) more representations of the Arab experience in America. But no, I don't really feel an obligation. I'm an American and the more my career develops, the more distance I feel from the early influences that moved me when I was writing my first book.

There's a ten-year gap between *Arabian Jazz* and *Crescent,* during which I wrote another book—a brooding, more politically-edged novel, that never got published. After that rather exhausting experience, I just tried to do what one of Salinger's characters suggests—I tried to write the sort of book I'd most want to read. So *Crescent* draws on a lot of my own passions and interests— on Middle Eastern food and language and culture. *The Language of Baklava* is filled with stories about growing up in Syracuse with a food-obsessed, interfaith, multi-cultural family—complete with my father's recipes for foods like shish kabobs and hummus. And my newest novel, *Origin,* is about family issues of identity and personal history, but I use the lens of memory and adoption—rather than race and culture—to tell this story. The main character is a fingerprint examiner who is forced to solve the mystery of her own identity.

RC: After choosing L.A. as the setting for *Crescent,* it is interesting that you return to Syracuse for the setting of *Origin.*[3]

DA-J: *Origin* is indeed set in Syracuse. Lena, the main character, is a fingerprint analyst at the Syracuse crime lab. Lena gets caught up in an investigation of a string of mysterious infant deaths and as she delves into the case, she finds that she has to confront the mystery of her own bizarre past. It's a literary thriller,

and Syracuse seemed like the perfect setting because I've always thought the city had such wonderful moodiness and texture—a sort of brooding, *film noir* quality. Syracuse's intense snowy winter is an important part of the tone of *Origin,* and a function of the plot. As harsh as the winters are there, they're part of what gives Syracusans a unique identity.

RC: You currently divide your time between Oregon and Florida. But I know you still have family here in town, and are planning to return to give some readings at local colleges in the spring. You have said that some small part of you misses Syracuse. Surely not the weather. Do you still think of yourself on some level as a Syracusan?

DA-J: I still feel very connected to Syracuse and proud of being affiliated with the city. My sister and her family still live in Syracuse and my parents return there (from Florida) every year, as do I. It's in the blood. There's something deeply nomadic in my nature that keeps me moving around, but I'll always think of Syracuse as my true home.

RC: What are you working on now?

DA-J: *The Language of Baklava* was great fun to write (especially testing the recipes) and I think I may return to the memoir form again soon. But at the moment, I'm working on a young adult book that I think is going to be called, "Silverland." It's about an Arab-American girl who never felt like she fit in anywhere—until she wanders through the mirror and meets her own reflection in this strange new country called Silverland. It's great fun—I get to write about all my obsessions and I get to make up a new world as well!

3. *Origin* will be published by W.W. Norton in June 2007.

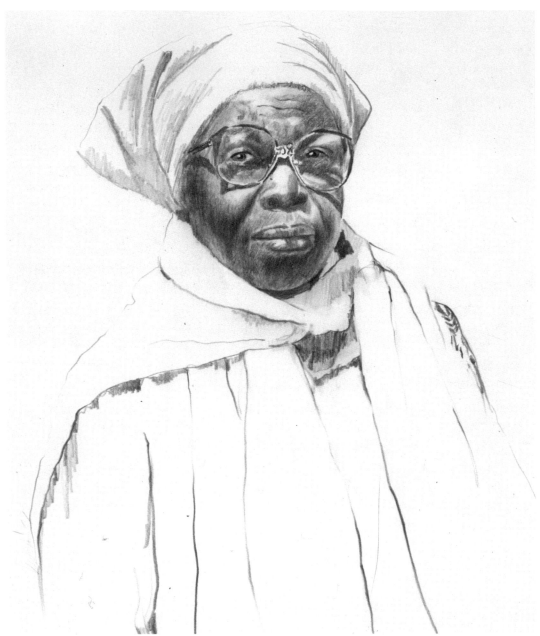

LUVON SHEPPARD, *Sister Vesta #2*, prismacolor pencils on hot-pressed watercolor paper

Contributors

Omanii Abdullah-Grace has written three collections of poetry, including, most recently, *This is Gonna Hurt Me a Whole Lot More'n It Hurts You.* He has taught at State University of New York (SUNY) at Morrisville and Syracuse University and is the director of the Hank Gathers' Players, a multicultural troupe of traveling college-student poets. Based in Syracuse, he focuses his energies on conducting poetry workshops throughout the country at youth centers, hospices, correctional facilities, high schools, and colleges.

Diana Abu-Jaber has been cited by critics as the pre-eminent Arab American novelist of her generation. She was born in Upstate New York, moved to Jordan when she was seven, and has lived between Jordan and America ever since. She studied with Joyce Carol Oates at the University of Windsor and with John Gardner at SUNY Binghamton, where she completed her doctorate. She is the author of *Arabian Jazz,* which was nominated for the PEN/Faulkner award, and *Crescent,* which won the 2004 PEN Center USA Award for Literary Fiction. Her memoir, *The Language of Baklava,* is a reminiscence of growing up in Syracuse, and her forthcoming novel, *Origins,* is also set in Syracuse. She is writer-in-residence at Portland State University, and lives in Florida for several months each year. Visit her web site at *dianaabujaber.com.*

Paul Aviles is a poet, translator, and essayist working on a new book of poems entitled *Funeral Tunes.* He has an M.F.A. in creative writing from Syracuse University and has received fellowships from the Saltonstall Foundation, the New York Foundation for the Arts, and the National Endowment for the Humanities. He is a professor of English at Onondaga Community College.

Kyle Bass holds an M.F.A. in playwriting from Goddard College. Kyle is a recipient of the New York State Foundation for the Arts fiction writing fellowship, and has been nominated for a Mentor Project 2007 fellowship at the prestigious Cherry Lane Theatre in New York. His play *Fall/Out* was produced by the Kitchen Theatre Company in Ithaca, New York, and his play, *Wind in the Field,* received a staged reading at the 2006 Great Plains Theatre Conference, hosted by Edward Albee. He teaches playwriting at Goddard College and Syracuse University, and is at work on a full-length play, *Leeboe and Sons,* and a screenplay, *Bridgewater.*

Mark Bender has received awards from *Communication Arts* magazine and the New York Society of Illustrators, and has won both gold and silver Addys. Mark is a full-time faculty member at the Art Institute of Pittsburgh, a member of the Pittsburgh Society of Illustrators, and a recent graduate of Syracuse University's master's program in illustration.

Douglas Biklen is a fine-arts photographer who specializes in abstract images of urban and rural scenes. His photography has been exhibited at the Delavan Art Gallery (Syracuse), the Nancy Price Gallery (Jamaica, Vermont), and the Brandon Artists' Guild (Brandon, Vermont), where he is a member. He is dean of the School of Education at Syracuse University and is internationally known for his research on autism. Biklen co-produced the Academy-Award-nominated CNN/State-of-the art film, *Autism Is A World* (2004), and the award-winning film, *My Classic Life as an Artist: A Portrait of Larry Bissonnette.* He is author of *Autism and the Myth of the Person Alone* (NYU Press, 2005).

LARRY BISSONNETTE is a Vermont-based painter and writer who is the subject of *My Classic Life as an Artist: A Portrait of Larry Bissonnette,* an award-winning documentary film by Douglas Biklen and Zach Rossetti of Syracuse University. Larry wrote the narration script for the film, which chronicles his liberation from a ten-year institutional confinement (during which he was diagnosed in turn as mentally retarded, schizophrenic, clinically insane, and autistic), and his evolution as an artist. He now lives at home with his family and continues to work in his studio and at weekly GRACE workshops with Howard Community Services in Burlington, Vermont. See *grace.org* for a description of this organization's work with "outsider" artists.

STEPHEN CARLSON completed his undergraduate degree at the Art Institute of Chicago and was awarded the Anna Louise Raymond traveling fellowship to Central and South America. He received his M.F.A. from Yale University, and is a professor of art at Syracuse University and the associate dean of the School of Art and Design.

REGIS COOK is a member of the Bear Clan of the Mohawk Nation. He lives in the Onondaga Nation and is in the 8th grade at the Onondaga Nation School. Regis excels in traditional learning and is a singer at the Longhouse.

JOHN BUL DAU fled Sudan in 1987 at age 12 to escape extermination by the Muslim-controlled government. After time spent in a refugee camp in Kenya, John eventually came to Syracuse in 2001, where he works at St. Joseph's Hospital and studies part time at Syracuse University. John's odyssey is documented in *God Grew Tired of Us,* a film directed by Christopher Quinn, produced by Brad Pitt, and narrated by Nicole Kidman, which won a major prize at the Sundance Film Festival in 2005. It is scheduled for public release in spring 2007. John balances work, family (he is a new father), and college with the demands of a tour to promote his memoir, just published by National Geographic Books and excerpted in this issue. See *godgrewtiredofus.com* for more information about his documentary film.

STEPHEN DUNN is a graduate of Syracuse University's master's program in creative writing. He the author of fourteen collections of poetry, including *Different Hours,* which won the Pulitzer Prize in 2001, and *Loosestrife,* A National Book Critics Circle Award finalist in 1996. His other awards include the Academy Award in Literature from the American Academy of Arts and Letters, fellowships from the Guggenheim and Rockefeller Foundations, the Levinson and Oscar Blumenthal Prizes from *Poetry* and the Theodore Roethke Prize from *Poetry Northwest.* His latest book of poems, *Everything Else in the World,* was issued by Norton in 2006. He is currently Distinguished Professor of Creative Writing at Richard Stockton College of New Jersey, but spends much of his time in Frostburg, Maryland with his wife, writer Barbara Hurd.

RHINA P. ESPAILLAT is an acclaimed poet who has published in many major journals and anthologies. Born in the Dominican Republic, she has lived in the U.S. since 1939 and writes in both Spanish and English. She has four poetry collections in print, including *Where Horizons Go,* winner of the 1998 T.S. Eliot Prize, and *Rehearsing Absence,* winner of the 2001 Richard Wilbur Prize. She is included in *Landscapes with Women: Four American Poets,* by Singular Speech Press, and has been featured on Prairie Home Companion. She runs a monthly workshop, the Powow River Poets, and coordinates a monthly reading series and a yearly poetry contest, both sponsored by the Newburyport (Mass.) Art Association. She delivered the Stephen Crane Memorial Lecture at Syracuse University in 2006.

David Eye left New York and a career in theater in August 2005 to pursue an M.F.A. in poetry at Syracuse University. As mid-life crises go, he figured this would be better than a red convertible.

LaToya Ruby Frazier is from Pittsburgh. She earned her B.F.A. in photography and graphic design from Edinboro University of Pennsylvania, and is pursuing her M.F.A. in art photography at Syracuse University. Her photographs have been exhibited at Light Work, the Community Folk Art Center, and the Everson Museum of Art in Syracuse, and Schweinfurth Memorial Art Center in Auburn, New York. Frazier has taught photography at Syracuse University and has conducted various workshops in Central New York. Her film, *A Mother to Hold,* has been screened in several film festivals and won the Producer's Choice award at the Women of Color Film Festival in 2006. She won the College Art Association's Professional Development Fellowship for Visual Artists in 2006.

Mary Gaitskill is the author of the novels *Two Girls, Fat and Thin* and *Veronica,* as well as the story collections *Bad Behavior* and *Because They Wanted To.* The latter was nominated for the PEN/Faulkner prize in 1998. Her story, "Secretary," was the basis for the feature film of the same name. Her stories and essays have appeared in the *New Yorker, Harper's, Esquire, Best American Short Stories,* and *The O. Henry Prize Stories.* In 2002 she was awarded a Guggenheim Fellowship for fiction; she is an associate professor of English at Syracuse University. Her novel, *Veronica,* was nominated for the National Book Award and the National Critic's Circle Award, and named one of the ten best books of 2005 by the *New York Times.*

Bob Gates studied photography at the University of Iowa School of Art while completing his Ph.D. in English, after which he joined the English department at Syracuse University. His photographs have won awards in regional and national competitions, have appeared in individual and juried group exhibitions, and have been published in such magazines as *Photolife* (Canada), *MaVista* (UK), *Photographic, Shutterbug, Outdoor Photographer,* and *Popular Photography.* His extensive work can be viewed at *bobgatesphoto.com.*

Mary Giehl was a registered nurse for 22 years, working in Pediatric ER, ICU, and Transport units. She completed her B.F.A. in fiber arts and her M.F.A. in sculpture at Syracuse University, and teaches part time in Syracuse's sculpture and fiber/materials studies program. She is active in the Syracuse arts community as the chairperson of the Westcott Art Gallery. Mary was an artist-in-residence at the Delaware Center for the Contemporary Arts, and will be an artist-in-residence in Ecuador in 2007.

Thomas Glave, winner of the O. Henry Prize for fiction, was nominated by the American Library Association for their Best Gay/Lesbian Book of the Year for *Whose Song? and Other Stories.* He is also author of an essay collection, *Words to Our Now: Imagination and Dissent* (winner of the 2006 Lambda Award in Nonfiction), and editor of the forthcoming anthology *Our Caribbean: A Gathering of Lesbian and Gay Writing from the Antilles* (Duke University Press, 2007). He is an associate professor of English and Africana Studies at SUNY Binghamton.

Jakk Glen III is a senior at Corcoran High School in Syracuse. He is 18 years old. He plays varsity football and throws shot-put and discus for the varsity track and field team. His favorite professional football team is the Philadelphia Eagles. He works part time at a local nursing home and participates in community-wide dialogues on race. He hopes to major in psychology when he attends college next fall.

WENDY GONYEA is a member of the Beaver Clan of the Onondaga Nation. She is a former teacher-counselor and editor of the *Onondaga Nation News*. She is actively involved in education and in speaking and writing on behalf of the Onondaga Nation.

LEWRAINE GRAHAM has exhibited paintings, assemblage, and installation art for over 20 years. She studied at the Art Students League in New York and the Ruskin School of Art in Oxford, England. Starting out as a painter, she began her assemblage work in 1993. She worked and exhibited in the New York/New Jersey area until 1998, when she moved to Syracuse. She is represented by the Jan Weiss Gallery in New York, and the SKH Gallery in Great Barrington, Massachusetts.

CHRISTOPHER GRAY is an architect and professor in the Syracuse University School of Architecture. Although he has been taking photographs for most of his adult life, he became a photographer about five years ago when he purchased his first digital camera. More of his work can be found at: *christophergrayphoto.com*.

KELLE GROOM has published two poetry collections: *Underwater City* (University Press of Florida, 2004) and *Luckily* (Anhinga Press, 2006). Her poems have appeared in *DoubleTake/ Points of Entry,* the *New Yorker, Ploughshares, Poetry, Witness,* and other magazines. She wrote many of the poems in her first book while living in Central New York. A native of Massachusetts, she now lives in New Smyrna, Florida. She is grants administrator and communications coordinator for Atlantic Center for the Arts.

DAVID HAJDU is the author of two award-winning books: *Lush Life: A Biography of Billy Strayhorn* and *Positively Fifth Street: The Lives and Times of Joan Baez, Bob Dylan, Mimi Baez Farina, and Richard Farina.* He is a columnist for the *New Republic* and writes frequently for publications such as the *New York Review of Books,* the *New Yorker,* and the *Atlantic Monthly.* Hajdu teaches magazine journalism in the S.I. Newhouse School of Public Communications at Syracuse University. His contribution to this issue will appear, in different form, in his next book, *The Ten-Cent Plague,* to be published by Farrar, Straus and Giroux in fall 2007.

ELAINE HANDLEY has a Ph.D. in creative writing from SUNY Albany and is associate professor of writing and literature at Empire State College in Saratoga Springs, New York. She was co-recipient of the 2006 Adirondack Center for Writing Award in poetry. She has received a New York State Council on the Arts individual artist's grant to complete work on *Deep River,* a novel about the Underground Railroad set in Upstate New York, a chapter of which is published in this issue.

DURIEL E. HARRIS is a co-founder of the Black Took Collective and poetry editor for *Obsidian III.* Her first book, *Drag* (Elixir Press, 2003) was hailed by *Black Issues Book Review* as one of the best poetry volumes of the year. She is at work on *Amnesiac,* a media art project (poetry volume, DVD, sound recording, web site) funded in part by the University of California Santa Barbara Center for Black Studies Race and Technology Initiative. *Amnesiac* writings appear or are forthcoming in *Nocturnes, The Encyclopedia Project, Mixed Blood,* and *The Ringing Ear.* A performing poet/sound artist, Harris is a Cave Canem fellow, recent resident at The MacDowell Colony, and member of the free jazz ensemble, Douglas Ewart & Inventions. She teaches English at St. Lawrence University in Canton, New York.

WENDY HARRIS has had her work shown at the Edward Hopper House, the Everson Museum, the Schweinfurth Memorial Art Center, and the Delavan Art Gallery. Wendy picked up her first pastel in a noncredit class at University College in 1996 and has been passionate about the medium and painting ever since. She is director of development at University College of Syracuse University.

LUCY HARRISON is a 30 year-old woman with autism. She has learned to type to communicate and uses typing to procuce her academic work and poetry. Recently she earned a degree in psychology from Le Moyne College in Syracuse. She likes to read Stephen King novels and *Writer* magazine, to which she subscribes. Her mom, Nita, has this to say about Lucy: "To me the magic of poetry is as incomprehensible as the wordlessness of autism. Given the right circumstances, Lucy emerges in her poems as a powerful and eloquent voice. At other times, she remains behind that mysterious wall." Lucy is the 2007 winner of the Bea González Prize for Poetry.

SARAH C. HARWELL earned an M.F.A. at Syracuse University, and has published a critically successful book of poems, with two other poets, titled *Three New Poets* (Sheep Meadow Press). She is a linguistic analyst at Syracuse University, teaching computers how to parse and comprehend the language of newspapers, dating web sites, and NASA engineers, and as an adjunct instructor in the English department. She lives in Syracuse with her daughter.

GAIL HOFFMAN received a B.A. with Honors in fine arts from Dickinson College and an M.F.A. in printmaking from Indiana University. She taught at the Park School in Brooklandville, Maryland, before coming to Syracuse, where she teaches 2-D creative processes and experimental animation in the foundation department of the School of Art and Design at Syracuse University. Her first solo show was at the Chuck Levitan Gallery in Soho in 1998. She has exhibited her work at the Denise Bibro Gallery in Chelsea and has been a National Affiliate Member of SOHO20 Chelsea Gallery since 2001.

TOM HUFF is a stone sculptor in various stones, styles, and mixed-media work. He began carving at home, inspired by the artists of the Cattaraugus Seneca Nation, and later attended the Institute of American Indian Arts in Santa Fe, New Mexico, and the Rhode Island School of Design. He is an adjunct professor at Onondaga Community College in stone carving and Iroquois art. Tom is a published writer of prose and poetry and has served as editor for *Stonedust,* an Iroquois newsletter. He lives on the Onondaga Nation with his wife, sculptor Trudi Shenandoah, his son Charlie, and daughter Kali, and maintains a carving studio.

MARIO JAVIER studied architecture and art education in Cuba. He came to the United States through the visa lottery system with his wife and two children in 2004, and resides in Syracuse. Recent projects include "Growing Up in the Darkness," a mural focusing on family literacy, commissioned by the CNY Community Foundation and displayed at the Onondaga County Civic Center. His work has been shown at the Community Folk Art Gallery and at the Center for New Americans.

MICHAEL JENNINGS was born in the French Quarter of New Orleans, grew up in east Texas and Iran, and graduated from the University of Pennsylvania and the graduate writing program at Syracuse University. He is an internationally recognized breeder and judge of Siberian Huskies and has written three books on the breed. He has published five limited edition books of poems, including *The Hardman County Sequence,* with photographs by Dorothea Lange and a foreword by W.D. Snodgrass, which is now a collectors' item. He is a CAPS Grant recipient and has had poems appear in such places as the *Georgia Review, Sewanee Review, Southern Review,* and the *Chattahoochee Review.* His latest book, *Silky Thefts,* was just released by Orchises Press in January 2007. He teaches at Cayuga Community College in Auburn, New York.

EVALENA AISHA JOHNSON is a senior at Nottingham High School in Syracuse. She is 18 years old and the proud mother of five-month-old Aidan. She would like to attend St. Louis University to study physical therapy. She is a music enthusiast and loves to listen to different genres of music including country, R&B, and classic R&B, depending on how she feels on any given day.

HUGH JONES is a lifelong resident of Central New York. His art and education background includes undergraduate study at Colgate University, an M.Ed. from the University of Massachusetts at Amherst, sculpture and architectural study at Syracuse University, and an apprenticeship in furniture and antiques restoration. His sculpture has been in the Cooperstown National Exhibition, where he received the *Art News* award and in the Ithaca "Art in the Heart of the City" show.

CHRISTOPHER KENNEDY is the director of the M.F.A. program in creative writing at Syracuse University and the author of three full-length collections of poetry. His latest collection will be published by BOA Editions in 2007. He has received grants from the New York Foundation for the Arts and the Constance Saltonstall Foundation for the Arts.

ROBIN WALL KIMMERER is the author of *Gathering Moss: A natural and cultural history of mosses,* which won the prestigious John Burroughs Medal for Nature Writing. She is currently working on a second book of essays on the subject of living in reciprocity with the land, which combines traditional indigenous knowledge with scientific perspectives. Kimmerer is professor of environmental and forest biology at the SUNY College of Environmental Science and Forestry in Syracuse, director of the Center for Native Peoples and the Environment, and an enrolled member of the Citizen Potawatomi Nation. She is the author of numerous scientific papers on the ecology of mosses, and has an active research program in the ecology and restoration of plants of cultural and medicinal significance to Native people. With the support of the National Science Foundation, she and her students are developing culturally-based environmental education programs that emphasize the significance of indigenous wisdom in addressing modern environmental problems.

JOELLEN KWIATEK has a B.A. from Syracuse University and an M.A. from Johns Hopkins University. She has been published in magazines such as the *Antioch Review* and the *Indiana Review,* and was the featured poet on the cover of the *American Poetry Review.* She has been awarded the Pushcart Prize and the Constance Saltonstall Award. Her book, *Eleven Days Before Spring,* was published by HarperCollins. She teaches at SUNY Oswego's Writing Institute.

Jhumpa Lahiri received the Pulitzer Prize in 2000 for *Interpreter of Maladies,* her debut story collection that explores issues of love and identity among immigrants and cultural transplants. She was the first Indian woman to receive that award. Her novel, *The Namesake,* published in 2003 to great acclaim, expands on the perplexities of the immigrant experience and the search for identity. She has won the PEN/Hemingway Award, the O. Henry Award, and the Addison Metcalfe Award from the American Academy of Arts. A film version of *The Namesake* will be released in spring 2007. She is currently working on a new book of short stories, to be published in 2008. Lahiri was a speaker for the Rosamond Gifford Lecture Series in Syracuse in April 2006.

Carly June L'Ecuyer is a 16-year-old fiction writer and student at Ichabod Crane High School in Columbia County, New York. She was a participant in the summer 2006 New York State Young Writer's Conference at Silver Bay, New York. She thanks Jenny Marion, whose life was the inspiration for her story.

David Lloyd is a professor of English and director of the creative writing program at LeMoyne College. He holds a B.A. from St. Lawrence University, an M.A. from the University of Vermont, and an M.A. and a Ph.D. from Brown University. His primary teaching interests are in creative writing, modern poetry and fiction, and Irish/Welsh studies. His anthology, *The Urgency of Identity: Contemporary English-language Poetry from Wales,* was published in 1994. He publishes poetry, fiction, critical studies, and interviews in journals and anthologies in the U.S., Canada, and Europe.

Charles Martin is a poet, translator, and three-time nominee for the Pulitzer Prize. His verse translation of the *Metamorphoses of Ovid,* published in 2003 by W.W. Norton, received the Harold Morton Landon Award from the Academy of American Poets. His most recent book of poems, *Starting from Sleep: New and Selected Poems,* was a finalist for the Lenore Marshall Award of the Academy of American Poets. He is the recipient of a Bess Hokin Award from *Poetry,* a 2001 Pushcart Prize, and fellowships from the Ingram Merrill Foundation and the National Endowment for the Arts. In 2005, he received an Award for Literature from the American Academy of Arts and Letters. Currently teaching in the English department at Syracuse University, he is Poet in Residence at The Poets' Corner of the Cathedral of St. John the Divine in New York City.

Bryan McGrath is a professor of art and head of the ceramics department of Pratt at Munson-Williams-Proctor Arts Institute in Utica, New York. He has an M.F.A. from Syracuse University, where he was a graduate fellow. His work has been featured in several ceramics publications, and is included in many public and private collections in the United States, Australia, Ireland, and Japan. He has exhibited nationally and internationally.

Philip Memmer is the author of three collections of poetry, including *Sweetheart, Baby Darling* (Word Press, 2004). A fourth, *Threat of Pleasure,* is expected in late 2007. His poetry has appeared in *Poetry, Poetry Northwest, Southern Poetry Review,* and *Mid-American Poetry Review,* and has been included in several anthologies. Phil lives in Central New York with his wife and daughter, where he edits the literary journal *Two Rivers Review.* He is director of the Arts Branch of the YWCA of Greater Syracuse, and founder of the Downtown Writer's center, the Syracuse affiliate of the YMCA National Writer's program.

WENDY MOLESKI has lived in Syracuse since she was six. After attending Syracuse public schools, she worked for a trucking company, married, and spent many years raising six beautiful children. She has volunteered for the Red Cross and has worked with handicapped youth at the Syracuse Development Center. She has also taught swimming at the YMCA and has tutored GED math students. After retirement, she joined the Syracuse Camera Club to pursue her interest in photography.

WILLIAM NEUMIRE teaches at Fabius-Pompey high school and lives in Fayetteville with his fiancée. His poems have appeared or are forthcoming in *Main Street Rag, Rattle, Cranky Poetry Journal,* and *Borderlands: Texas Poetry Review.*

ANNE NOVADO CAPPUCCILLI has a B.A. and an M.F.A. from Syracuse University, where she is an adjunct professor in the School of Art foundation program. Her work has been exhibited in the Arnot Art Museum (Elmira), the Essex Art Center (Lawrence, Massachusetts), the Schweinfurth Memorial Art Gallery (Auburn), Fisher Weisman (San Francisco), Sikkema Jenkins and Co. (New York), and the Tiskale Studio (Syracuse). She is a board member and past president of ThiNC, a Syracuse-based art organization, and maintains an active studio in downtown Syracuse.

VICTOR OSHEL has been a factory worker, truck driver, newspaper writer, white water river guide, substance abuse counselor, and teacher. He has a degree in English from Utica College, and works as a substitute teacher in Blossvale, New York.

E.C. OSONDU was born in Nigeria. He is in the Syracuse University M.F.A. program and is a University Fellow. His work has appeared in *Agni* and *Salt Hill.* He lives in Syracuse with his wife and three children. One of the reasons he came to Syracuse was because as a child growing up in Nigeria he loved a picture of snow he saw on a postcard. He is the 2007 winner of the Allen and Nirelle Galson Prize for Fiction.

ELENA PETEVA is a figurative painter originally from Sofia, Bulgaria, who came to the United States at age 17 to study at the Interlochen Arts Academy in Michigan and the Pennsylvania Academy of Fine Arts. She is a third-year M.F.A. student in painting and a Dedalus Foundation Fellow at Syracuse University's College of Visual and Performing Arts. Recently she was included in the Arnot Museum 71st Annual Juried Exhibition, and had a solo exhibition at the Artist's House Gallery in Philadelphia. Her work is in several permanent collections, including the Graphic Arts Collection at Princeton University. She was awarded the Elizabeth Greenshields Foundation grant last fall for international representational art.

MICHAEL PETROSILLO owns a coffee house in Syracuse and markets a sports company in California. He lives in Fayetteville with his wife, Susan, and two small children. This is his first published story.

ROBERT PHILLIPS earned a B.A. and an M.A. from Syracuse University in 1960 and 1962 respectively. He is the author or editor of 30 volumes of poetry, fiction, criticism, and *belle lettres,* and is currently a Cullen Distinguished Professor at the University of Houston. His honors and awards include the Syracuse University Arents Pioneer Medal, a Pushcart Prize, an American Academy and Institute of Arts and Letters Award in Literature, MacDowell Colony and Yaddo fellowships, and a Texas Institute of Letters membership. *Icehouse Poems,* excerpted in this issue of *Stone Canoe,* is a work in progress.

GEORGIA POPOFF is a community poet, performer, educator, spoken word producer, and senior editor of *The Comstock Review.* A teaching poet in schools and community settings, her work has appeared in numerous journals, anthologies, and web publications. Her first collection is *Coaxing Nectar from Longing.* She is the Central New York Community Coordinator for Partners for Arts Education and a board member of the Association of Teaching Artists.

MINNIE BRUCE PRATT is completing *The Only Danger,* poems about living under capitalism. Her most recent book of poetry, *The Dirt She Ate: Selected and New Poems,* (University of Pittsburgh Press), received a Lambda Literary Award. Her previous book, *Walking Back Up Depot Street,* also from Pitt, was named Best Lesbian/Gay Book of the Year by *ForeWord: The Magazine of Independent Bookstores and Booksellers.* Her work, *Crime Against Nature,* was chosen as the Lamont Poetry Selection of the Academy of American Poets. She is professor of writing and women's studies at Syracuse University.

PAUL B. ROTH is editor and publisher of *The Bitter Oleander Press,* recognized in 2005 as Best Literary Journal by National Public Radio's "Excellence in Print" award. His forthcoming collection of poetry, *Cadenzas by Needlelight,* will be published by Cypress Books in 2008. He lives in Fayetteville.

MONK ROWE is a saxophonist, pianist, and composer and has been the Joe Williams Director of the Hamilton College Jazz Archive since its inception in 1995. The Archive currently holds 260 interviews with jazz personalities that exist on DVD, in transcript, and electronic format. For further information about the Jazz Archive visit *hamilton.edu/jazzarchive.*

GEORGE SAUNDERS teaches in the Syracuse University Creative Writing program. He is the author of a number of critically acclaimed books: *CivilWarLand in Bad Decline, Pastoralia, The Very Persistent Gappers of Frip, The Brief and Frightening Reign of Phil,* and, most recently, *In Persuasion Nation.* He writes regularly for the *New Yorker* and GQ. In 2006, Saunders won both a MacArthur Prize and a Guggenheim Fellowship.

JOSEPH SCHEER is a Constance Saltonstall Fellow, and professor of print media and co-director/founder of the Institute for Electronic Arts at Alfred University's School of Art and Design. His work spans print media, video, sound, and web-based projects, using technology to re-examine nature through interpretive collecting and visual recording. He has exhibited at the Brooklyn Museum of Art (New York), the National Museum of China (Beijing), the National Museum of Sweden (Stockholm), and the Field Museum (Chicago). He has published two books about his work: *Night Visions: The Secret Designs of Moths* (Prestel), and *Night Flyers* (Nexus Press).

LUVON SHEPPARD is a professor of illustration and painting at the Rochester Institute of Technology School of Art and Design. He has served as coordinator of neighborhood affairs for the University of Rochester Memorial Art Gallery and director of the Allofus Art Workshop, and has taught classes at SUNY Brockport and Geneseo. His work has been represented in many galleries and shows throughout New York State, and has won numerous awards. Sheppard has always played an active leadership role in the Rochester arts community, served on many boards, and lectured on the arts for diverse audiences.

S. ANN SKIOLD is Fine Arts Librarian at Syracuse University. She serves as faculty liaison to the College of Visual and Performing Arts and to the department of fine arts in the College of Arts and Sciences. She is a native of Sweden, where she studied law and English. She has a B.A. in English literature from University of California at Santa Barbara, an M.F.A. in painting from Bradley University, and an M.L.I.S. in library and information science from San Jose State University. Ann is fluent in Swedish, Danish, Norwegian, French, and Spanish.

W.D. SNODGRASS has had a long and distinguished career as a poet and teacher. He has written eight books of poetry, including the Pulitzer Prize-winning *Heart's Needle,* seven volumes of translations, and a book of essays, *In Radical Pursuit.* His most recent book is *Not For Specialists: New and Collected Poems* (BOA 2006). One of the book's poems is featured in this issue of *Stone Canoe,* along with an earlier draft, to offer the reader a look at Snodgrass' revision process. Snodgrass has taught at Syracuse University, Cornell, the University of Rochester, and several other universities. He retired from teaching in 1994 and devotes himself full time to his writing. He and his "fourth, last, and best" wife, writer Kathleen Snodgrass (née Browne), spend six months of each year at their home in Erieville, New York, and six months in Mexico.

LAURIE STONE is the author of two nonfiction collections and a novel, *Starting with Serge.* A long-time writer for the *Village Voice* and *Ms.,* she has also been theatre critic for the *Nation,* and critic-at-large for NPR's Fresh Air. Laurie has taught at Antioch, Fairleigh Dickinson, Sarah Lawrence, Ohio State, and the Paris Writer's Workshop. She is on the board of the National Book Critic's Circle and was a 2006 resident fellow at the Constance Saltonstall Institute for the Arts in Ithaca. Laurie lives in New York.

JOHN THOMPSON is a painter, illustrator, and professor of art at Syracuse University. He has been featured in *Communication Arts, Step-By-Step Graphics,* and *Art Direction* magazines. He has won gold and silver medals from the Society of Illustrators, The New Jersey Art Directors Club, The Denver Art Directors club, The Society of Illustrators of Los Angeles, and the CBA Award for Communication Excellence in Black Publishing and Advertising, as well as awards of excellence from *Communication Arts* and *Print.* John is the recipient of the 2006 Hamilton King Award for the best illustration of the year, and was recently included in *The Illustrator in America,* 1860-2000, by Walt Reed. The paintings in this issue were inspired by a recent trip to India.

JOHN VON BERGEN is the co-founder of Sculpture Space in Utica. He has degrees from Hamilton College and Pratt Institute, and has taught sculpture at the Munson-Williams-Proctor Arts Institute, Hamilton College, and Colgate University. He maintains studios in Clinton, New York, and Bayside, Maine. His sculpture has been shown throughout the Northeast, including the Kouros Gallery (New York), the Everson Museum (Syracuse), Stone Quarry Art Park (Cazenovia), and the Caldbeck Gallery and Farnsworth Art Museum (Rockland, Maine).

THOM WARD is editor at BOA Editions, based in Rochester, New York. Among his poetry publications are *Small Boat with Oars of Different Size* and *Various Orbits,* both from Carnegie Mellon University Press. Though he has some facility in paddling a small boat, it would be exceedingly difficult for him to keep a stone canoe afloat. Luckily, he can swim.

CARRIE MAE WEEMS is an artist and photographer who has in the course of her illustrious career created a rich array of documentary series, still lives, narrative tableaux, and installation works on themes of family, race, and gender. The daughter of Mississippi sharecroppers who moved to Oregon in the 1950s, she studied dance in San Francisco, joined the labor movement as a labor organizer, and came to the visual arts as an adult, eventually getting degrees from California Institute of the Arts, University of California San Diego, and UC Berkeley. Her works have been published and exhibited widely, and she has taught at numerous colleges throughout the country. She was awarded the Rome Prize in 2006, and after a year abroad has returned home to Syracuse, where she teaches at Syracuse University and lives with her husband, Jeffrey Hoone, also an artist.

JACK WHITE is a nontraditional painter, using metals, fabrics, paper, and wood to create works that draw inspiration from African cultures. His current work is related to the art and artifacts of the Kingdom of Benin, formerly known as West Africa's "Slave Coast." Jack studied painting at Morgan State and Syracuse University, and is one of the founders of the Community Folk Art Center in Syracuse. During his long career, he has had 36 solo shows. His work is represented in the permanent collections of Syracuse University, Colgate University, the Munson-Williams-Proctor Arts Institute (Utica), the Schomberg Cultural Center (New York), the Asheville Museum of Art, the Arkansas Arts Center, and the Tampa Museum of Art. After many years based in Upstate New York, Jack recently relocated to Austin, Texas.

DIANA WHITING has been photographing since 1994. Her work has appeared in calendars, on CD covers, in *Nature Photographer Magazine,* and most recently, the *Best of Photography Annual 2006.* She was a 1999 grand prize winner for *Nature Photographer Magazine,* and 2000 first place winner in macro for Rocky Mountain School of Photography. She is an active member in the Syracuse Camera Club and works with the Montezuma Wildlife Refuge, Baltimore Woods, and Beaver Lake Nature Center to promote environmental education. To view more of her work, go to *pbase.com/syrcam/whiting.* She owns and operates Headquarters Unisex Hair Design and resides in Skaneateles. She is the 2007 winner of the Michael Fawcett Prize for Visual Arts.

ERROL WILLETT is associate professor of art and coordinator of the ceramics program at Syracuse University's College of Visual and Performing Arts. He is a Meredith Professor for excellence in teaching at the University. His work has shown at the Everson Museum of Art (Syracuse), the Clay Studio (Philadelphia), the Baltimore Clayworks Gallery, and the Banff Centre of the Arts (Canada), and has been included in numerous books and magazines.

MARION WILSON has had exhibitions at the New Museum of Contemporary Art (New York), Sculpture Center (New York), Hallwalls Contemporary Arts Center (Buffalo), SPACES (Cleveland, Ohio), Cheryl Pelavin Fine Arts (New York), Everson Museum of Art (Syracuse), scope/Miami/Art Basel, and scopeNewYork. She has been awarded residencies at the International Studio Program funded by NYSCA and the Elizabeth Foundation. She has received grants from Gunk Artists in the Public Realm, NYFA artists in the school, and the Constance Saltonstall Foundation. Wilson earned a B.A. from Wesleyan University, an M.A. from Columbia University, and an M.F.A. from the University of Cincinnati. She lives and works in Syracuse and New York. Marion's work for this issue was on display in the Building Show at Exit Art in New York through early February 2007.

LEAH ZAZULYER is a poet, Yiddish translator, and former educator and school psychologist. She grew up in California but has lived in Rochester since 1968. Her parents came from Belarus. She has received grants from the Constance Saltonstall Foundation for the Arts, the New York State Council on the Arts, the New York State Foundation for the Arts, and the National Yiddish Book Center. She has long been interested in issues regarding the impact of language and culture upon each other. Her current project, sponsored by the Speilberg Foundation, involves creating dramatic monologues from interviews with Holocaust victims.

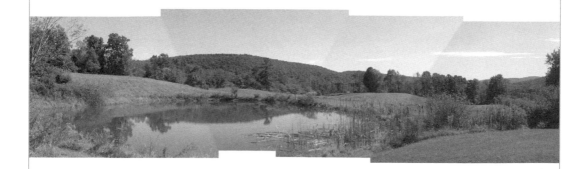

The Constance Saltonstall Foundation for the Arts

is committed to serving the individual NYS artist (especially in the Finger Lakes region) through all stages of the creative process. We serve NYS artists and writers with summer fellowships, grants, seminars and access to studio space. Learn more about our programs and how you can get involved at www.saltonstall.org

CONSTANCE SALTONSTALL
Foundation for the Arts

435 Ellis Hollow Creek Road
Ithaca, New York 14850
phone: 607.539.3146
fax: 607.539.3147
web: www.saltonstall.org
email: info@saltonstall.org

A CELEBRATION OF THE
Humanities

A great community deserves a great arts journal,

and that's why The College of Arts and Sciences at

Syracuse University is proud to congratulate *Stone Canoe*

on its inaugural issue. Like the newly re-opened

Tolley Building at SU, this lustrous publication exemplifies

the spirit of the humanities by connecting people and ideas

to better understand the world around us.

The Tolley Building, home of:
- Center for the Public and Collaborative Humanities
- Imagining America national consortium for arts, humanities, and design
- Central New York Humanities Corridor
- Interdisciplinary programming in Judaic, Latino-Latin American, LGBT, and Native American studies and the Religion and Society Program

THE COLLEGE OF ARTS AND SCIENCES
SYRACUSE UNIVERSITY

http://www-hl.syr.edu/cas-pages/HumanitiesPrograms.htm
315-443-1995 / 888-CAS-ALUM

COLLEGE OF VISUAL
AND PERFORMING ARTS

The Syracuse University College of Visual and
Performing Arts and Dean Carole Brzozowski
congratulates *Stone Canoe* on its inaugural issue.

Congratulations on the inaugural issue
of **Stone Canoe**
from the **School of Architecture**

Whitman
SCHOOL *of* MANAGEMENT
SYRACUSE UNIVERSITY

The Whitman School
Congratulates

Stone Canoe

on its Inaugural Issue

SCHOOL OF EDUCATION
SOE 100
SYRACUSE UNIVERSITY

THE SYRACUSE
SCHOOL OF
EDUCATION

**Spring 2007
Centennial
Lectures**

This spring, the School of Education invites you to attend two Centennial Lecture Series events that demonstrate the power of the enduring partnership of education and the arts. These lectures will take place in the Public Events Room, 220 Eggers Hall, on the Syracuse University campus. They are free and open to the public.

March 1, 2007, 4 p.m.

Kris D. Gutierrez, "Looking for Educational Equity: Immigrants, Migrants, and the New Latino Diaspora"

Ms. Gutierrez is a professor of social research methodology at UCLA, and focuses her research on the relationship between language, culture, development, and the pedagogies of empowerment. Her lecture will explore the sociocultural contexts of literacy development for minority students.

April 26, 2007, 4 p.m.

Julie Eizenberg, "Expectations Need to Change"

Ms. Eizenberg is a founding principal of KoningEizenbergArchitecture, and is a pioneer in socially conscious architectural design. She will discuss how designers can take responsibility for setting ideological and conceptual frameworks for their work.

Established in 1906, Syracuse University's School of Education is a national leader in improving and informing educational practice for diverse communities. A pioneer in the inclusion movement in the United States, the school is dedicated to finding new ways to make it possible for all learners to participate fully in mainstream classrooms and other inclusive learning and arts environments.

Coalition of Museum and Art Centers
350 West Fayette Street, Syracuse, NY 13202
(315) 443-6450, (315) 443-6494 fax
http://cmac.syr.edu

Formed in September 2005 by Syracuse University President and Chancellor Nancy Cantor, the Coalition of Museum and Art Centers (CMAC) brings together the programs, services, and projects of several different campus art centers and affiliated non-profit art organizations in the campus community in a collaborative effort to expand the public's awareness, understanding, appreciation, and involvement in the visual and electronic arts. The mission of CMAC is to celebrate and explore the visual and electronic arts through exhibitions, publications, public presentations, education, and scholarship.

THE WAREHOUSE GALLERY
Coalition of Museum and Art Centers
350 West Fayette Street, Syracuse, NY 13202
(315) 443-6450, (315) 443-6494 fax
www.thewarehousegallery.org

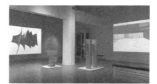

LIGHT WORK
Robert B. Menschel Media Center
316 Waverly Avenue, Syracuse, NY 13244
(315) 443-1300, (315) 443-9516 fax
www.lightwork.org

COMMUNITY FOLK ART CENTER
805 East Genesee Street, Syracuse, NY 13210
(315) 442-2230, (315) 442-2972 fax
www.communityfolkartcenter.org

SUART GALLERIES
Shaffer Art Building on the Syracuse University Quad
Syracuse, NY 13210-1230
(315) 443-4097, (315) 443-9225 fax
http://suart.syr.edu/index.html

SPECIAL COLLECTIONS RESEARCH CENTER
600 E. S. Bird Library, Syracuse, NY 13244
(315) 443-2697, (315) 443-2671 fax
http://scrc.syr.edu

POINT OF CONTACT GALLERY
914 E. Genesee Street, Syracuse, NY 13210
(315) 443-2169
www.pointcontact.org

LOUISE AND BERNARD PALITZ GALLERY
Syracuse University Joseph I. Lubin House
11 East 61st Street, New York, NY 10021
(212) 826-0320, (212) 826-0331 fax
http://lubinhouse.syr.edu/gallery/current.html

fig. A

[crafting theatre from well-crafted words]

CONGRATULATIONS

To Robert Colley and the staff of

Stone Canoe

A welcome literary and artistic contribution to our community

"I am of the opinion that my life belongs to the whole community and
as long as I live, it is my privilege to do for it whatever I can.
I want to be thoroughly used up when I die,
for the harder I work, the more I live."

—*George Bernard Shaw, playwright,
novelist, essayist, and critic*

THE GOLDRING ARTS JOURNALISM PROGRAM
S. I. NEWHOUSE SCHOOL OF PUBLIC COMMUNICATIONS
SYRACUSE UNIVERSITY

**the partnership
for better education**

Congratulations to *Stone Canoe,*
the new community arts journal,
from
the Partnership for Better Education

The Partnership for Better Education provides opportunities
for students from the Syracuse City School District to
achieve success at the following institutions of higher
education: LeMoyne College, Onondaga Community College,
Syracuse University, SUNY College of Environmental Science
and Forestry, and SUNY Upstate Medical University.

SYRACUSE UNIVERSITY BOOKSTORE

YOUR CAMPUS SOURCE FOR THE FINEST IN READING AND LITERATURE

THE UNIVERSITY

BOOKSTORE

Owned and Operated by Syracuse University

Schine Student Center
303 University Place
Syracuse, NY 13244
(315) 443-9900
www.syr.edu/bkst

Art
Literature
Journals

follett's Orange
Bookstore

Marshall Square Mall
720 University Avenue
Syracuse, NY 13210
(315)478-6821
efollett.com

Serving the Syracuse University Community for 40 Years

THE ROSAMOND GIFFORD LECTURE SERIES

2006-2007

Joyce Carol
Oates
10.3.2006

John
Feinstein
11.1.2006

Barbara
Ehrenreich
12.6.2006

Jonathan Safran
Foer
3.14.2007

Azar
Nafisi
4.12.2007

Norman
Mailer
&
John Buffalo
Mailer

Appearing together 5.10.2007

For tickets, call
315.435.2121.
Individual tickets
can also be
purchased at
ticketmaster.com.

R os A mond
G i f f o r D
L E c t u r e
S e r i e s

Proceeds benefit the Onondaga County Central Library. | Lectures are held in the John H. Mulroy Civic Center,
421 Montgomery Street, Syracuse, NY.

Guaranteed to give you an art attack.

[Warning: once you see our selection and prices,
there's no going back…to any other store.]

The Art Store
Commercial Art Supply

America's Leading Discount Framing & Art Supplier

**Service, Selection & Guaranteed Low Price…
Why Shop Anywhere Else?**

Just a mile from campus . . . and so good for your art.

Where the Art is . . .

Syracuse

The Art Store
Corner of Erie Blvd East &
Crouse Avenue, 315-474-1000

The Art Store Annex
Across from SU Warehouse
315-701-1038

Rochester

The Art Store Rochester
Southtown Plaza
585-424-6600

"If you can't find it at The Art Store, it probably doesn't exist."

– Online reviewer

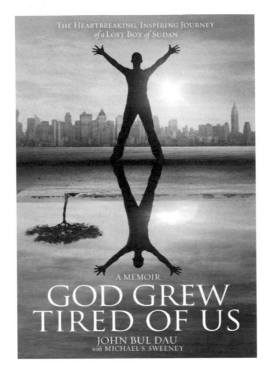